A SHORT COURSE IN PHOTOGRAPHY

A SHORT COURSEIN PHOTOGRAPHY THIRD EDITION

an introduction to black-and-white photographic technique

BARBARA LONDON/JIM STONE

HarperCollinsCollegePublishers

Acquisitions Editor: Cynthia Biron Developmental Editor: Betty Slack Project Coordination: Nancy Benjamin, Benjamin Production Services Cover Photograph: Bonnie Kamin Art Studio: Network Graphics, Inc. Electronic Production Manager: Christine Pearson Manufacturing Manager: Helene G. Landers Printer and Binder: R.R. Donnelley & Sons Company Cover Printer: The Lehigh Press, Inc.

A Short Course in Photography, Third Edition

Copyright © 1996 by Barbara London

HarperCollins[®] and # [®] are registered trademarks of HarperCollins Publishers, Inc.

All rights reserved. Printed in the United States of America. No part of this book may be used or reproduced in any manner whatsoever without written permission, except in the case of brief quotations embodied in critical articles and reviews. For information address HarperCollins College Publishers, 10 East 53rd Street, New York, NY 10022. For information about any HarperCollins title, product, or resource, please visit our World Wide Web site at http://www.harpercollins.com/college.

Library of Congress Cataloging-in-Publication Data

London, Barbara A short course in photography: an introduction to black-and-white photographic technique / Barbara London and Jim Stone. — 3rd ed. p. cm. Includes bibliographical references and index. ISBN 0-673-52439-6 1. Photography. I. Stone, Jim. II. Title. TR146.L618 1996 771—dc20

95-31003 CIP

96 97 98 98765432

CONTENTS

Preface vii

Camera 2

Getting Started: Camera and film **4** Loading film into the camera **5** Focusing and setting the exposure **6** Exposure readout **7** Exposing the film **8** What will you photograph? **9** •Types of Cameras **10** •Basic Camera Controls **12** •More About Camera Controls **14** •Shutter Speed: Affects light and motion **16** •Aperture: Affects light and depth of field **18** •Shutter Speed and Aperture: Blur vs. depth of field **20** •Care of Camera and Lens **22**

ENS 24

Lens Focal Length: The basic difference between lenses 26 •Normal Focal Length: The most like human vision 28 •Long Focal Length: Telephoto lenses 30 •Short Focal Length: Wide-angle lenses 32 •Zoom, Macro, and Fisheye Lenses 34 •Focus and Depth of Field 36 •Automatic Focus 37 •Depth of Field: Controlling sharpness in a photograph 38 •More About Depth of Field: How to preview it 40 •Perspective: How a photograph shows depth 42 •Lens Performance: Getting the most from a lens 44 •Solving Camera and Lens Problems 45

FILM 46

Selecting and Using Film **48** •Film Speed and Grain: *The two go together* **50** •Special-Purpose Films: *High contrast and infrared* **52** •Color Films **54**

EXPOSURE 56

Normal Exposure, Underexposure, and Overexposure **58** •Exposure Meters: What different types do **60** How to calculate and adjust an exposure manually **62** •Overriding an Automatic Exposure Camera **64** •Making an Exposure of an Average Scene **66** •Exposing Scenes with High Contrast **68** •Exposing Scenes that Are Lighter or Darker than Average **70** •Exposures in Hard-to-Meter Situations **71** •Solving Exposure Problems **72**

DEVELOPING THE NEGATIVE 74

Processing Film: Equipment and chemicals you'll need **76** •Mixing and Handling Chemicals **78** •Processing Film Step by Step: Setting out materials needed **79** Preparing the film **80** Development **82** Stop bath and fixer **83** Washing and drying **84** •Summary of Film Processing **85** •How Chemicals

Affect Film **86** • Evaluating Your Negatives **88** • Push Processing **90**

•Solving Negative Development Problems 92

PRINTING 94

Printing: Equipment and materials you'll need **96** •Making a Contact Print Step by Step **98** •Processing a Print Step by Step: Development **100** Stop bath and fixer **101** Washing and drying **102** •Summary of Print Processing **103** •Making an Enlarged Print Step by Step: Setting up the enlarger **104** Exposing a test print **106** Exposing a final print **107** •Evaluating Your Print for Density and Contrast **108** •More About Contrast: How to control it in a print **110** •Local Controls: Burning in and dodging **112** •More About Local Controls: Burning in and dodging **114** •Cropping **115** •Spotting **116** •Solving Printing Problems **117** •Mounting a Print **118** Equipment and materials you'll need **119** •Dry Mounting a Print Step by Step **120** •Bleed Mounting/Overmatting **122**

LIGHTING 124

Qualities of Light: From direct to diffused 126 •Existing Light: Use what's available 128 •The Main Light: The strongest source of light 130 •Fill Light: To lighten shadows 132 •Simple Portrait Lighting 134 •Using Artificial Light: Photolamp or flash 136 •More About Flash: How to position it 138 •Solving Flash Problems 140

Special Techniques 142

Close-ups 144 •More About Close-ups 146 •Using Filters: How to change film's response to light 148 •Lens Attachments: Polarization and other effects 150 •Digital Imaging 152 Equipment and materials you'll need 153 •Editing a Digital Image 154

SEEING LIKE A CAMERA 156

What's in the Picture: The edges or frame **158** The background **160** •Depth in a Picture: Three dimensions become two **162** •Depth of Field: Which parts are sharp **164** •Time and Motion in a Photograph **166** •Portraits **168** •More About Photographing People **170** •Photographing the Landscape/Cityscape **172** •Responding to Photographs **174**

Glossary **176** Bibliography **181** Index **182** Exposure Meter Dials **185**

PREFACE

f you don't know anything about photography and would like to learn, or if you want to make better pictures than the ones you make now, *A Short Course in Photography* will help you. It presents in depth the basic techniques for black-and-white photography:

- · How to get a good exposure
- How to adjust the focus, shutter speed, and aperture (the size of the lens opening) to produce the results you want
- · How to develop film and make prints

Many of today's cameras incorporate automatic features, but that doesn't mean that they automatically produce the results you want. *A Short Course in Photography* devotes special attention to:

 Automatic focus and automatic exposure—what they do and, particularly, how to override them when it is better to adjust the camera manually

The book covers other essential topics as well:

• Types of lenses, types of film, lighting, filters

New to this edition

- Getting Started. If you are brand new to photography, this section will walk you through the first steps of selecting and loading film, focusing sharply, adjusting the exposure, and making your first pictures. See pages **4–9**.
- Digital Imaging. In one sense, digital imaging is just another tool, but it is also an immensely powerful technique that is changing photography and that will empower those who know how to use it. See pages 152–155.
- Projects. These projects are designed to help you develop your technical and expressive skills. See, for example, page 126 or 169.
- Making Better Prints. Additional information about how to fine tune your prints by burning in and dodging (darkening or lightening selected areas), and by cropping the edges to concentrate attention on the portion of the scene you want. See pages 112–115.
- Technical updates throughout.

Photography is a subjective and personal undertaking. A

Short Course in Photography emphasizes your choices in picture making:

- How to look at a scene in terms of the way the camera can record it
- How to select the shutter speed, point of view, or other elements that can make the difference between an ordinary snapshot and an exciting photograph
- Chapter 9, Seeing Like a Camera, explores your choices in selecting and adjusting the image, and covers how to photograph subjects such as people and landscapes

This book is designed to make learning photography as easy as possible:

- · Every two facing pages completes a single topic
- Detailed step-by-step instructions clarify each stage of extended procedures such as negative development and printing
- · Boldfaced headings make subtopics easy to spot
- Numerous photographs and drawings illustrate each topic

Acknowledgements

Many people gave generously of their time and effort in the production of this book. Feedback from numerous instructors was a major help in confirming the basic direction of the book and in determining the new elements in this edition.

At HarperCollins, Cynthia Biron and Betty Slack provided editorial support. Nancy Benjamin supervised the production of the book from manuscript to printer. Paul Agresti redesigned the book and helped make it even more user friendly.

If, as you read the book or use it in your class, you have suggestions to make, please send them to Communications Editor, HarperCollins, 10 E. 53rd St., New York, NY 10022. They will be sincerely welcomed.

Barbara London Jim Stone

GETTING STARTED: Camera and film 4 Loading film into the camera 5 Focusing and setting the exposure 6 Exposure readout 7 Exposing the film 8 What will you photograph? 9 TYPES OF CAMERAS 10 BASIC CAMERA CONTROLS 12

SHUTTER SPEED: Affects light and motion 16
APERTURE: Affects light and depth of field 18
SHUTTER SPEED AND APERTURE: Blur vs. depth of field 20

MORE ABOUT CAMERA CONTROLS 14

CARE OF CAMERA AND LENS 22

CAMERA

his chapter describes your camera's most important controls

and how you can take charge of them, instead of always letting them control you. Cameras have become increasingly automatic in recent years; today, a new 35mm camera is often equipped with automatic exposure, automatic focus, and automatic flash. If you are interested in making better pictures, however, you should know how your camera makes its decisions, even if it is an automatic model. You will want to override your camera's automatic decisions from time to time and make your own choices.

- You may want to blur the motion of a moving subject or freeze its motion sharply. Pages **16–17** show how.
- You may want the whole scene sharp from foreground to background or perhaps the foreground sharp but the background out of focus. Pages 38–39 show how.
- You may want to override your camera's automatic focus mechanism so that the right part of a scene is sharp. Page **37** tells when and how to do so.
- You may decide to silhouette a subject against a bright background, or perhaps you want to make sure that you *don't* end up with a silhouette. See pages 68–69.

Many professional photographers use automatic cameras, but they know how their cameras operate manually as well as automatically so they can choose which is best for a particular situation. You will want to do the same because the more you know about how your camera operates, the better you will be able to get the results you want.

If you are just getting started in photography, the next few pages will help you make your first photographs. You can go directly to page **10** if you prefer more detailed information right away.

Cropping is one of the basic controls you have in making a photograph (see the two photographs of dancers this page and opposite). Horizontal or vertical? The whole scene or only a part of it? More about cropping on pages **115** and **158–159**.

PROJECT **expose a roll of film**

YOU WILL NEED

Camera. We suggest a 35mm single-lens reflex. Roll of film (page 4 tells how to choose one). Optional, but highly recommended for all the projects: Pencil and notepad to keep track of what you do.

PROCEDURE See pages **4–9** if you are just beginning to photograph. Those pages walk you through the first steps of selecting and loading film, focusing an image sharply, adjusting the camera settings so your photographs won't be too light or too dark, and making your first pictures.

Have some variety in the scenes on this roll. For example, photograph

subjects near and far, indoors and outside, in the shade and in the sun. Photograph different types of subjects, such as a portrait, a landscape, and an action scene.

HOW DID YOU DO? To evaluate your work, you will need to see it in prints or slides. Developing and printing black-and-white film is coming in later chapters. To see prints right away, try one-hour commercial color prints. Did some of your camera's operations cause you confusion? It helps to read your instruction book all the way through or to ask for help from someone who is familiar with your camera.

GETTING STARTED Camera and film

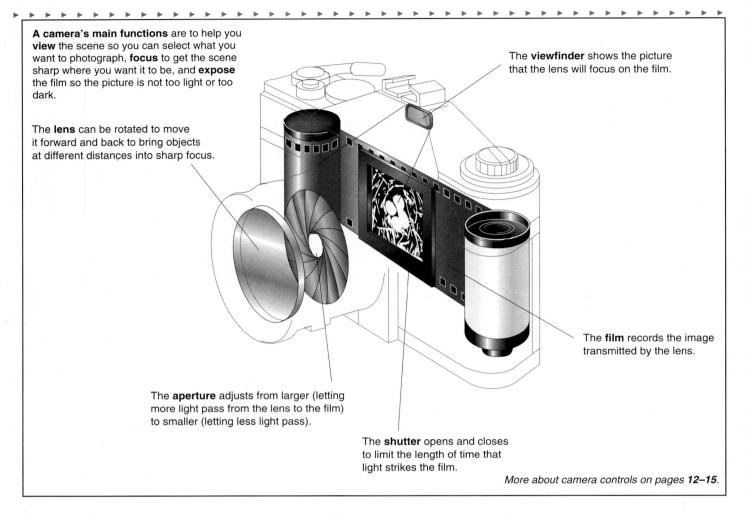

Choose a Film

Negative film Negative Print If you want prints, select a negative film, either color or black and white. Developing the film produces a negative image, which is then printed onto paper to make a positive.

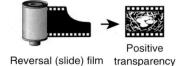

If you want slides (transparencies), select a reversal film, which produces a positive image directly on the film that is in the camera. Most reversal films are for color.

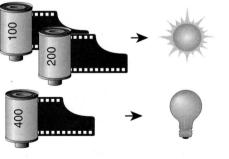

Film speed (ISO 100, 200, and so on) describes a film's sensitivity to light. The higher the number, the less light it needs for a correct exposure (one that is not too light or too dark). Choose a film with a speed of 100 to 200 for shooting outdoors in sunny conditions. In dimmer light, such as indoors, use film with a speed of 400 or higher.

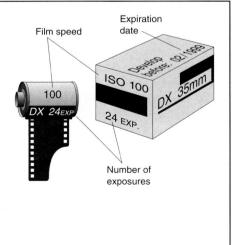

More about film characteristics on page 49.

Loading film into the camera

Open the Camera > <t

Make sure there is no film in the camera before you open it. Check that the film frame counter shows empty or that your camera's film rewind knob (if it has one) rotates freely. If there is film in the camera, rewind it (page 8).

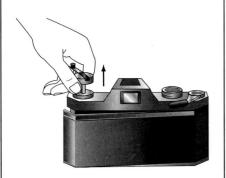

A camera that loads film manually will have a rewind knob at the top. This type of camera usually opens for loading when you pull up on the rewind knob.

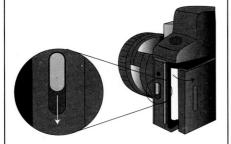

A camera that loads film automatically probably will have a release lever, not a rewind knob, to open the camera. Turn on the camera's main power switch. Open the camera back by sliding the release lever to its open position

Keep film out of direct sunlight. Load film into the camera in subdued light or at least shield the camera from direct light with your body as you load it.

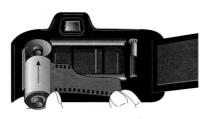

Insert the film cassette. A 35mm singlelens reflex camera usually loads film in the left side of the camera with the extended part of the cassette toward the bottom. The film should lie flat as it comes out of the cassette; if needed, rotate the cassette slightly to the right.

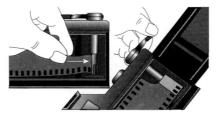

Manual loading. Push down the rewind knob. Pull out the tapered end of the film until you can insert it into the slot of the take-up spool on the other side of the camera. Alternately press the shutter release button and rotate the film advance lever until the teeth that advance the film engage the sprocket holes securely at the top and bottom of the film and any slack in the film is reeled up by the take-up spool.

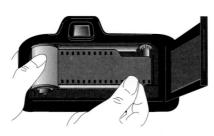

Automatic loading. Pull out the tapered end of the film until it reaches the other side of the camera. Usually a red mark or other indicator shows where the end of the film should be. The film won't advance correctly if the end of the film is in the wrong position.

Close the camera back. The part of the film that you pulled out of the cassette has been exposed to light. You'll need to advance the film past this exposed film to an unexposed frame.

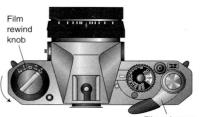

Film advance

Manual film advance. With the camera back closed, alternately press the shutter release button and rotate the film advance lever. Repeat two times.

If the film is advancing correctly, the film rewind knob will rotate counterclockwise as vou move the film advance lever. If it does not, open the camera and check the loading. Don't rely on the film frame counter; it may advance even though the film does not

Automatic film advance. Depending on your camera, you may simply need to close the camera back to have the film advance to the first frame. Some cameras require you to also depress the shutter button.

If the film has correctly advanced, the film frame counter will display the number 1. If it does not, open the camera back and check the loading.

GETTING STARTED Focusing and setting the exposure

Shutter speed Aperture size ISO 100 24 EXP 1/125 sec. Film speed Film speed. Set the camera to the speed of Focus on the most important part of your scene to make sure it will be sharp in the the film you are using. Film speed is marked on the film box and on the film casphotograph. Practice focusing on objects at different distances as you look through the sette. viewfinder so that you become familiar with the way the camera focuses. Ground glass Microprism Split image Manually setting the film speed. On some cameras, you must set the film speed Manual focusing. As you look through the manually. Turn the film speed dial (marked To get a correctly exposed picture, one viewfinder, rotate the focusing ring at the that is not too light (overexposed) or too front of the lens. The viewfinder of a single-ISO or sometimes ASA) to the speed of your film. Here it is set to a film speed of lens reflex camera has a ground-glass dark (underexposed), you-or the camera-set the shutter speed and the aperture screen that shows which parts of the scene 100. depending on the sensitivity of the film (its are most sharply focused. Some cameras also have a microprism, a small ring at the speed) and how light or dark your subject is. The shutter speed determines the length center of the screen in which an object apof time that light strikes the film; the aperpears coarsely dotted until it is focused. With split-image focusing, part of an object ture size determines how bright the light is that passes through the lens and shutter to appears offset when it is out of focus. the film. Shutter release button Part way down: autofocus activated Automatically setting the film speed. On All the way some cameras, the film speed is set by the down: shutter camera as it loads the film. The film must released be DX coded, marked with a bar code that is read by a sensor in the camera. DX-Automatic focusing. Usually this is done coded films have "DX" printed on the casby centering the focusing brackets (visible sette and box in the middle of the viewfinder) on your subject as you depress the shutter release part way. The camera adjusts the lens for you to bring the bracketed object into focus. Don't push the shutter release all the way down until you are ready to take a picture. More about shutter speed and aperture on More about film speed on pages 50-51. More about focus and when and how to pages 16-21 and about exposure and override automatic focus on page 37. metering on pages 57-73.

Exposure readout

Exposure Readout ____

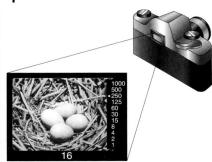

The shutter speed and aperture settings appear in the viewfinder of many cameras. Here, 1/250 sec. shutter speed, f/16 aperture.

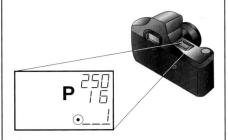

A data panel appears on the body of some cameras, displaying shutter speed and aperture settings (here, 1/250 sec. shutter speed, f/16 aperture), as well as other information.

This needle-centering display in the camera's viewfinder doesn't show the actual shutter speed and aperture settings, but it does show when the exposure is correct. You change the shutter speed and/or aperture until the needle centers between + (overexposure) and - (underexposure).

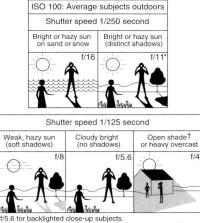

[†]Subject shaded from sun but lighted by a large area of sky.

With manual exposure, you set both the shutter speed and aperture vourself. How do you know which settings to use? At the simplest level you can use a chart like the one above. Decide what kind of light illuminates the scene, and set the aperture (the fnumber shown on the chart) and the shutter speed accordingly.

Notice that the recommended shutter speeds on the chart are 1/250 sec. or 1/125 sec. These relatively fast shutter speeds make it easier for you to get a sharp exposure when hand holding the camera (when it is not on a tripod). At slow shutter speeds, such as 1/30 sec. or slower, the shutter is open long enough for the picture to be blurred if you move the camera slightly during the exposure.

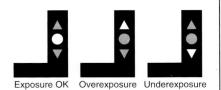

You can use a camera's built-in meter for manual exposure. Point the camera at the most important part of the scene and activate the meter. The viewfinder will show whether the exposure is correct. If it isn't, change the shutter speed and/or aperture until it is. Here, an arrow pointing up signals overexposure, an arrow pointing down means underexposure. The dot in the center lights up when the exposure is right.

To prevent blur caused by the camera moving during the exposure (if the camera is not on a tripod), select a shutter speed of at least 1/60 sec. A shutter speed of 1/125 sec. is safer.

🔶 🛌 🛌 🕨 Manually Setting the Exposure 👝 🛌 🗠 Automatically Setting the Exposure 🔔

With automatic exposure, the camera sets the shutter speed or aperture or both for you.

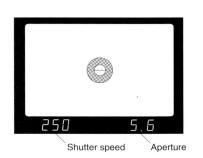

With programmed (fully automatic) exposure, each time you press the shutter release button, the camera automatically meters the light then sets both shutter speed and aperture.

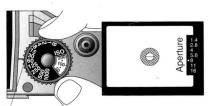

Shutter speed

With shutter-priority automatic exposure, you set the shutter speed and the camera sets the aperture. To prevent blur from camera motion if you are hand holding the camera, select a shutter speed of 1/60 sec. or faster.

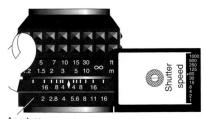

Aperture

With aperture-priority automatic exposure, you set the aperture and the camera sets the shutter speed. To keep the picture sharp when you hand hold the camera. check that the shutter speed is 1/60 sec. or faster. If it is not, set the aperture to a larger opening (a smaller f-number).

> More about how to override automatic exposure on page 64.

SETTING STARTED Exposing the film

For horizontal photographs, keep your arms against your body to steady the camera. Use your right hand to hold the camera and your right forefinger to press the shutter release. Use your left hand to help support the camera or to focus or make other camera adjustments.

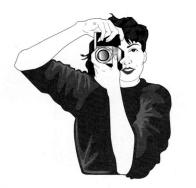

For vertical photographs, support the camera from below in either your right or left hand. Keep that elbow against your body to steady the camera.

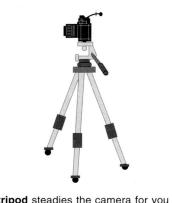

A tripod steadies the camera for you and lets you use slow shutter speeds, such as for night scenes or other situations when the light is dim.

▶ Hold the Camera Steady <u>▶ ▶ ▶ ▶</u> ▶ Expose the Film <u>▶ ▶ ▶ ▶ ▶ ▶ ▶ ▶</u> ▶ At the End of the Roll, Rewind the Film

Make an exposure. Recheck the focus and composition just before exposure. When you are ready to take a picture, stabilize your camera and yourself and gently press the shutter release all the way down.

Make some more exposures. You might want to try several different exposures of the same scene, perhaps from different angles. See opposite page for some ideas.

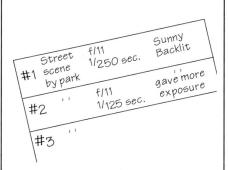

You'll learn faster about exposure settings and other technical matters if you keep a record of your exposures. For example, write down the frame number, subject, f-stop and shutter-speed settings, direction or quality of light, and any other relevant information. This way you won't forget what you did by the time you develop and print the film.

After your last exposure on the roll, rewind the film back into the cassette before opening the camera. Store film away from light and heat until it is developed.

Manual rewind. You'll know that there is no more film left on the roll when the film advance lever will not turn. The film frame counter will also show the number of exposures you have made: 36, for example, if you used a 36-exposure roll of film.

Activate the rewind button or catch at the bottom of the camera. Lift the handle of the rewind crank and turn it clockwise until tension on the crank releases.

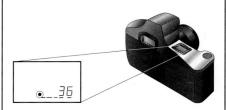

Automatic rewind. Your camera may automatically rewind the film after you make the last exposure on the roll, or it may signal the end of a roll and then rewind when you press a film rewind button.

What will you photograph?

Where do you start? One place to start is by looking around through the viewfinder. A subject often looks different isolated in a viewfinder than it does when you see it surrounded by other objects. What interests you about this scene? What is it that you want to make into a photograph?

Get closer (usually). Often people photograph from too far away. What part of the scene attracted you? Do you want to see the whole garden, or are you interested in

the person working in it? Do you want the whole wall of a building, or was it the graffiti on it that caught your attention?

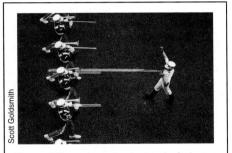

Try a different angle. Instead of always shooting from normal eye-level height, try getting up high and looking down on your subject or kneeling and looking up.

Look at the background (and the foreground). How does your subject relate to its surroundings? Do you want the subject centered or off to one side to show more of the

setting? Is there a distraction (like a post or sign directly behind someone's head) that you could avoid by changing position? Take a look.

More about backgrounds and the image frame on pages 158–161.

Check the lighting. If this is your first roll, you are most likely to get a good exposure if you photograph a more or less evenly lit scene, not one where the subject is against a very light background, such as a bright sky.

More about lighting on pages 125-141.

Experiment, too. Include a bright light or bright sky in the picture (just don't stare directly at the sun through the viewfinder). In the photograph, darker parts of the scene

may appear completely black, or the subject itself may be silhouetted against a brighter background.

TYPES OF CAMERAS

What kind of camera is best for you? For occasional snapshots of family and friends, an inexpensive, completely automatic, nonadjustable camera that you just point and shoot will probably be satisfactory. But if you have become interested enough in photography to take a class or buy a book, vou will want an adjustable camera, like one of those described here, because it will give you greater creative control. If you buy a camera with automatic features, make sure it is one that allows you to manually override them when vou want to make exposure and focus choices yourself.

Single-lens reflex cameras (SLRs) show you a scene directly through the lens, so you can preview what will be recorded on the film. You can see what the lens is focused on; with some cameras, you can check the depth of field (how much of the scene from foreground to background will be sharp). Through-thelens viewing is a definite advantage for close-ups or any work when you want an exact view of a scene.

Many different interchangeable lenses for SLRs are available. Automatic exposure is commonly available, as are automatic focus, automatic flash, and automatic film advance and rewind. Most SLRs use 35mm film. A few models are designed for larger film, such as 120 (2¹/₄-inch wide) roll film. SLRs are very popular with professionals, such as fashion photographers, and with nonprofessionals who want to move beyond making snapshots.

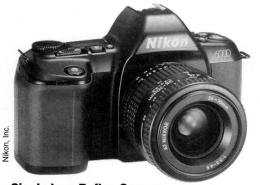

Single-lens Reflex Camera

Viewfinder cameras

let you see a scene through a peephole, the viewfinder, which shows almost-but not quite-the same image as the one formed by the lens that exposes the film. The image in the viewfinder always looks sharp overall. It is used to select the scene to be photographed, but can't be used for focusing because it doesn't show you which part of the scene will be sharply focused on the film. To get the scene in focus, either the camera automatically focuses the image for you, or you set a numbered dial to the approximate distance to the subject.

Because the viewing system is in a different position from the lens that exposes the film, you do not see exactly what the lens sees. This difference between the viewfinder image and the lens image, called parallax, increases as objects come closer to the camera.

Compact cameras and point-and-shoot cameras are viewfinder cameras.

Rangefinder cameras

are viewfinder cameras with a visual focusing system that you use as

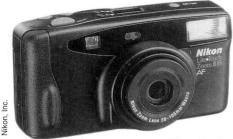

Viewfinder Camera

you look through the viewfinder window. The window has a central portion that shows a split image when an object is not in focus. The rangefinder is coupled to the lens's focusing ring. As you rotate the focusing ring, the split image comes together when the object is focused sharply. Rangefinder cameras let you focus precisely, even in dim light, but you cannot visually assess the depth of field because, except for the split image, all parts of the scene look equally sharp in the viewfinder.

Better rangefinder cameras correct for parallax and have interchangeable lenses, although usually not in as many focal lengths as are available for SLRs. Most use 35mm film, although a few are designed for wider roll film. Rangefinder cameras are fast, reliable, quiet in operation, and relatively small. Highquality brands are in

demand among professionals, particularly photojournalists. Inexpensive, compact 35mm models are popular for snapshots and

View cameras have a

less exacting work.

lens in the front, a ground-glass viewing screen in the back, and a flexible, accordionlike bellows in between. The camera's most valuable feature is its adjustability: the camera's parts can be moved in relation to each other, which lets you alter perspective and sharpness to suit each scene. You can change lenses and even the camera's back; for example, you can attach a back to make Polaroid pictures or one to record a digital image. Each film exposure is made on a separate sheet of film, so you can make one exposure in color and the next in black and white, or develop each sheet differently. Film size is large-4 x 5

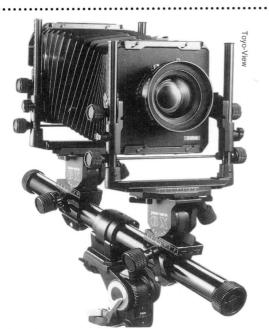

View Camera

inches and larger which makes detail crisp and sharp even in a big print.

View cameras are slow and rather inconvenient to use compared to smaller hand-held cameras. They are large and heavy and must be mounted on a tripod. The image on the viewing screen is upside down, and it is usually so dim that you have to put a focusing cloth over your head and the screen to see the image clearly. Nevertheless, when you want complete control of an image, such as for architectural or product photography or for personal work, the view

camera's advantages outweigh its inconveniences.

Twin-lens reflex cameras (TLRs) have two lenses: one for viewing the scene and another just below it that exposes the film. A relatively large format (2¼-inch square) and a

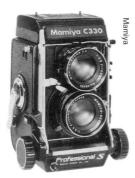

Twin-lens Reflex Camera

moderate cost are the TLR's advantages. Its disadvantages are parallax (because the viewing lens is in a different position from the taking lens) and a viewfinder image that is reversed left to right. Only a few models have interchangeable lenses. TLRs have been largely displaced by single-lens-reflex cameras, but some models-mostly used ones-are still available.

Electronic cameras

don't use film. Instead, they use electronic circuitry to capture an image. (For more about electronic imaging, see pages **152–155**.)

Digital cameras record an image directly in digital form (as a series of numbers that, for example, can be used by image-editing computer software). The light passes through the camera's lens, then onto a chargecoupled device (CCD), an array of tiny lightsensitive elements. Conventional film can record much more detail than current CCDs. but digital cameras have the advantage of one-step transfer into a computer or to another location over phone lines.

Still-video cameras record an analog (continuous-tone) image onto a small floppy disc, similar to a computer floppy. The image can be viewed directly, for example, on a television set that has video input. For computer use, such as with image-editing software, the image is converted to digital form. photograph that can be interesting, for example, for landscapes. Some of these cameras crop out part of the normal image rectangle to make a panoramic shape. Others use a longerthan-normal section of roll film or rotate the lens from side to side during the exposure. *Stereo cameras* take

Electronic Camera

Some cameras fill a specialized need.

Instant cameras produce a print within a few seconds, if not instantly. Polaroid makes instant films for its own cameras, as well as for 35mm and view cameras. Underwater cameras, such as the Nikonos, are not only for use underwater but for any situation in which a camera is likely to get wet. Some cameras are water resistant, rather than usable underwater.

Panoramic cameras make a long, narrow two pictures at the same time through two side-by-side lenses. The resulting pair of images, a stereograph, gives the illusion of three dimensions when seen in a stereo viewer.

BASIC CAMERA CONTROLS

Getting the pictures you want. Cameras don't quite "see" the way the human eye does, so at first the pictures you get may not be the ones you expected. One of the aims of this book is to help you gain control over the

picture-making process by showing you how to see the way the camera does and how to use the camera's controls to make the picture you have in mind.

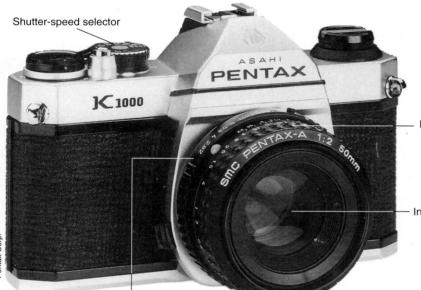

Manually operated controls on this single-lens reflex camera let you select the shutter speed (the length of time the shutter remains open) and the aperture (the size of the opening inside the lens). You can also focus the lens or exchange one lens for another.

- Focusing ring

Interchangeable lens

Data panel shows shutter

Aperture ring

Dial for setting the aperture manually

SOESTE

In automatic operation, pressing the shutter release focuses the lens and sets shutter speed and aperture

Dial for setting the shutter speed manually

On some automatic cameras, pushbutton controls replace adjustable knobs and rings. When you press the shutter release, this camera automatically focuses the lens and sets the shutter speed and aperture. When you want to choose camera settings yourself, you can override the automatic functions. **Focusing.** Through the viewfinder window you see the scene that will be recorded on the film, including the sharpest part of the scene, the part on which the camera is focused. A particular part of a scene can be focused sharply by manually turning the focusing ring on the lens, or you can let an autofocus camera adjust the lens automatically. More about focusing and sharpness appears on pages **36–37**.

Shutter-speed control.

Moving objects can be shown crisply sharp, frozen in midmotion, or blurred either a little bit or a lot. The faster the shutter speed, the sharper the moving object will appear. Turn to pages **16–17** for information about shutter speeds, motion, and blur.

Aperture control. Do you want part of the picture sharp and part out of focus or do you want the whole picture sharp from foreground to background? Changing the size of the aperture (the lens opening) is one way to control sharpness. The smaller the aperture, the more of the picture that will be sharp. See pages **18–19**.

Lens focal length. Your lens's focal length controls the size of objects in a scene and how much of that scene is shown. The longer the focal length, the larger the objects will appear. See pages 26–33 for more about focal length.

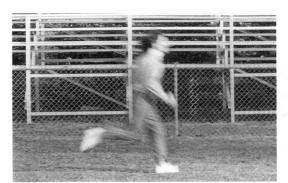

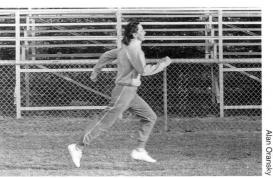

MORE ABOUT CAMERA CONTROLS

Automatic exposure is a basic feature on many 35mm single-lens reflex cameras because film needs a controlled amount of light so that the resulting image is neither too light nor too dark. The camera's built-in meter measures the brightness of the scene and then sets shutter speed, aperture (lens opening), or both in order to let the right amount of light reach the film. As you become more experienced, you will want to set the exposure manually in certain cases, instead of always relying on the camera. More about exposure in Chapter 4, pages **57–73**.

You have a choice of exposure modes with many cameras. Read your camera's instruction manual to find out which exposure features your model has and how they work. You may be able to get a replacement manual from the manufacturer, if you don't have one.

With programmed (fully automatic) exposure, the camera selects both the shutter speed and the aperture based on a program built into the camera by the manufacturer. This automatic operation can be useful in rapidly changing situations because it allows you simply to respond to the subject, focus, and shoot.

In shutter-priority mode, you set the shutter speed and the camera automatically sets the correct aperture. This mode is useful when the motion of subjects is important, as at sporting events, because the shutter speed determines whether moving objects will be sharp or blurred.

In aperture-priority mode, you set the lens opening and the camera automatically sets the shutter speed. This mode is useful when you want to control the depth of field, or sharpness of the image from foreground to background, because the size of the lens opening is a major factor affecting sharpness.

Manual exposure is also a choice with many automatic cameras. You set both the lens opening and shutter speed yourself using, if you wish, the camera's built-in light meter to measure the brightness of the light.

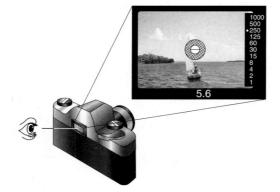

Exposure information appears in the viewfinder of many cameras. This viewfinder shows the shutter speed (here, 1/250 sec.) and aperture (f/5.6). Displays also show you when the flash is ready to fire and give you warnings of under- or overexposure.

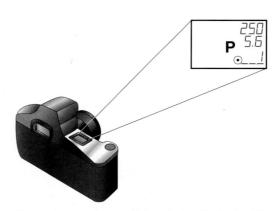

Some cameras have a data panel on the body of the camera that shows information such as shutter speed (here, 1/250 sec.) and aperture (f/5.6). This model also shows the mode of exposure operation (P, for programmed automatic) and the frame number of the film (number 1).

Inside a Single-Lens Reflex Camera

All film-based cameras have the same basic features:

- A light-tight box to hold the camera parts and film
- A viewing system that lets you aim the camera accurately
- A lens to form an image and a mechanism to focus it sharply
- A shutter and lens aperture to control the amount
 of light that reaches the film
- · A means to hold and advance the film

A. **Body.** The light-tight box that contains the camera's mechanisms and protects the film from light until you are ready to make a photograph.

B. Lens. Focuses an image in the viewfinder and on the film.

C. **Lens elements.** The optical glass lens components that produce the image.

D. **Focusing ring.** Turning the ring focuses the image by adjusting the distance of the lens from the film plane. Some cameras focus automatically.

E. **Diaphragm.** A circle of overlapping leaves inside the lens that controls the size of the aperture or lens opening. It opens up to increase (or closes down to decrease) the amount of light reaching the film.

F. **Aperture ring or button.** Setting the ring or button determines the size of the diaphragm during exposure.

G. **Mirror.** During viewing, the mirror reflects light from the lens upward onto the viewing screen. During an exposure, the mirror swings out of the way so light can pass straight to the film.

H. **Viewing screen.** A ground-glass (or similar) surface on which the focused image appears.

I. **Pentaprism.** A five-sided optical device that reflects the image from the viewing screen into the viewfinder.

J. Metering cell. Measures the brightness of the scene being photographed.

K. **Viewfinder eyepiece.** A window through which the image from the pentaprism is visible to the photographer.

L. **Shutter.** Keeps light from the film until you are ready to take a picture. Pressing the shutter release opens

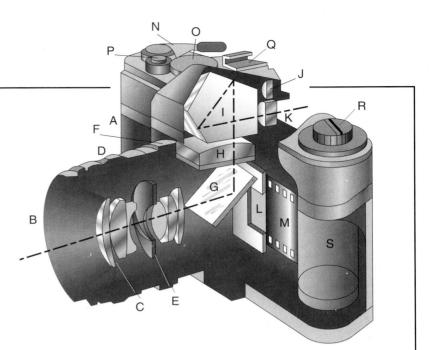

and closes the shutter to let a measured amount of light reach the film.

M. **Film.** The light-sensitive material that records the image. The film speed (the rating of a particular film's sensitivity) is set into the camera by turning a dial or, on some cameras, is set automatically when you load the film. Electronic cameras record images on a different medium, such as a computer disk.

N. **Film advance.** A lever that advances the film to the next unexposed segment. Some cameras advance film automatically.

O. **Shutter-speed dial or button.** Selects the shutter speed, the length of time the shutter remains open. On some models, it also sets the mode of automatic exposure operation.

P. **Shutter release.** A button that activates the exposure sequence in which the aperture adjusts, the mirror rises, the shutter opens, and light strikes the film.

Q. **Hot shoe.** A bracket that attaches a flash unit to the camera and provides an electrical linking that synchronizes camera and flash.

R. **Rewind mechanism.** A crank that rewinds the film into its cassette after the roll of film has been exposed. Some cameras rewind the film automatically.

S. **Film cassette.** The light-tight container in which 35mm film is packaged.

A simplified look inside a single-lens reflex 35mm camera (designs vary in different models). The camera takes its name from its single lens (another kind of reflex camera has two lenses) and from its reflection of light upward for viewing the image.

SHUTTER SPEED Affects light and motion

Light and the shutter speed. To expose film correctly, so that your picture is neither too light nor too dark, you need to control the amount of light that reaches the film. The shutter speed (the amount of time the shutter remains open) is one of two controls your camera has over the amount of light. The aperture size (page 18) is the other. In automatic operation, the camera sets the shutter speed, aperture, or both. In manual operation, you choose both settings. The shutter-speed dial (a push button on some cameras) sets the shutter so that it opens for a given fraction of a second after the shutter release has been pressed. The B (or bulb) setting keeps the shutter open as long as the shutter release is held down.

Motion and the shutter speed. In addition to controlling the amount of light that enters the camera, the shutter speed also affects the way that moving objects are shown. A fast shutter speed can freeze motion—1/250 sec. is more than fast enough for most scenes. A very slow shutter speed will record even a slow-moving object with some blur. The important factor is how much the image actually

moves across the film. The more of the film it crosses while the shutter is open, the more the image will be blurred, so the shutter speed needed to freeze motion depends in part on the direction in which the subject is moving in relation to the camera (see opposite page).

The focal length of the lens and the distance of the subject from the camera also affect the size of the image on the film and thus how much it will blur. A subject will be enlarged if it is photographed with a long-focallength lens or if it is close to the camera; it has to move only a little before its image crosses enough of the film to be blurred.

Obviously, the speed of the motion is also important: all other things being equal, a darting swallow needs a faster shutter speed than does a hovering hawk. Even a fast-moving subject, however, may have a peak in its movement, when the motion slows just before it reverses. A gymnast at the height of a jump, for instance, or a motorcycle negotiating a sharp curve is moving slower than at other times and so can be sharply photographed at a relatively slow shutter speed.

See the project on motion, page 167.

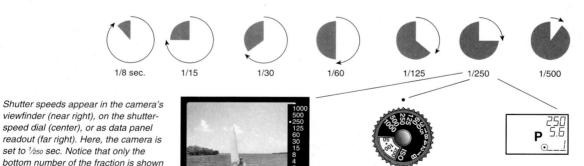

setting, half as much as the next slower setting: 1/250

sec. lets in twice as much light as 1/500 sec., half as much as 1/125 sec. In automatic operation, shutter speeds are often "stepless"; the camera can set the shutter to 1/225 sec., 1/200 sec., or whatever speed it calculates will produce a correct exposure.

A focal-plane shutter consists of a pair of curtains usually located in the camera body just in front of the film. During exposure, the curtains open to form a slit that moves across the film. The size of the slit is adjustable: the wider the slit, the longer the exposure time and the more light that reaches the film. Focal-plane shutters are found in most singlelens reflex cameras and some rangefinder cameras.

on the camera.

A leaf shutter is usually

built into the lens instead

of the camera body. The

overlapping leaves that open during the exposure, then close again. The longer the shutter stays

open, the more light that

reaches the film. Leaf

shutters are found on

most rangefinder and

point-and-shoot cameras,

format single-lens reflex cameras, and twin-lens

reflex cameras.

view camera lenses, large-

shutter consists of

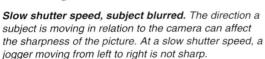

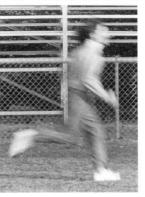

Fast shutter speed, subject sharp. Photographed at a faster shutter speed, the same jogger moving in the same direction is sharp. During the shorter exposure, her image did not cross enough of the film to blur.

1/125 sec.

Slow shutter speed, subject sharp. Here the jogger is sharp even though photographed at the slow shutter speed that recorded blur in the first picture. Because she was moving directly toward the camera, her image did not cross enough of the film to blur.

Panning with the jogger is another way to keep her relatively sharp. During the exposure, the photographer moved the camera in the same direction that the jogger was moving. Notice the streaky look of the background, characteristic of a panned shot.

Blurring to show motion. Freezing motion is one way of representing it, but it is not the only way. In fact, freezing motion sometimes eliminates the feeling of movement altogether so that the subject seems to be at rest. Allowing the subject to blur can be a graphic means of showing that it is moving. **Panning to show motion.** Panning the camera—moving it in the same direction as the subject's movement during the exposure—is another way of showing motion (bottom right). The background will be blurred, but the subject will be sharper than it would be if the camera were held steady.

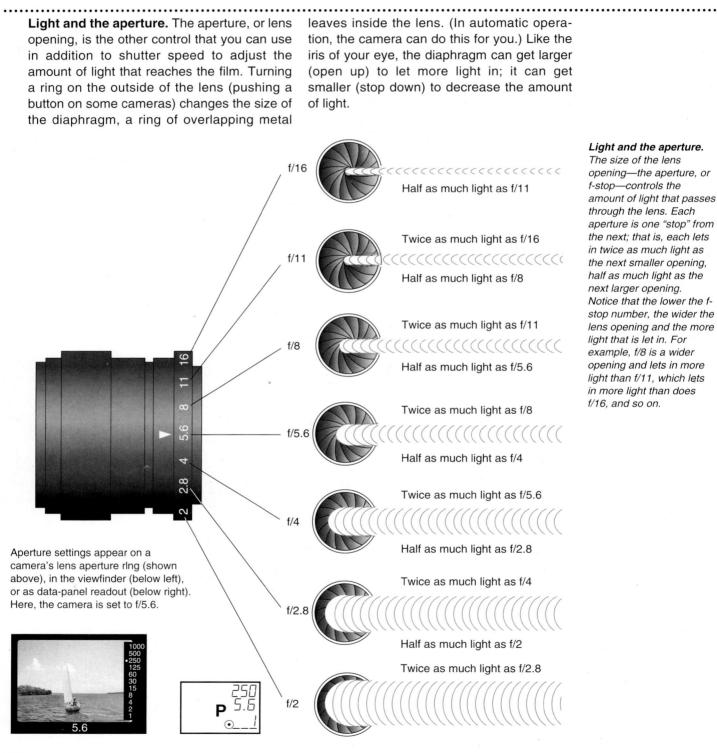

Aperture settings (f-stops). Aperture settings, from larger lens openings to smaller ones, are f/1, f/1.4, f/2, f/2.8, f/4, f/5.6, f/8, f/11, f/16, f/22, and f/32. Settings beyond f/32 are usually found only on some view-camera lenses.

The lower the f-stop number, the wider the lens opening; each setting lets in twice as much light as the next f-stop number up the scale, half as much light as the next number down the scale. For example, f/11 lets in double the light of f/16, half as much as f/8.

Referring to a "stop" is a shorthand way of stating this half-or-double relationship. You can give one stop more (twice as much) exposure by setting the aperture to its next wider opening, one stop less (half as much) exposure by stopping (closing) down the aperture to its next smaller opening.

No lens has the entire range of f-stops; most have about seven. A 50mm lens may range from f/2 at its widest opening to f/16 at its smallest, a 200mm lens may range from f/4 to f/22. Most lenses can set intermediate fstops part way between the whole stops, often in one-third-stop increments. The widest lens setting may be an intermediate stop, for example, f/1.2.

Depth of field and the aperture. The size of the aperture setting also affects how much of the image will be sharp, known as the depth of field. As the aperture opening gets smaller, the depth of field increases and more of the scene from near to far appears sharp in the photograph (see photos, below, and pages 38-39). A project about using depth of field appears on page 165.

Depth of field and the

aperture. The smaller the aperture opening, the greater the depth of field. At f/16 (left), the entire depth in the scene from foreground to background appears sharp. At a much larger aperture, f/2 (right), there is less depth of field and the background is completely out of focus.

Small Aperture, More Depth of Field

Large Aperture, Less Depth of Field

SHUTTER SPEED AND APERTURE Blur vs. depth of field

Controlling the exposure. Both shutter speed and aperture affect the amount of light reaching the film. To get a correctly exposed negative, one that is neither too light nor too dark, you need to find a combination of shutter speed and aperture that will let in the right amount of light for a particular scene and film. (Chapter 4, Exposure, pages **57–73**, explains how to do this.)

Equivalent exposures. Once you know a correct combination of shutter speed and aperture, you can change one setting and still keep the exposure the same as long as you change the other setting the same amount in the opposite direction. If you want to use a smaller aperture (which lets in less light), you can keep the exposure the same by using a slower shutter speed (which lets in more light), and vice versa.

A "stop" of exposure change. Each full f-stop setting of the aperture lets in half (or double) the amount of light as the next full setting, a one-stop difference. Each shutterspeed setting does the same. The term *stop* is used whether the aperture or shutter speed is changed. The exposure stays constant if, for example, a move to the next faster shutter speed (one stop less exposure) is matched by a move to the next larger aperture (one stop more exposure).

Which combination do you choose? Any of several combinations of shutter speed and aperture could expose the film correctly, but the effect on the appearance of the image will be different. Shutter speed affects the sharpness of moving objects, aperture size affects depth of field (the sharpness of a scene from near to far). Shutter speed also helps prevent blur caused by camera motion during the exposure. If you are holding the camera in your hands, you need a faster shutter speed than if you have the camera on a tripod (see page **44** for details).

You can decide for each picture whether stopped motion or depth of field is more important. More depth of field and near-to-far sharpness with a smaller aperture means you would be using a slower shutter speed and so risking that motion would blur. Using a faster shutter speed to freeze motion means you would be using a larger aperture, with less of the scene sharp near to far. Depending on the situation, you may have to compromise on a moderate amount of depth of field with some possibility of blur.

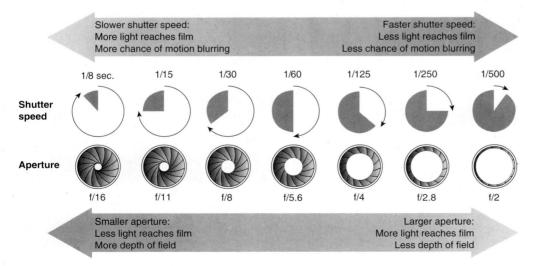

Shutter speed and aperture combina-

tions. Both the shutter speed and the aperture size control the amount of light that strikes the film. Each setting lets in half (or double) the amount of light as the adjacent setting—a one-stop difference.

If you decrease the amount of light one stop by moving to the next smaller aperture setting, you can keep the exposure constant by also moving to the next slower shutter speed. In automatic operation, the camera makes these changes for you.

Each combination of aperture and shutter speed shown at left lets in the same amount of light; but see the photographs on the opposite page: the combinations change the sharpness of the picture in different ways.

Shutter speed and aperture combinations. Each of the exposure combinations for this scene lets in the same total amount of light, so the overall exposure stayed the same. But the motion of the swing is blurred with a slow shutter speed, sharp with a fast shutter speed. The depth of field (overall sharpness of near-to-far objects) extends farther with a small aperture, less far with a larger aperture.

Fast shutter speed (1/200 sec.): the moving swing is sharp. **Wide aperture** (f/2): the trees, picnic table, and person in the background are out of focus.

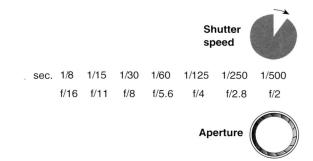

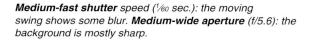

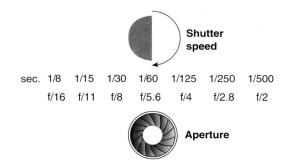

Slow shutter speed (½ sec.): the moving swing is completely blurred. **Small aperture** (f/16): the background is completely sharp.

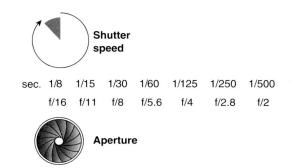

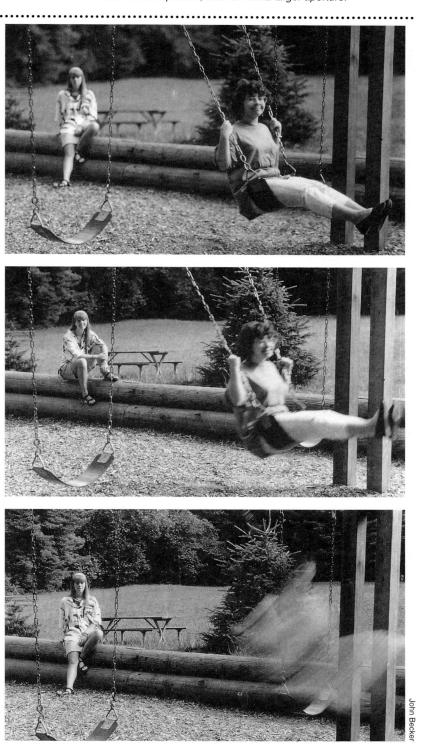

CARE OF CAMERA AND LENS

Cameras are remarkably sturdy instruments considering the precision mechanisms that they contain, but a reasonable amount of care in handling and maintaining a camera will more than repay you with longer, trouble-free life and better performance.

To protect a camera in use, use a neck strap, either worn around your neck or wound around your wrist. It keeps the camera handy and makes you less likely to drop it. Eveready cases enclose the camera and have a front that folds down for picture-taking. They provide protection but can be tedious to take off and put on. Gadget bags are good for carrying extra items. Lenses can be kept in lens cases or plastic bags to protect them from dust, with lens caps both back and front for additional protection of lens surfaces. Aluminum cases with fitted foam compartments provide the best protection against jolts and jars: their disadvantage is that they are bulky and not conveniently carried on a shoulder strap. In high-theft areas, some photographers prefer a case that doesn't look like a camera case-for example, a sports bag or a small backpack. A beatup case that looks as though it contains sneakers and a sweat suit is less likely to be stolen than one that shouts "cameras."

Battery power is essential to the functioning of most cameras. If your viewfinder display or other data display begins to act erratically, the batteries may be getting weak. Many cameras have a battery check that will let you test battery strength. It's a good idea to check batteries before beginning a day's shooting or a vacation outing and to carry spares in your camera bag. If you don't have spares and the batteries fail, try cleaning the ends of the batteries and the battery contacts in the camera with a pencil eraser or cloth; the problem may just be poor electrical contact. Warming the batteries in the palm of your hand might also bring them back to life temporarily. **Cameras and film in transit** should be protected from excessive heat; for example, avoid leaving them in a car on a hot day. Excessive heat not only damages the quality of film, it can also soften the oil lubricant in the camera, causing the oil to run out and create problems, such as jamming lens diaphragm blades. At very low temperatures, meter batteries and other mechanisms may be sluggish, so on a cold day it is a good idea to keep the camera warm by carrying it under your coat until you're ready to take a picture. On the beach, protection from salt spray and sand is vital.

If a camera will not be used for a while, push the shutter release button so that the shutter is not cocked, turn off any on/off switches, and store the camera away from excessive heat, humidity, and dust. Operate the shutter occasionally, because it can become balky if not used. For long-term storage, remove batteries because they can corrode and leak.

Protecting a camera from dust and dirt is the goal of ordinary camera care. Load and unload film or change lenses in a dust-free place if you possibly can. When changing film, blow or brush around the camera's filmwinding mechanism and along the film path. This will remove dust as well as tiny bits of film that can break off and work into the camera's mechanisms. Be careful of the shutter curtain when doing this; it is delicate and should be touched only with extreme care. You may want to blow occasional dust off the focusing mirror or screen, but a competent camera technician should do any work beyond this. Use the right equipment for the job: to blow, a rubber squeeze bulb; to brush, a soft brush designed for photo use. A can of compressed gas produces more force than a rubber squeeze bulb. If you use such a product, buy a brand such as Dust-Off Plus that does not contain ozone-damaging chlorofluorocarbon (CFC). Never lubricate any part of the camera yourself.

If you have an electronic camera, follow the general guidelines for camera body, lens, and battery care. Be especially careful, however, to protect the camera against shock and heat, and to keep it away from strong magnetic fields.

The lens surface must be clean for best performance, but keeping dirt off it in the first place is much better than frequent cleaning, which can damage the delicate lens coating. Particularly avoid touching the lens surface with your fingers because they leave oily prints that corrode the coating. Keep a lens cap on the front of the lens when it is not in use and add one on the back of the lens if the lens is removed from the camera. During use, a lens hood helps protect the lens surface in addition to shielding the lens from stray light that may degrade the image. UV (ultraviolet) and 1A filters are designed for use with color film but have virtually no effect on black-andwhite film, so some photographers leave one on the lens all the time for protection against dirt and accidental damage.

To clean the lens you will need a rubber squeeze bulb or a can of environmentally friendly compressed gas, a soft brush, lens tissue, and lens cleaning fluid. Avoid using cleaning products made for eyeglasses, particularly any treated cloths; they are too harsh for lens surfaces. A clean cloth or paper tissue is usable in an emergency, but lens tissue is much better.

Cleaning inside the camera. When you blow or dust inside the camera, tip the camera so the dust falls out and isn't pushed farther into the mechanism. Do not touch the delicate shutter curtain unless absolutely necessary.

Cleaning the lens. First, blow or brush any visible dust off the lens surface. Holding the lens upside down helps the dust fall off the surface instead of just circulating on it.

Using lens cleaning fluid. Dampen a wadded piece of lens tissue with the fluid and gently wipe the lens with a circular motion. Don't put lens fluid directly on the lens because it can run to the edge and soak into the barrel. Finish with a gentle, circular wipe using a dry lens tissue.

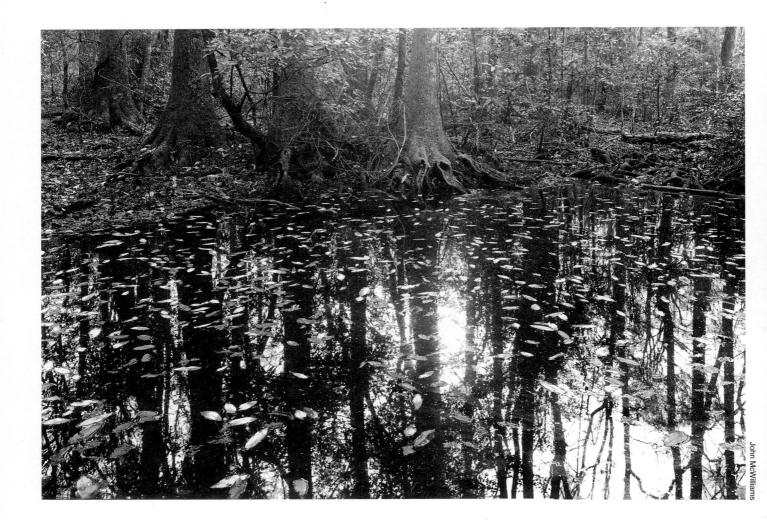

LENS FOCAL LENGTH: The basic difference between lenses 26
NORMAL FOCAL LENGTH: The most like human vision 28
LONG FOCAL LENGTH: Telephoto lenses 30
SHORT FOCAL LENGTH: Wide-angle lenses 32
ZOOM, MACRO, AND FISHEYE LENSES 34
FOCUS AND DEPTH OF FIELD 36
AUTOMATIC FOCUS 37 DEPTH OF FIELD: Controlling sharpness in a photograph **38**

- More About Depth of Field: How to preview it 40
- PERSPECTIVE: How a photograph shows depth 42
- LENS PERFORMANCE: Getting the most from a lens 44
- SOLVING CAMERA AND LENS PROBLEMS 45

ENS

Forming an image. Although a good lens is essential for making crisp, sharp photographs, you don't actually need one to take pictures. A primitive camera can be constructed from little more than a shoe box with a tiny pinhole at one end and a piece of film at the other. A pinhole won't do as well as a glass lens, but it does form an image of objects in front of it.

A simple lens, such as a magnifying glass, will form an image that is brighter and sharper than an image formed by a pinhole. But a simple lens has many optical defects or aberrations that prevent it from forming an image that is sharp and accurate. A modern compound lens eliminates these aberrations by combining several lens elements made of different kinds of glass and ground to different thicknesses and curvatures so that they cancel out each other's aberrations.

The main function of a lens is to project a sharp image onto the film. Lenses vary in design, and different types perform some jobs better than others. Two major differences in lens characteristics are focal length and speed.

Lens focal length is the most important characteristic of a lens. One of the prime advantages of a single-lens reflex camera or a view camera is the interchangeability of its lenses; the reason photographers own more than one lens is so that they can change lens focal length. More about focal length appears on the following pages.

Lens speed is not the same as shutter speed; it is the widest aperture to which the lens diaphragm can be opened. A lens that is "faster" than another opens to a wider aperture and admits more light; it can be used in dimmer light or at a faster shutter speed.

Focusing ring rotates to bring different parts of the scene into focus.

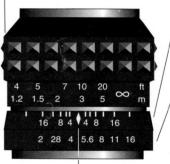

Depth-of-field

scale shows how much of the scene will be sharp at a given aperture (explained on page 40).

Aperture-control ring selects the f-stop or size of the lens opening.

Distance marker indicates on the distance scale the distance in feet and meters on which the lens is focused.

On the lens barrel (as shown above) are controls such as a ring that focuses the lens. Cameras and lenses vary in design, so check the features of your own camera. For example, some cameras have pushbutton controls on the camera body instead of an aperture control ring on the lens. Engraved around the front of the lens (shown below) are its focal length and other information.

Focal length. The shorter the focal length, the wider the view of a scene. The longer the focal length, the narrower the view and the more the subject is magnified.

Manufacturer

Maximum aperture. The lens's widest opening or speed. Appears as a ratio, here 1:2. The maximum aperture is the last part of the ratio, f/2.

Filter size. The diameter in mm of the lens, and so the size of filter needed when one is added onto the lens.

LENS FOCAL LENGTH The basic difference between lenses

Photographers generally describe lenses in terms of their focal length; they refer to a normal, long, or short lens, a 100mm lens, a 75-150mm zoom lens, and so on. Focal length affects the image formed on the film in two important and related ways: the amount of the scene shown (the angle of view) and thus the size of objects (their magnification).

How focal length affects an image. The shorter the focal length of a lens, the more of a scene the lens takes in and the smaller it makes each object in the scene appear in the image. You can demonstrate this by looking through a circle formed by your thumb and forefinger. The shorter the distance between your hand (the lens) and your eye (the film), the more of the scene you will see (the wider the angle of view). The more objects that are shown on the same size negative, the smaller all of them will have to be (the less magnification). Similarly, you could fill a negative either with an image of one person's head or with a

group of twenty people. In the group portrait, each person's head is smaller.

Interchangeable lenses are convenient. The amount of the scene shown and the size of objects can be changed by moving the camera closer to or farther from the subject, but the additional option of changing lens focal length gives you much more flexibility and control. Sometimes it is impossible to get closer to your subject-for example, if you are standing on shore photographing a boat on a lake. Sometimes it is difficult to get far enough away, as when you are photographing a large group of people in a small room.

With a camera that accepts different lenses, such as a single-lens reflex camera, you can remove one lens and put on another when you want to change focal length. Interchangeable lenses range from superwide-angle fisheve lenses to extra long telephotos. A zoom lens is a single lens with adjustable focal lengths.

Focal length is measured from an optical point in a lens to the image it forms on the film. It is measured when the lens is sharply focused on an object in the far distance (technically known as infinity). Magnification, the size of an object in an image, is directly related to focal length. As the focal length increases, the imaged size of the object increases. A 100mm lens produces an image twice as large as one produced by a 50mm lens.

YOU WILL NEED A

camera either with a zoom lens or with lenses of two different focal lengths. The greater the difference in focal lengths, the easier it will be to see the difference between them. If you can, use a short-focal-length lens (35mm or shorter) and a long lens (85mm or longer).

PROCEDURE

Put the shorter lens on the camera or adjust the zoom lens to its shortest focal length (its widest view as you look through the camera). Make a head-totoe photograph of a friend. Note the distance you have to stand from your subject to have his or her feet just touch the bottom edge of the viewfinder frame, while the top of the head grazes its upper edge.

Do the same with the longer lens or with the zoom lens adjusted to its longest focal length (its narrowest view). Make a similar pair of views with a house or a chair, fitting your subject exactly into the frame on the film.

HOW DID YOU DO?

Compare prints of the pairs of views. How did the distances you had to be from your subject with the short lens compare to those needed with the long lens? Do the sizes of background objects in the pairs of views differ? Did the impression of depth in the photographs change when you switched from the short to the long lens?

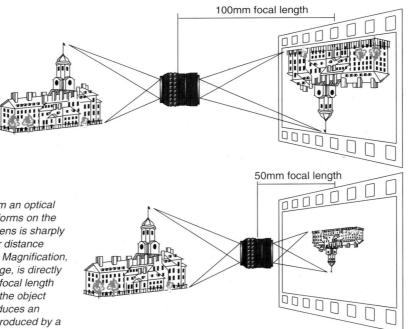

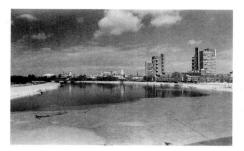

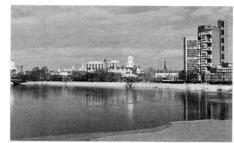

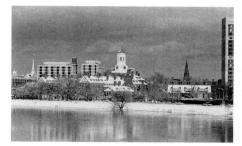

24mm focal length

50mm focal length

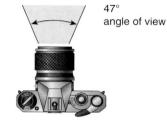

100mm w focal length 24° angle of view

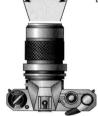

200mm focal length 12° angle of view

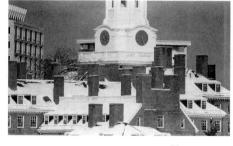

500mm focal length 5° angle of view

1000mm

focal length

2.5° angle of view

What happens when you change lens focal length? With a given size of film, the amount of a scene included in the image (angle of view) and the size of objects (magnification) are changed if the focal length of the lens is changed. To make this sequence, the photographer changed only the focal length of the lenses, while the distance from lens to subject remained the same. As the focal length increases (for example, from 24mm to 50mm), the angle of view narrows and the size of objects increases.

NORMAL FOCAL LENGTH The most like human vision

A lens of normal focal length, as you might expect from the name, produces an image on film that seems normal when compared with human vision. The image includes about the same angle of view as the human eye sees clearly when looking straight ahead, and the relative size and spacing of near and far objects appear normal. For 35mm cameras, this effect is produced by a lens of about 50mm focal length; 35mm single-lens reflex cameras typically are fitted by manufacturers with lenses of that length.

The size of the film used in a particular camera determines what focal length is normal for that camera; cameras that use film sizes larger than 35mm have proportionately longer focal lengths for their normal lenses. Normal focal length for a film format of 21/4 x 21/4 inches (6 x 6 cm) is 80mm. Normal focal length for a view camera with 4 x 5-inch film is 150mm.

Normal lenses have many advantages. Compared with lenses of much shorter or much longer focal length, normal lenses are

generally faster; they can be designed with wider maximum apertures to admit the maximum amount of light. Therefore, they are convenient for use in dim light, especially where action is involved, as in theater or indoor sports scenes or in low light levels outdoors. They are a good choice if the camera is to be hand held because a wide maximum aperture permits a shutter speed fast enough to prevent blur caused by camera movement during exposure. Generally, the normal lens is more compact and lighter, as well as somewhat less expensive, than lenses of much longer or much shorter focal length.

Choice of focal length is a matter of personal preference. Many photographers with 35mm cameras regularly use a lens with a focal length of 35mm rather than 50mm because they like the wider view and greater depth of field that a 35mm lens has compared to a 50mm lens. Some photographers use an 85mm lens because they prefer its narrower view, which can concentrate the image on the central objects of interest in the scene.

A lens of normal focal length produces an image that appears similar to that of normal human vision. The amount of the scene included in the image and the relative size and placement of near and far objects are what you would expect to see if you were standing next to the camera. The scene does not appear exaggerated in depth, as it might with a short-focallength lens, nor do the objects seem compressed and too close together, as sometimes happens with a longfocal-length lens.

LONG FOCAL LENGTH Telephoto lenses

A lens of long focal length seems to bring things closer, just as a telescope does. As the focal length gets longer, less of the scene is shown (the angle of view narrows), but what is shown is enlarged (the magnification increases). This is useful when you are so far from the subject that a lens of normal focal length produces an image that is too small. Sometimes you can't get really close—at a sports event, for example. Sometimes it is better to stay at a distance, as in nature photography. An intercepted pass, the president descending from Air Force One, and an erupting volcano are all possible subjects for which you might want a long lens.

How long is a long lens? A popular mediumlong lens for a 35mm camera is 105mm; this focal length magnifies your view significantly but not so much that the lens's usefulness is limited to special situations. A lens of 150mm has a comparably long focal length for a camera with a $2^{1/4}$ -inch format, 300mm for a 4 x 5 view camera. The difference between a medium-long lens and an extremely long one (for example, a 500mm lens with a 35mm camera) is rather like that between a pair of binoculars and a high-power telescope. You may want a telescope occasionally, but usually binoculars will do.

A long lens provides relatively little depth of field. When you use long lenses, you'll notice that as the focal length increases, depth of field decreases so that less of the scene is in focus at any given f-stop. For example,

A long lens enlarges a distant subject.

Photographer Scott Goldsmith was standing on the sidelines at the moment that a 6th-grade football player on the field realized that his team was too far behind to win the city championship. Goldsmith's 180mm lens on his 35mm camera brought the boy's face close.

Scott Goldsn

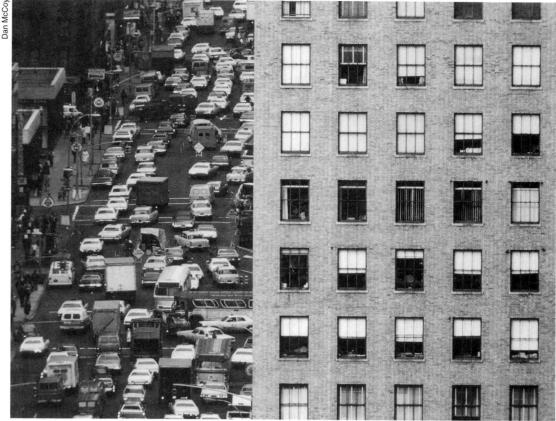

A long lens can seem to compress space. Though traffic was heavy in New York on the day this picture was taken, a longfocal-length lens made the scene look even more crowded than it was. When do vou get this effect, and why? See pages 42-43 to find out.

> when focused at the same distance, a 200mm lens at f/8 has less depth of field than a 100mm lens at f/8. This can be inconvenient-for example, if you want objects to be sharp both in the foreground of a scene and in the background. But it can also work to your advantage by permitting you to minimize unimportant details or a busy background by having them out of focus.

A medium-long lens is particularly useful for portraits because the photographer can be relatively far from the subject and still fill the image frame. Many people feel more at ease when photographed if the camera is not too close. Also, a moderate distance between camera and subject prevents the exaggerated size of facial features closest to the camera that occurs when a lens is very close. A good working distance for a head-and-shoulders portrait is 6-8 ft. (2-2.5 m), easy to do with a medium-long lens of from 85-135mm focal length with a 35mm camera.

A long lens, compared with one of normal focal length, is larger, heavier, and somewhat more expensive. Its largest aperture is relatively small; f/4 or f/5.6 is common. It must be focused carefully because with its shallow depth of field there will be a distinct difference between objects that are sharply focused and those that are not. A faster shutter speed is needed to keep the image sharp while hand holding the camera (or a tripod should be used for support) because the enlarged image magnifies the effect of even a slight movement of the lens during exposure. These disadvantages increase as the focal length increases, but so do the long lens's unique image-forming characteristics.

Photographers often call any long lens a telephoto lens, or tele, although not all long lenses are actually of telephoto design. The optics of a true telephoto make it smaller than a conventional long lens of the same focal length. A tele-extender or teleconverter contains an optical element that increases the effective focal length of a lens. It attaches between the lens and the camera. The optical performance, however, will not be as good as the equivalent long lens.

SHORT FOCAL LENGTH Wide-angle lenses

Short lenses let you move in close to the action, here, a diver exploring tidepools. They are popular with photojournalists, feature photographers, and others who shoot in fast-moving and sometimes crowded situations. For example, many photojournalists with 35mm cameras regularly use 35mm or 28mm lenses instead of 50mm lenses. These medium-short lenses give a wider angle of view than does a 50mm lens, which makes it easier to photograph in close quarters. Medium-short lenses also have more depth of field, which can let a photographer focus the lens approximately instead of having to fine-focus every shot.

Lenses of short focal length are also called wide-angle or sometimes wide-field lenses, which describes their most important feature—they view a wider angle of a scene than normal. A lens of normal focal length records what you see when you look at a scene with eyes fixed in one position. A 35mm wide-angle lens records the 63° angle of view that you see if you move your eyes slightly from side to side. A 7.5mm fisheye lens records the 180° angle you see if you turn your whole head to look over your left shoulder and then over your right shoulder.

A popular short focal length for a 35mm camera is 28mm. Comparable focal lengths are 55mm for a camera with $2\frac{1}{4}$ -inch format, 90mm for a 4 x 5 view camera.

A short lens can give great depth of field. The shorter the focal length of a lens, the more of a scene will be sharp (if the f-stop and distance from the subject remain unchanged). A 28mm lens, for example, when stopped down to f/8 can produce an image that is sharp from less than 6.5 ft. (2 m) to infinity (as far as the eye or lens can see), which often will eliminate the need for further focusing as long as the subject is within the range of distances that will be sharp.

Wide-angle "distortion." A wide-angle lens can seem to distort an image and produce strange perspective effects. Sometimes these effects are actually caused by the lens, as with a fisheye lens (page 35). But, more often, what seems to be distortion in an image made with a wide-angle lens is caused by the photographer shooting very close to the subject.

A 28mm lens, for example, will focus as close as 1 ft. (0.3 m), and shorter lenses even closer. Any object seen from close up appears larger than an object of the same size that is at a distance. While you are at a scene, your brain knows whether you are very close to an object, and ordinarily you would not notice any visual exaggeration. In a photograph, however, you notice size comparisons immediately. See photographs at right. Short lenses show a wide view.

Short-focal-length lenses are useful for including a wide view of an area. They are capable of great depth of field so that objects both close to the lens and far from it will be in focus, even at a relatively large aperture.

Objects up close appear larger. A short lens can produce strange perspective effects. Since it can be focused at very close range, it can make objects in the foreground large in relation to those in the background. With the lens close to the statue, it looks larger relative to the buildings behind it than it does in the photograph above.

edrik D. Bodin

\mathbb{Z} OOM, MACRO, AND FISHEYE LENSES

In addition to the usual range of short-, long-, and normal-focal-length lenses, other lenses, such as those shown here, can view a scene in a new way or solve certain problems with ease.

Zoom lenses are popular because they combine a range of focal lengths into one lens (see below). The glass elements of the lens can be moved in relation to each other; thus, infinitely variable focal lengths are available within the limits of the zooming range. Using a 50-135mm zoom, for example, is like having a 50mm, 85mm, and 135mm lens instantly available, plus any focal length in between. Compared to fixed-focal-length lenses, zooms are somewhat more expensive, bulkier, and heavier, but one of them will replace two or more fixed-focal-length lenses. Zoom lenses are best used where light is ample because they have a relatively small maximum aperture. New designs produce a much sharper image than did earlier zoom lenses, which were significantly less sharp than fixed-focallength lenses.

Macro lenses are used for close-up photography (opposite, top). Their optical design corrects for the lens aberrations that cause problems at very short focusing distances, but they can also be used at normal distances. Their main disadvantage is relatively small maximum aperture, often f/3.5 for a 50mm lens. (More about close-up photography on pages **143–147**.)

Macro-zoom lenses combine both macro and zoom features. They focus relatively close, although usually not as close as a fixed-focal-length macro lens, and give a range of focal length choices in one lens.

Fisheye lenses have a very wide angle of view—up to 180°—and they exaggerate to an extreme degree differences in size between objects that are close to the camera and those that are farther away. They actually distort the image by bending straight lines at the edges of the picture (opposite, bottom). Fisheye lenses also produce a great deal of depth of field: objects within inches of the lens and those in the far distance will be sharp.

A zoom lens gives you a choice of different focal lengths within the same lens. The rectangles overlaid on the picture show some of the ways you could have made this photograph by zooming in to shoot at a long focal length or zooming back to shoot at a shorter one. A macro lens enabled the photographer to move in very close to this denizen of the Florida Everglades without having to use supplemental close-up attachments such as extension tubes.

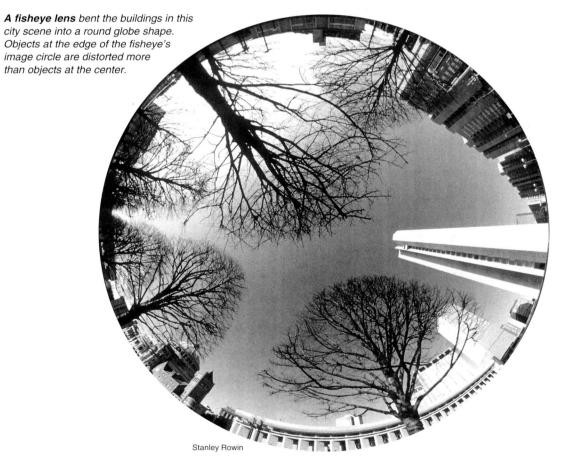

Focus and depth of field

Sharp focus attracts the eye. Sharp focus acts as a signal to pay attention to a particular part of a photograph, especially if other parts of the image are not as sharp. If part of a picture is sharp and part is out of focus, it is natural to look first at the sharply focused area (see photographs, page **165**). When you are photographing, it is also natural to focus the camera sharply on the most important area. You can select and, to a certain extent, control which parts of a scene will be sharp.

When you focus a camera on an object, the distance between lens and film is adjusted, usually by rotating the lens barrel until the object appears sharp on the viewing screen. You focus manually by turning the focusing ring on the lens barrel. If you are using an automatic-focus camera, you focus by partially depressing the shutter-release button.

Depth of field. In theory, a lens can only focus on one single distance at a time (the plane of critical focus) and objects at all other distances will be less sharp. But, in most cases, part of the scene will be acceptably sharp both in front of and behind the most sharply focused plane. Objects will gradually become more and more out of focus the farther they are from the most sharply focused area. This region within which objects appear acceptably sharp in the image—the depth of field—can be increased or decreased (see pages **38–39**).

Depth of field is the part of a scene that appears acceptably sharp in a photograph. Depth of field can be deep, with everything sharp from near to far. Here it extends from the flowers in the foreground to the greenhouse windows in the background. The photographer actually focused on some flowers in the third row of pots.

For another picture, the photographer wanted shallow depth of field, with only some of the scene sharp. Here the only sharp part of the picture is the flower on which the lens was focused.

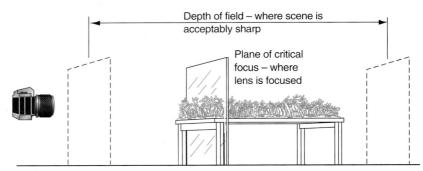

Imagine the plane of critical focus (the distance on which you focus the lens) to be something like a pane of glass stretched from one side of the scene to the other. Objects that lie along that plane will be sharp. In front of and behind the plane of critical focus lies the depth of field, the area that will appear acceptably sharp. The farther that objects are from the plane of critical focus in a particular photograph, either toward the camera or away from it, the less sharp they will be. If objects are far enough from the plane of critical focus to be outside the depth of field, they will appear noticeably out of focus.

Notice that the depth of field extends about one-third in front of the plane of critical focus, two-thirds behind it. This is true at normal focusing distances, but, when focusing very close to a subject, the depth of field is more evenly divided, about half in front and half behind the plane of critical focus.

Automatic focus

Automatic focus can mean out of focus when a scene has a main subject (or subjects) off to one side and at a different distance from whatever object is at the center. Most autofocus cameras will focus on the object at the center of the frame, here within the small bracketed area.

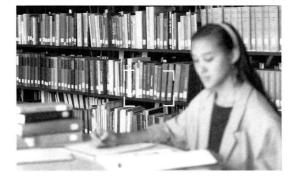

To correct this, first choose the focusing distance by placing the autofocus brackets on the main subject and partially pressing down the shutterrelease button. Lock the focus by keeping partial pressure on the shutter release.

Reframe your picture while keeping partial pressure on the shutter release. Push the shutter button all the way down to make the exposure.

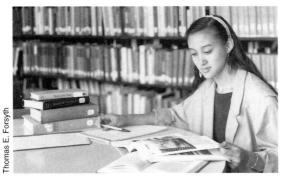

Automatic focus used to be found only on point-and-shoot snapshot cameras. But increasingly it is standard equipment on new 35mm single-lens reflex cameras. When you push down the shutter-release button part way, the camera adjusts the lens to focus sharply on what it thinks is your subject—usually whatever object is at the center of the viewing screen.

Sometimes you will want to focus the camera manually. Just as with automatic exposure, there will be times when you will want to override the automatic mechanism and focus the camera yourself. Almost all 35mm single-lens reflex cameras with automatic focus will also let you focus manually.

The most common problem occurs when your subject is at the side of the frame, not at the center (see photos, left). A camera may also have problems focusing if a subject has very low contrast, is in very dim light, or consists of a repetitive pattern.

Moving subjects can also cause problems. The adjustment of the autofocus mechanism can sometimes take long enough for a fast-moving subject, such as a race car, to move out of range. The lens may "hunt" back and forth, unable to focus at all or maybe making an exposure with the subject out of focus.

Some cameras have more sophisticated electronics to deal with these problems better. Read the instructions for your camera so you know how its autofocus mechanism operates.

Take a moment to evaluate each situation. Override the automatic system when it is better to do so, rather than assume that the right part of the picture will be sharp simply because you are set for automatic focus.

DEPTH OF FIELD Controlling sharpness in a photograph

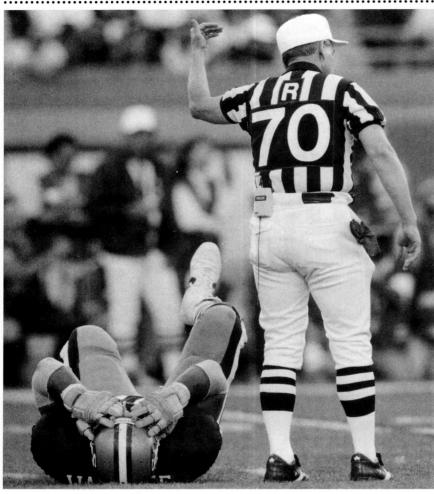

With the main subject sharply focused and the background out of focus, the player and umpire in the foreground are distinctly separated from the jumble of people on the sidelines in the background. When depth of field is shallow, only a narrow band of objects across the photograph appears sharp. Here, the photographer was using a long-focal-length lens set to a wide aperture, both of which contribute to shallow depth of field. The lens was focused on the player and umpire in the foreground, while the background was far enough away to be well beyond the depth of field, and therefore significantly out of focus.

Depth of field. Completely sharp from foreground to background, totally out of focus except for a shallow zone, or sharp to any extent in between—you can choose how much of your image will be sharp. When you make a picture, you can manipulate three factors that affect the depth of field (the distance in a scene between the nearest and farthest points that appear sharp in a photograph). Notice in the illustrations opposite that doing so may change the image in other ways.

Aperture size. Stopping down the lens to a smaller aperture, for example, from f/2 to f/16, increases the depth of field. As the aperture gets smaller, more of the scene will be sharp in the photograph.

Focal length. Using a shorter-focal-length lens also increases the depth of field at any given aperture. For example, more of a scene will be sharp when photographed with a 50mm lens at f/8 than with a 200mm lens at f/8.

Lens-to-subject distance. Moving farther away from the subject increases the depth of field most of all, particularly if you started out very close to the subject.

The smaller the aperture (with a given lens), the greater the depth of field. Using a smaller aperture for the picture on the far right increased the depth of field and made the image much sharper overall. With the smaller aperture, the amount of light reaching the film decreased, so a slower shutter speed had to be used to keep the total exposure the same. Large Aperture

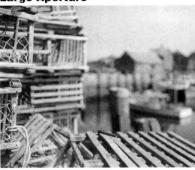

Long Lens

Short Lens

The shorter the focal length of the lens, the greater the depth of field. Both of these photographs were taken from the same position and at the same aperture. Notice that changing to a shorter focal length for the picture on the far right not only increased the depth of field but also changed the angle of view (the amount of the scene shown) and the magnification of objects in the scene.

The farther you are from a subject, the greater the depth of field, at any given focal length and aperture. The photographer stepped back to take the picture on the far right. If you focus on an object far enough away, the lens will form a sharp image of all objects from that point out to infinity.

Up Close

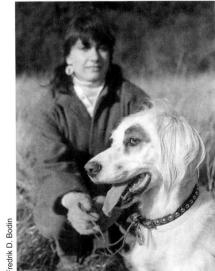

Farther Back

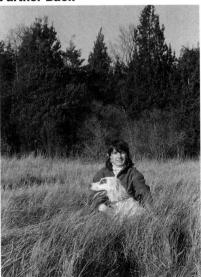

MORE ABOUT DEPTH OF FIELD How to preview it

When photographing a scene, you will often want to know the extent of the depth of field how much of the scene from near to far will be sharp. You may want to be sure that certain objects are sharp. Or you may want something deliberately out of focus, such as a distracting background. To control what is sharp, it is useful to have some way of gauging the depth of field.

Checking the depth of field. With a singlelens reflex camera, you view the scene through the lens. No matter what aperture setting you have selected, the lens is ordinarily wide open for viewing to make the viewfinder image as bright and easy to see as possible. However, the large aperture size means that you see the scene with depth of field at its shallowest. When you press the shutter release, the lens automatically closes down to the taking aperture. Unless you are taking a picture using the widest aperture, the viewfinder image will not have the same depth of field as the final photograph. Some single-lens reflex cameras have a previewing down the lens to view the scene at the taking mechanism so that, if you wish, you can stop aperture and see how much will be sharp.

Unfortunately, if the lens is set to a very small aperture, the stopped-down image on the viewing screen may be too dark to be seen clearly. If so, or if your camera doesn't have a preview feature, you may be able to read the nearest and farthest limits of the depth of field on a depth-of-field scale on the lens barrel (this page, bottom). Manufacturers sometimes provide printed tables showing the depth of field for different lenses at various focusing distances and f-stops.

Depth of field with a view camera, which also views through the lens, can be seen on the ground-glass viewing screen when the lens is stopped down to the taking aperture. A rangefinder camera shows you the scene through a viewfinder, a small window in the camera body through which all objects look equally sharp. A depth-of-f eld scale on the lens barrel is your best means for estimating depth of field with a rangefinder camera.

Zone focusing for action. Knowing the depth of field in advance is useful when you want to preset the lens to be ready for an action shot without last-minute focusing. Zone focusing uses the depth-of-field scale on the lens to set the focus and aperture so that the action will be photographed well within the depth of field (see below).

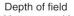

Aperture ring lines up opposite the pointer to show the aperture to which the lens is set.

Distance scale lines up opposite the pointer to show the distance from the camera to the most sharply focused object.

Depth-of-field scale lines up opposite the distance scale to show the range of distances that will be sharp at various apertures.

With zone focusing you

can be ready for an action shot by focusing in advance, if you know approximately where the action will take place. Suppose you are on a ski slope and you want to photograph a skier coming down the hill. The nearest point at which you might want to take the picture is 15 ft. (4.5 m) from the action; the farthest is 30 ft. (9 m).

Line up the distance scale so that these two distances are opposite a pair of f-stop indicators on the depth-of-field scale (with the lens shown below, the two distances fall opposite the f/16 indicators). Now, if your aperture is set to f/16, everything from 15-30 ft. (4.5-9 m) will be within the depth of field and in focus. It doesn't matter exactly where the subject is when you make the photograph, as long as it is somewhere within these distances.

hn D. Upton

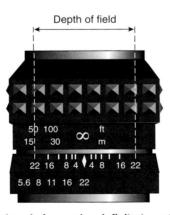

When the lens is focused on infinity (∞ on the lens distance scale), everything at some distance away and farther will be sharp: with this lens at f/22 everything will be sharp from 50 ft. (16 m) to infinity (as far as the eye can see).

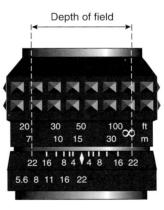

You can increase the depth of field even more if, instead of focusing on infinity, you set the ∞ infinity mark opposite the point on the depth-of-field scale (22) that shows the f-stop you are using (f/22). You are now focused on a distance (50 ft., 16 m) slightly closer than infinity (technically called the hyperfocal distance). Now everything from 23 ft. (7 m) to the far background is within the depth of field and will be sharp in the print.

Focusing for the greatest depth of field. When you are shooting a scene that includes important objects at a long distance as well as some that are closer, you will want maximum depth of field. Shown above is a way of setting the lens to permit as much as possible of the scene to be sharp. It will be easier to understand if you work these examples through on your own lens as you read. You'll need a lens that has a depth-of-field scale.

PERSPECTIVE How a photograph shows depth

Perspective: the impression of depth. Few lenses (except for the fisheye) noticeably distort the scene they show. The perspective in a photograph-the apparent size and shape of objects and the impression of depth-is what you would see if you were standing at camera position. Why then do some photographs seem to have an exaggerated depth, with the subject appearing stretched and expanded (this page, top), whereas other photographs seem to show a compressed space, with objects crowded very close together (this page, bottom)? The brain judges depth in a photograph mostly by comparing objects in the foreground with those in the background; the greater the size differences perceived, the greater the impression of depth. When viewing an actual scene, the brain has other clues to the distances and it disregards any apparent distortion in sizes. But, when looking at a photograph, the brain uses relative sizes as the major clue.

Perspective can be controlled in a photograph. Any lens moved in very close to the foreground of a scene increases the impression of depth by increasing the size of foreground objects relative to objects in the background. As shown on the opposite page, perspective is not affected by changing the focal length of the lens if the camera remains at the same distance. However, it does change if the distance from lens to subject is changed.

Perspective can be exaggerated. The appearance of perspective is exaggerated if you change both focal length and lens-to-subject distance. A short-focal-length lens used close to the subject increases differences in size because it is much closer to foreground objects than to those in the background. This increases the impression of depth. Distances appear expanded and sizes and shapes may appear distorted when scenes are photographed in this way.

The opposite effect occurs with a longfocal-length lens used far from the subject. Differences in sizes are decreased because the lens is relatively far from all objects. This decreases the apparent depth and sometimes seems to squeeze objects into a smaller space than they could occupy in reality.

Expanded perspective.

A short-focal-length lens used close to a subject stretches distances because it magnifies objects near the lens in relation to those that are far from the lens.

tive. A long-focal-length lens used far from a subject compresses space. The lens is relatively far from both foreground and background, so size differences between near and far parts of the scene are minimized, as is the impression of depth.

Compressed perspec-

Changing focal length alone does not change perspective—the apparent size or shape of objects or their apparent position in depth. In the photographs above, the camera was not moved, but the lens focal length was increased. As a result, the size of all the objects increased at a comparable rate. Notice that the size of the fountain and the size of the windows in the background both change the same amount. The impression of depth remains the same.

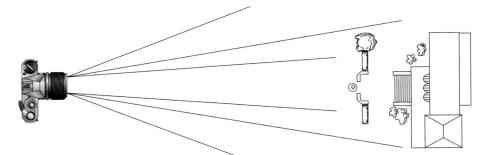

Lens-to-subject distance controls perspective. Perspective is changed when the distance from the lens to objects in the scene is changed. Notice how the size of the fountain gets much bigger while the size of the windows remains about the same. The depth seems to increase because the camera was brought closer to the nearest part of the subject.

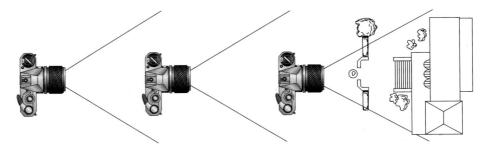

ENS PERFORMANCE Getting the most from a lens

Camera motion causes blur. Though some photographers claim to be able to hand hold a camera steady at slow shutter speeds—1/15 sec. or even slower—it takes only a slight amount of camera motion during exposure to cause a noticeable blur in an image. If a sharp picture is your aim, using a fast shutter speed or supporting the camera on a tripod is a much surer way to produce an image that will be sharp when enlarged.

When hand holding the camera, use the focal length of your lens as a guide to how fast a shutter speed you need to keep your picture acceptably sharp. The longer the focal length, the faster the shutter speed must be, because a long lens magnifies any motion of the lens during the exposure just as it magnifies the size of the objects photographed. As a general rule, the slowest shutter speed that is safe to hand hold can be matched to the focal length of the lens. That is, a 50mm lens should be hand held at a shutter speed of 1/50 sec. or faster, a 100mm lens at 1/100 sec. or faster, and so on. This doesn't mean that the camera can be freely moved during the exposure. At these speeds, the camera can be hand held, but with care. At the moment of exposure, hold your breath and squeeze the shutter release smoothly. Not everyone can hold a camera equally steady; you will have to experiment a bit to find your own limits. The camera itself can affect your ability to hand hold it; some cameras vibrate more than others during exposure. A single-lens reflex camera, with its moving mirror, for example, vibrates more than a rangefinder camera.

A tripod and cable release (shown above right) can make your pictures noticeably sharper by keeping the camera absolutely still during an exposure. The tripod supports the camera steadily; the cable release lets you trigger the shutter without having to touch the camera directly. A tripod and cable release

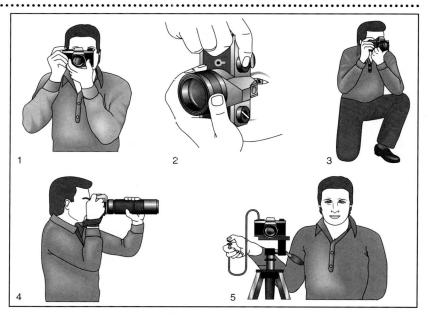

1. To hand hold a camera steady, keep feet apart and rest the camera lightly against your face. Hold your breath and squeeze the shutter release slowly.

4. With a long lens on the camera, use one hand to support the weight of the lens. Winding the camera strap around your wrist helps to steady the camera and to prevent dropping it.

2. With the camera in a vertical position, the left hand can hold and focus the camera; the right hand releases the shutter.

5. A tripod and cable release provide the steadiest support and are essential for slow shutter speeds if you want a sharp image. Keep some slack in the cable release so it doesn't tug on the camera.

are useful in situations that require a slower shutter speed than is feasible for hand holding; for example, at dusk when the light is dim. They also help when you want to compose a picture carefully or do close-up work. They are standard equipment for copy work, such as photographing another photograph or something from a book, because hand holding at even a fast shutter speed will not give the critical sharpness that resolves fine details to the maximum degree possible. A view camera is always used on a tripod. 3. In kneeling position, kneel on one leg and rest your upper arm on the other knee. Leaning against a wall or a steady object will help brace your body.

${f S}$ olving camera and lens problems

From time to time, every photographer encounters negatives or prints that display unexpected problems. This section can help you identify the cause of some problems caused by the camera or lens, and how to prevent them in the future. See also Solving Exposure Problems, page **72**; Negative Development Problems, page **92**; Printing Problems, page **117**; and Flash Problems, page **140**.

Light streaks. Image area flared or foggy looking overall (darkened in a negative, lightened in a print or slide), with film edges unaffected. The image may also show ghosting or spots in the shape of the lens diaphragm, as in the print at right.

Cause: The sun, a bright bulb, or other light source was within or close to the image, or bright light struck the lens at an angle.

Prevention: Expect some flare if you can see a light source in your viewfinder. The larger or brighter the light, the more flare you will get; distant or dim lights may not produce any flare at all. To prevent stray light from striking the lens, use the correct lens shade for your lens focal length. Even with a lens shade, make sure the sun is not shining directly on your lens.

Light streaks on film edges, as well as in image area.

Cause: The camera back was accidentally opened with film inside, light leaked into the film cassette, or light in the darkroom struck the film while it was being loaded or developed. Heat or age can fog film overall.

Prevention: Load and unload your camera in the shade, or at least block direct light with your body. Don't let bright light strike the film cassette or roll: put it back into its protective container or box until ready for development.

Vignetting. Image obscured at the corners (clear in a negative, dark in a print or slide). Cause: A lens shade, filter, or both projected too far forward of the lens and partially blocked the image from reaching the lens.

Prevention: Lens shades are shaped to match different focal-length lenses (see right, bottom). Use the correct shade for your lens; too long a lens shade can cause vignetting, but one that is too shallow will not provide adequate protection from flare. Using more than one filter or a filter plus a lens shade can cause vignetting, especially with a short lens.

Picture not sharp. Easier to see in an enlarged print, but may even be visible in the negative.

Cause: Too slow a shutter speed will blur a moving subject or blur the picture overall due to camera motion. Too wide an aperture will make the scene sharp where you focused it but not in front of or behind that part. An extremely dirty lens can sometimes reduce sharpness overall, especially when combined with lens flare. **Prevention:** Use a faster shutter speed or smaller aperture, or support the camera more steadily. Keep fingerprints and dirt off the lens.

Light Streaks

Vignetting

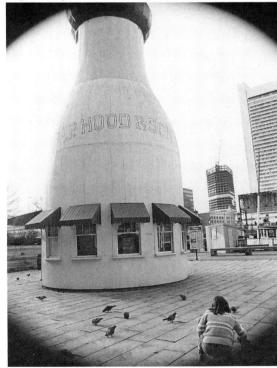

Lens Shade

For long-focal-length lens

For short-focal-length lens

Selecting and Using Film 48 Film Speed and Grain: The two go together 50 SPECIAL-PURPOSE FILMS: High contrast and infrared 52 COLOR FILMS 54

The light sensitivity of film. The most important characteristic of film is that it is light-sensitive; it undergoes a physical change when exposed to light. Light is energy, the visible part of the wavelike energy that exists in a continuum from radio waves through visible light to cosmic rays. These forms of energy differ only in their wavelength, the distance from the crest of one wave to the crest of the next. The visible part of this spectrum, the light that we see, ranges between 400 and 700 nanometers (billionths of a meter) in wavelength.

Not all films respond the same way to light. Silver halides (compounds of silver) are the light-sensitive part of film. They respond primarily to blue and ultraviolet wavelengths, but dyes in the gelatin emulsion that holds the halides increase the film's range of sensitivity. General-purpose black-and-white films are panchromatic (pan); they are designed to be sensitive to the wavelengths in the visible spectrum, so that the image they record is similar to that perceived by the human eye. Some special-purpose films are designed to be sensitive to selected parts of the spectrum. Orthochromatic (ortho) black-and-white films are sensitive to blue and green wavelengths, but not to red. Infrared films are sensitive to infrared wavelengths that are invisible to the human eye (see pages **52–53**).

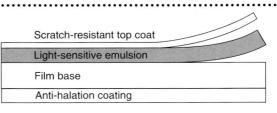

Film cross section. Film is made up of layers of different materials. On top is a tough coating that helps protect the film from scratches during ordinary handling. Next is the emulsion, a layer of gelatin that contains the light-sensitive part of the film, silver halide crystals—silver chloride, silver bromide, and silver iodide. (Color film has three layers of halides, each made sensitive to a different part of the spectrum.) An adhesive bonds the emulsion to the base, a flexible plastic support. Below the base is an antihalation dye that absorbs light in order to prevent light rays from bouncing back through the film and adding unwanted exposure to the emulsion.

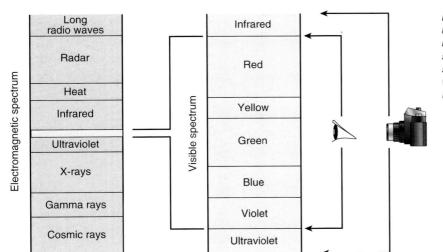

Light. When certain wavelengths of energy strike the human eye, they are perceived as light. Film is manufactured so that it undergoes changes when struck by this part of the electromagnetic energy spectrum. Film also can respond to additional wavelengths that the eye cannot see, such as ultraviolet and infrared light.

${f S}$ electing and using film

When you buy film, check the expiration date printed on the film package before you make your purchase. The film is usable beyond that date but steadily deteriorates. Color film changes slightly each time the manufacturer makes a batch, so many professionals buy a quantity with the same emulsion number, which identifies the batch. That way they can test one roll and know the others will behave the same way.

Storing film. Heat accelerates the deterioration of film, so avoid storing it in a warm place such as the inside of a glove compartment on a hot day or the top of a radiator on a cold one. Room temperature is fine for short-term storage, but for longer storage, especially in warm weather, a refrigerator or freezer is better. (Don't freeze Polaroid instant-picture film.) Be sure that the film to be chilled is in a moisture-proof wrapping, and, when you remove the film from refrigeration, avoid condensation of moisture on the film surface by giving it several hours to come to room temperature before opening.

Loading. Light exposes film, and you want only the light that comes through the lens to strike the film. So load and unload your camera away from strong light to avoid the possibility of stray light leaking into the film cassette and causing streaks of unwanted exposure. When loading film into your camera outdoors, find shade, or at least block direct sun by shading the camera with your body.

Airport security X-ray devices are generally safe for film, but some, especially in foreign airports, fog undeveloped film when the machines are not adjusted correctly. This is more likely to be a problem with very high-speed film (more than ISO 1000) than with slowerspeed films. You can ask to have film (and camera, if it is loaded) inspected by hand to reduce the possibility of X-ray damage. A **fast film,** such as one rated at ISO 400, is good not only for action shots but for any situation in which the light is relatively dim and you want to work with a fast shutter speed or a small aperture.

A **medium-speed film**, ISO 125, was chosen for this photograph of a forest road. The fine grain and excellent sharpness of the film recorded every detail of the delicate shading on the tree trunks and intricate pattern of leaves. With a slow- or medium-speed film, you can make large prints without the image showing significant graininess (see page **50**).

Selecting Film

Camera stores stock a wide variety of films, but which one you select depends on only a few basic choices.

Do you want black and white or color? This book primarily covers black-and-white photography, but see pages **54–55** for information on color film. One basic choice in color film is its color balance. Daylight-balanced color films are designed for the relatively bluish light of daylight or electronic flash. Tungsten-balanced films give better results in the relatively reddish light from incandescent light bulbs.

Do you want a print? If so, choose a *negative film*, which will produce an image on the film in which the tones are the opposite of the original scene: light areas in the scene are dark in the negative, dark areas are light. The negative is then used to make a positive print in which the tones are similar to those in the original scene.

Do you want a transparency? A transparency is usually a positive color image on film. A slide is a 35mm transparency mounted in a small frame of cardboard or plastic so that it can be inserted into a projector or viewer. A *chrome* is the professionals' slang for any color transparency, but more often those larger than 35mm. Choose a color *reversal film* if you want a transparency. During processing, the film tones are chemically reversed so that a positive image appears on the film.

If you want a black-and-white transparency, special reversal-processing kits are made. For example, you can process Kodak T-Max 100 in the T-Max 100 Direct Positive Film Developing Outfit. Polaroid makes self-developing films for 35mm transparencies both in black and white and in color.

Do you want a color print? They are usually made from a color negative, but they can be made from a color transparency (see page **54**).

What film speed do you want? The higher its film speed rating, the more sensitive a film is to light and so the less light needed for a correct exposure. Slow films have a film speed of about ISO 50 or less; medium-speed films about ISO 100; fast films about ISO 400; ultra-fast films ISO 1000 or more. See pages **50–51** for more about film speed.

What size film and number of exposures do you want? The film size to buy depends on the format your camera accepts.

35mm film is packaged in cassettes, usually with 12, 24, or 36 exposures per roll, labeled 135-12, 135-24, or 135-36. Some 35mm films can be purchased in 50- or 100-foot rolls and hand loaded into cassettes. This reduces your cost per roll.

Roll film is wrapped around a spool and backed with a strip of opaque paper to protect it from light. (The term *roll* is also used in a general sense to refer to any film that is rolled, as compared to a flat sheet film.) 120 roll film makes 12 2¹/₄-inch (6 cm) square negatives or, in some cameras, 8, 10, or 16 rectangular negatives, depending on the dimensions of the format. Some cameras accept longer 220 roll film, which gives twice as many exposures per roll.

Sheet film or cut film, made in 4×5 inch and larger sizes, is used in view cameras. It must be loaded into film holders before use, and it produces one picture per sheet.

Do you want a film for a special purpose? *High contrast film* produces only two tones on the film black or clear film base. The result is an image of only solid black or pure white tones, instead of the range of gray tones produced by conventional film (see page **52**). *Infrared film* responds to infrared wavelengths that the human eye cannot see (see pages **52–53**).

FILM SPEED AND GRAIN The two go together

Film speed ratings. How sensitive a film is to light, that is, how much it reacts to a given quantity of light, is indicated by its film speed. The more sensitive—or faster—the film, the higher its number in the rating system. (See opposite page: Film Speed Ratings.)

A high film speed is often useful: the faster the film, the less exposure it needs to produce an image. Fast films are often used for photographing in dim light or when a fast shutter speed is important. But along with fast film speed go some other characteristics: most important, an increase in graininess plus some decrease in contrast and loss of sharpness. With color films, there is also a loss of color accuracy and saturation. As the photographs on this page show, the most detailed image was produced by the slow ISO 25 film. The very fast ISO 3200 film, by comparison, gave a relatively mottled, grainy effect.

Graininess occurs when the bits of silver that form the image clump together. It is more likely to occur with fast films, which have large and small silver halide crystals, than it is with slower films, which have only small crystals. The effect is more noticeable in big enlargements, if the film is overexposed, if it is not processed at a consistent temperature, or if it is "pushed" to increase its film speed by extended development.

What film speed should you use? Ideally, for maximum sharpness you should choose the slowest film usable in a given situation. For practical purposes, however, most photographers load a medium-speed (ISO 100) film for general use. A higher-speed (ISO 400) film will be their choice for dimly lit subjects or those requiring high shutter speeds.

There is nothing necessarily wrong with grain. Some photographers even try to increase the graininess of their pictures be-

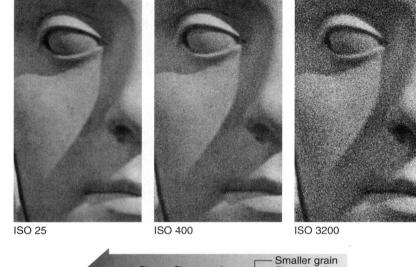

Slower film speed

cause they like the textured look it can give, especially in extreme enlargements. Films such as Ilford HP-5 Plus and Kodak Tri-X, which both have a film speed of ISO 400, are relatively fine grained when exposed and developed normally, but increase considerably in graininess when pushed. See Push Processing, page **90**.

Certain new technology films have reduced graininess for their speed, such as Kodak T-Max or Ilford Delta films. The shape of their silver crystals makes them more sensitive to light, but without a corresponding increase in grain. A caution: follow processing instructions carefully. Even a slight increase in time, temperature, or agitation during development may cause a distinct increase in film contrast. Although, for example, Kodak Tri-X (ISO 400) is grainier than T-Max 400 (same film speed), Tri-X and other standard ISO 400 films continue to be used because they are easier to control with ordinary darkroom processing.

Film speed and grain.

Finer detail More contrast

> Generally speaking, the slower the film (the lower the ISO number), the finer the grain structure of the film and the more detailed the image the film records. Compare these extreme enlargements. Film speed also affects color film; for example, slower films have more accurate color reproduction.

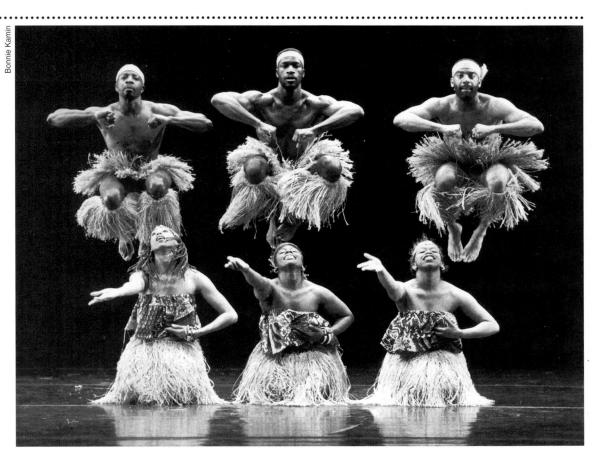

Film Speed Ratings_

Although there are different rating systems for film speeds, the most important point to remember is that the higher the number in a given system, the faster the film, and, so, the less light needed for a correct exposure.

The most common ratings found in English-speaking countries are **ISO** (International Organization for Standardization) and **EI** (exposure index). **ASA** is an older rating system that is still sometimes mentioned. All use the same numerical progression: each time the light sensitivity of the film doubles, the film speed rating doubles. An ISO (or EI or ASA) 200 film is twice as fast as an ISO 100 film, half as fast as an ISO 400 film. For a correct exposure, the ISO 200 film needs half as much light as the ISO 100 film, twice as much light as the ISO 400 film.

Sometimes the ISO rating includes the European **DIN** (Deutsche Industrie Norm) rating; for example, ISO 200/24°. In the DIN system, the rating increases by 3 each time the film speed doubles. DIN 24 (equivalent to ISO 200) is twice as fast as DIN 21, half as fast as DIN 27. Except for the unlikely case of using a piece of equipment marked only with DIN numbers, you can ignore the DIN part of an ISO rating.

A fast film, ISO 400, let the photographer use a shutter speed of ¹/₅₀₀ sec. This shutter speed was fast enough to guarantee that action would be sharp in the picture and fast enough to let the photographer shoot freely, hand holding the camera without fear that camera motion would blur the picture overall.

SPECIAL-PURPOSE FILMS High contrast and infrared

Most films are designed to "see" as the human eye does and to respond to light in ways that appear realistic. But some films depart from the reality that we know.

High-contrast black-and-white film does not record a continuous range of tones from black through many shades of gray to white, as films of normal contrast do. Instead, it translates each tone in a scene into either black or white (see illustration below). Any film can be processed for higher-than-normal contrast, but some films are specially made for high-contrast photography, such as Kodak Ektagraphic HC Slide Film.

Infrared black-and-white film is sensitized to wavelengths that are invisible to the human eye, the infrared waves that lie between visible red light and wavelengths that are produced by heat. Because the film responds to wavelengths that are not visible to the eye, it can be used to photograph in the dark. The sun is a strong source of infrared radiation; tungsten filament lamps, flash bulbs, and electronic flash can also be used. Unusual and strangely beautiful images are possible because many materials reflect and absorb infrared radiation differently from visible light (see opposite page). Grass, leaves, and other vegetation reflect infrared wavelengths very strongly and thus appear very bright, even white. Clouds too are highly reflective of infrared wavelengths, but since the blue sky does not contain them, it appears dark, even black, in a print.

Because infrared wavelengths are invisible, you cannot fully visualize in advance just what the print will look like—sometimes a frustration but sometimes an unexpected pleasure. The correct exposure is also something of a guess; most meters do not measure infrared accurately. (See Using Infrared Film, opposite.) Infrared color film is also available.

High-contrast film changes the many shades of gray in an ordinary scene into a graphic abstraction of blacks and whites.

Barbara Londo

Infrared film records leaves and grass as very light. The result can be a strangely dreamlike landscape.

Using Infrared Film _

Storage and loading. Infrared film can be fogged by exposure to heat or even slight exposure to infrared radiation. Buy infrared film only if it has been refrigerated, and once you have it, store it under refrigeration when possible. Load and unload the camera in total darkness, either in a darkroom or in a changing bag (a light-tight bag into which you put your hands, camera, and film).

Focusing. Lenses focus infrared wavelengths at a slightly different distance than they do visible light from the same object, so a focus adjustment may be required. With black-and-white infrared film, after focusing as usual, rotate the lens barrel forward very slightly as if you were focusing on an object closer to you. Some lenses have a red indexing mark on the lens barrel to show the adjustment needed. The difference is very slight, so, unless depth of field is very shallow (as when you are photographing close up or at a large aperture), you can usually make do without any correction. No correction is needed for infrared color film.

Filtration. See manufacturer's instructions. Kodak recommends a No. 25 red filter for general use with black-and-white infrared film to enhance the infrared effect by absorbing the blue light to which the film is also sensitive. Kodak recommends a No. 12 minus-blue filter for general use with color infrared film.

Exposure. A general-purpose exposure meter, whether built into the camera or hand held, cannot reliably measure infrared radiation. Kodak recommends the following manually set trial exposures for its films used in daylight. High Speed Infrared black-and-white film used with No. 25 filter: distant scenes— $\frac{1}{125}$ sec. at f/11; nearby scenes— $\frac{1}{125}$ sec. at f/11. Ektachrome Infrared color film with a No. 12 filter— $\frac{1}{125}$ sec. at f/16. Overexposure is safer than underexposure; after making the trial exposure, make additional exposures of $\frac{1}{2}$ stop and 1 stop more and $\frac{1}{2}$ stop less (see Bracketing, page **63**).

COLOR FILMS

What can you get in color films? Many color films are available, belonging basically to two categories: negative films and reversal films. A negative film (often with "-color" in its name, such as Agfacolor or Kodacolor) produces a negative in which the tones and colors are the opposite of those in the original scene. The negative (which appears orange because of a built-in color correcting mask) is then printed to make a positive image. A reversal film (almost always with "-chrome" in its name, such as Ektachrome or Fujichrome) is given special reversal processing to produce a film positive. 35mm color positives are called slides. Color positives from larger film are called transparencies or chromes.

Color films are balanced for either daylight or tungsten light. We see a wide variety of light as "white," that is, having no color of its own. However, the color temperature of light-the mixture of wavelengths of different colors that it contains-varies with different light sources. Light from an ordinary light bulb, for example, has proportionately less blue and more yellow and red than does daylight. You can often see this if you turn on an indoor lamp in a daylit room: the light from the lamp looks guite yellow. At night, with no daylight for comparison, you see the same lamplight not as yellow but as white. The brain involuntarily ignores color balance when we look at a scene, perceiving either daylight or lamplight as "white" if there is only one kind of light present. However, color film can't adjust itself and so is made to match the color temperatures of specific light sources. If the color balance of your film doesn't match that of your light source, an easily noticed color shift will appear in your photographs.

Daylight-balanced films yield naturallooking colors when shot in daylight. Electronic flash units produce light of the same color, so you should also use daylight films with flash. *Tungsten-balanced* or *indoor*

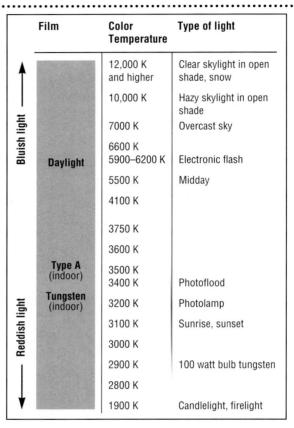

The color temperature of a light source (measured in degrees Kelvin) describes its color exactly. Color films are made to be used either with daylight, which is relatively blue, or with tungsten light, which is reddish. The lower the color temperature, the more "warm" red wavelengths are in the light. Higher color temperatures have more "cool" blue wavelengths.

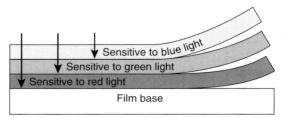

Color film consists of three light-sensitive layers, each of which responds to about one-third of the colors in the light spectrum. Each layer is matched to a primary color dye that is built into the emulsion or added during processing. Every color can be produced by mixing varying proportions of these color primaries.

films produce the best results when used in more reddish light, such as the light from incandescent bulbs. Most indoor films are designed for light of 3200 K (degrees Kelvin) color temperature; however, they give acceptable results for most purposes when used with any type of tungsten light. *Type A indoor film* has a slightly different balance for precise color rendition when used with high-intensity 3400 K photofloods. Color correcting lens filters can balance the light if it does not match the film you are using. See chart, page **149**.

Fluorescent light presents a special problem because the color balance does not match either daylight or tungsten films and varies depending on the type of fluorescent tube and its age. The light often gives an unpleasant greenish cast to pictures. Film manufacturers provide filtration data for different tubes, but, practically speaking, you usually won't know which tube is installed, and there may be several different kinds of tubes in one room. Try an FL-D (fluorescent) filter with one stop increase in exposure using daylight film. Daylight film will give a better balance than tungsten film if you use no filter.

Color balance is very important with reversal films. Color slides are made directly from the film that was in the camera, so color balance cannot be corrected unless the slides are remade. Reversal film should be shot either in the light for which it was intended or with a filter over the lens to adjust the color balance. If this is not done, the resulting slides will have a distinct color cast. Color shifts in color negatives can be adjusted during printing.

If you are expecting to scan your color film into a digital system, the choice of film type is less important because some color corrections can be made with image-editing software. Nevertheless, matching the film to the light source is still preferable.

You can make prints from either color negatives or color slides. If you know you want to make color prints, load color negative film into your camera. If you want both prints and slides or if you are not sure which you want, use color reversal film.

Prints made from slides have brilliant color saturation and are somewhat sharper and less grainy in larger sizes. Prints from color negatives are less contrasty, more easily processed, and less expensive. Since slides tend to have greater contrast than do color negatives, they often give best results when the light is soft and low in contrast.

PROJECT <u>color balance during the day</u>

YOU WILL NEED

Roll of daylight-balanced color film. Use slide film so that color balance changes are not altered during printing.

PROCEDURE On a sunny day, find a location that you think will make a good landscape or cityscape. Photograph from that location at midday, in the late afternoon, and at dusk. Try to shoot from the same point each time. Identify the resulting slides so that you know when each was shot.

HOW DID YOU DO? How are the colors rendered in your pictures? Did one or more look cooler (more bluish) overall, compared to the others? Were one or more warmer (more reddish)? What time or times of day created these changes? Do you prefer the look of certain times of day? Incidentally, notice how the direction of the light, and so the shadows it created, changed over the course of the day.

Normal Exposure, Underexposure, AND OVEREXPOSURE 58 EXPOSURE METERS: What different types do 60 How to calculate and adjust an exposure manually 62 OVERRIDING AN AUTOMATIC EXPOSURE CAMERA 64 MAKING AN EXPOSURE OF AN AVERAGE SCENE 66 EXPOSING SCENES WITH HIGH CONTRAST 68 EXPOSING SCENES THAT ARE LIGHTER OR DARKER THAN AVERAGE 70 EXPOSURES IN HARD-TO-METER SITUATIONS 71 SOLVING EXPOSURE PROBLEMS 72

EXPOSURE

E ture so they let in the correct amount of light for a given film and scene) makes a big difference if you want a rich image with realistic tones, dark but detailed shadows, and bright, delicate highlights, instead of a too dark, murky picture or a picture that is barely visible because it is too light.

At the simplest level, you can let your automatic camera set the shutter speed and aperture for you. If your camera has manual settings, you can calculate them by using an exposure meter to make an overall reading of the scene. You can even use the chart of general exposure recommendations that film manufacturers provide with each roll of film. In many cases, these standardized procedures will give you a satisfactory exposure. But standard procedures don't work in all situations. If the light source is behind the subject, for example, an overall reading will silhouette the subject against the brighter background. This may not be what you want.

You will have more control over your pictures—and be happier with the results—if you know how to interpret the information your camera or meter provides and how to adjust the recommended exposure to get any variation you choose. You will then be able to select what you want to do in a specific situation rather than exposing at random and hoping for the best.

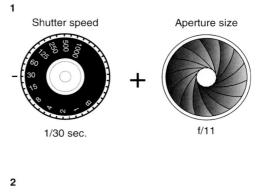

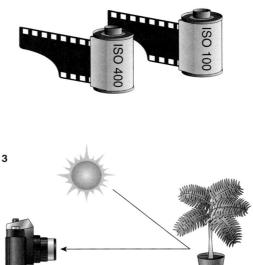

Learning to expose film properly, letting the right amount of light into the camera, involves understanding just three things:

1. How the shutter speed and the size of the lens opening (the aperture) work together to control light (pages **16–21**).

2. The sensitivity of your film to light—the film's speed (pages 50–51).

3. How to measure the amount of light and then set the exposure, either automatically or manually (pages **60–71**).

NORMAL EXPOSURE, UNDEREXPOSURE, AND OVEREXPOSURE

A negative is the image that is produced

when film is exposed to light and then developed. The tones of a negative are the reverse of the original scene: the brightest areas in the scene are the darkest in the negative. How does this happen? When light strikes film, the energy of the light changes lightsensitive silver halide crystals in the film's emulsion. The energy rearranges the structure of the crystals so that during development they convert to particles of dark, metallic silver.

The more light that strikes a particular area, the more the light-sensitive crystals are activated and so the denser with silver (and the darker) that part of the negative will be. As a result, a white ship, for example, will be very dark in the negative. If film is exposed to light long enough, it darkens simply by the action of light, but ordinarily it is exposed only long enough to produce a latent or invisible image that is then made visible by chemical development.

A positive print can be made from the negative by shining light through the negative onto a piece of light-sensitive paper. Where the original scene was bright (the white ship), the negative is very dark and dense with many particles of silver. Dense areas in the negative block light from reaching the paper; few particles of silver form in those parts of the print, so those areas are bright in the final positive image.

The opposite happens with dark areas such as the shadows in the original scene: dark areas reflect little light, so only a little silver (or sometimes none) is produced in the negative. When the positive print is made, these thin or clear areas in the negative pass much light to the paper and form dark deposits of silver corresponding to the dark areas in the original scene. When a positive transparency such as a color slide is made, the tones in the negative itself are chemically reversed into a positive image.

Exposure determines the lightness or darkness of the image. The exposure you give a negative (the combination of f-stop and shutter speed) determines how much light from a scene will reach the film and how dense or dark the negative will be: the more light, the denser the negative, and, in general, the lighter the final image. The "correct" exposure for a given situation depends on how you want the photograph to look. The following pages tell how to adjust the exposure to get the effect you want.

Film and paper have exposure latitude; that is, you can often make a good print from a less-than-perfect negative. Color slides have the least latitude; for best results, do not overexpose or underexpose them more than $\frac{1}{2}$ stop (one stop is acceptable for some scenes). Black-and-white or color prints can be made from negatives that vary somewhat more: from about one stop underexposure to two stops overexposure is usually acceptable. (More about stops and exposure on page 62.)

With too much variation from the correct exposure, prints and slides begin to look bad. Too much light overexposes a negative; it will be much too dense with silver to pass enough light to the printing paper, resulting in a final print that will be too pale (see photographs, opposite bottom). Conversely, too little exposure produces a negative that is underexposed and too thin, resulting in a print that is too dark (see photographs, opposite top). The results are similar with color slides. Too much exposure produces slides that are too light and that have pale, washed-out colors. Too little exposure produces dark, murky slides with little texture or detail.

Normal Negative

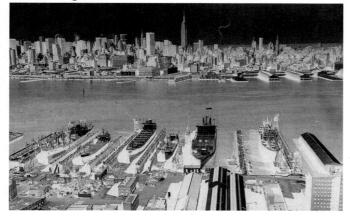

Overexposed, Dense Negative

Normal Positive

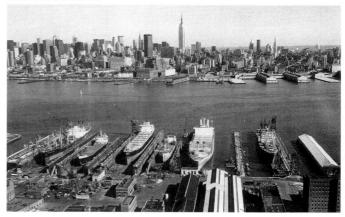

Light Positive

EXPOSURE 59

EXPOSURE METERS What different types do

Exposure meters vary in design, but they all perform the same basic function. They measure the amount of light; then, for a given film speed, they calculate f-stop and shutterspeed combinations that will produce a correct exposure for a scene that has an average distribution of light and dark tones.

Meters built into cameras measure reflected light (see opposite page, top center). The light-sensitive part of the meter is a photoelectric cell. When the metering system is turned on and the lens of the camera is pointed at a subject, the cell measures the light reflected from that subject. With automatic exposure operation, you set either the aperture or the shutter speed and the camera adjusts the other to let in a given amount of light. Some cameras set both the aperture and the shutter speed for you. In manual exposure operation, you adjust the aperture and the shutter speed based on the meter's viewfinder readout. Hand-held meters measure reflected light or incident light (see opposite page, top left and right). When the cell of a hand-held meter (one that is not built into a camera) is exposed to light, it moves a needle across a scale of numbers or activates a digital display. The brighter the light, the higher the reading. The meter then calculates and displays recommended f-stop and shutter-speed combinations.

Meters are designed to measure middle

gray. A reflected-light meter measures only one thing—the amount of light—and it calculates for only one result—an exposure that will reproduce that overall level of light as a medium-gray tone in the final photograph. The assumption is that most scenes, which consist of a variety of tones including very dark, medium gray, and very light, average out to a medium gray tone. Most, in fact, do. Pages 66–71 tell how to use a meter to measure an average scene and what to do for scenes that are not average.

A hand-held meter is separate from the camera. After measuring the amount of light, the meter's calculator dial or other readout shows recommended f-stop and shutter-speed combinations. This type of meter can read either incident or reflected light depending on the position of the small dome on the top of the meter.

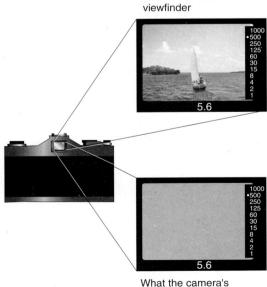

metering system "sees"

The scene visible in the

A through-the-lens (TTL) meter, built into a camera, shows in the camera's viewfinder the area that the meter is reading. You can see the details of the scene, but the camera's metering system does not. Many "see" simply the overall light level Whether the scene is very light or very dark, the meter always calculates a shutter speed and aperture combination to render that light level as middle gray on the negative. Some meters (as shown opposite, bottom) are more sophisticated and favor the exposure of certain parts of the image.

A TTL meter may be coupled to the camera to set the exposure automatically or it may simply show an f-stop and shutter-speed combination for you to set. This viewfinder displays the aperture (below) and shutter speed (at side) to which the camera is set. It also signals under- or overexposure when you choose an aperture or shutter speed for which there is no corresponding setting within the range of those available on your camera.

Reading Reflected Light

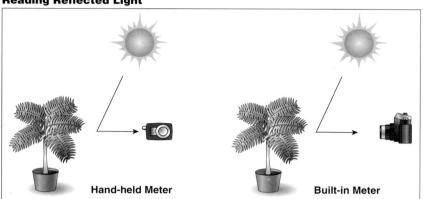

A reflected-light meter measures the amount of light reflected from an object. It can be hand held (left) or built into a camera (right). To make a reading, point the meter at the entire scene or at a specific part of it.

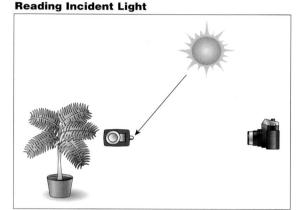

An incident-light meter measures the amount of light falling on it—and so, the amount of light falling on a subject in similar light. To make a reading, point the meter away from the subject, toward the camera.

Meter Weighting What part of a scene does a reflected-light meter measure?

An averaging or overall meter reads most of the image area and computes an exposure that is the average of all the tones in the scene. A hand-held meter, like the one shown opposite, typically makes an overall reading.

A spot meter reads only a small part of the image. Very accurate exposures can be calculated with a spot meter, but it is important to select with care the areas to be read. Hand-held spot meters are popular with photographers who want exact measurement and control of individual areas. Some cameras with built-in meters have a spot metering option.

Averaging Meter

Spot Meter

Center-weighted Meter

A center-weighted meter favors the light level of the central area of an image, which is often the most important one to meter. Cameras with built-in meters usually use some form of center weighting.

A multi-segment meter is the most sophisticated of the meters built into a camera. It divides the scene into areas that are metered individually, then analyzed against a series of patterns stored in the camera's memory. The resulting exposure is more likely to avoid problems such as underexposure of a subject against a very bright sky.

EXPOSURE METERS How to calculate and adjust an exposure manually

How do you calculate and adjust an exposure manually? Even if you have an automatic exposure camera, it will help you to know how to do so. Many automatic cameras do not expose correctly for backlit scenes or other situations where the overall illumination is not "average," and you will need to know how much and in what direction to change the camera's settings to get the results you want.

This page shows the way a hand-held meter works. Once you understand its operation, you will know how any meter functions, whether built into a camera or separate and hand-held. Pages 66-71 tell how to use a meter for different types of scenes.

Exposure = Intensity x Time. Exposure is a combination of the intensity of light that reaches the film (controlled by the size of the aperture) and of the length of time the light strikes the film (controlled by the shutter speed). You can adjust the exposure by changing the shutter speed, aperture, or both.

Exposure changes are measured in stops, a doubling (or halving) of the exposure. A change from one aperture (f-stop) to the next larger aperture opening, such as from f/5.6 to f/4, doubles the light reaching the film and results in one stop more exposure. A change from one shutter speed to the next slower speed, such as from $\frac{1}{250}$ sec. to $\frac{1}{125}$ sec., also results in one stop more exposure. A change to the next smaller aperture or the next faster shutter speed halves the light and produces one stop less exposure.

It is worth your effort to memorize the fstop and shutter-speed sequences, so that you know which way to move the controls when you are faced with an exposure you want to bracket or otherwise adjust.

Shutter speeds are one stop apart. A shutter speed of 1/125 sec. lets in twice as much light as a shutter speed of 1/250 sec.

The f-stop settings are one stop apart. F/4 lets in twice as much light as f/5.6. Remember that the lower the f-number, the larger the lens aperture, and so the more light let into the camera.

Film speed ratings double each time the sensitivity of the film doubles. An ISO 400 film is one stop faster than an ISO 200 film. It needs only half as much light as does the ISO 200 film.

Light measurement. On this meter, the light measurement number from the scale at the top of the meter is set into a rotating dial that calculates the exposure for a given film speed.

Each light measurement

number records a light level twice as bright as the next lower number-a one-stop difference. A reading of 11 is twice as high as a reading of 10.

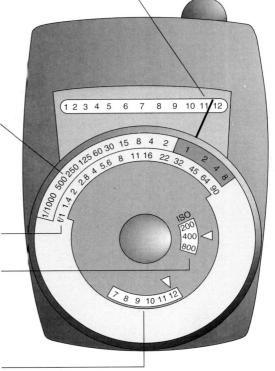

A hand-held exposure meter. Light striking this meter's light-sensitive photoelectric cell moves a needle across a scale that measures the intensity of the light. When you rotate the meter's dials to set in the light measurement reading and the film speed, the meter shows the combinations of f-stops and shutter speeds suggested for a normal exposure. An automatic exposure camera performs the same calculation, but selects the shutter speed and/or aperture for you.

The meter shows how light intensity, film speed, and shutter speed and aperture settings relate to each other. With a greater amount of light or a faster film speed, the camera can be set to a smaller aperture or a faster shutter speed. See page 185 for a light meter dial to cut out and assemble to help understand this.

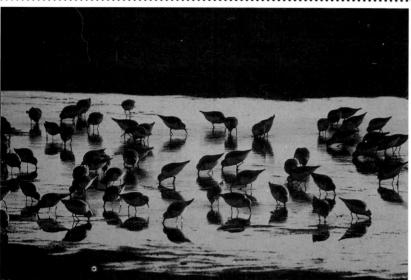

Bracketing your exposures is useful when you are not sure if an exposure is correct or if you want to see the results from different exposures of the same scene. Decreasing the exposure several stops for this scene darkened it so that the birds were silhouetted against the much brighter water. With more exposure, the scene would have been lighter, showing more details of the birds.

Bracketing produces lighter and darker versions of the same scene. Suppose an exposure for a scene is $\frac{1}{60}$ sec. shutter speed at f/5.6 aperture.

Original exposure

1/8	1/15	1/30	1/60	1/125	1/250	1/500 sec.
f/16	f/11	f/8	f/5.6	f/4	f/2.8	f/2

To bracket for one stop less exposure, which would darken the scene, keep the shutter speed at $\frac{1}{60}$ sec., while changing to the next smaller aperture, f/8. (Or keep the original f/5.6 aperture, while changing to the next faster shutter speed, $\frac{1}{125}$ sec.)

Bracketed for one stop less exposure

1/8	1/15	1/30	1/60	1/125	1/250	1/500 sec.
f/16	f/11	f/8	f/5.6	f/4	f/2.8	f/2

To bracket for one stop more exposure, which would lighten the scene, keep the shutter speed at $\frac{1}{60}$ sec. while changing to the next larger aperture, f/4. (Or keep the original f/5.6 aperture, while changing to the next slower shutter speed, $\frac{1}{30}$ sec.)

Bracketed for one stop more exposure

1/8	1/15	1/30	1/60	1/125	1/250	1/500 sec.
f/16	f/11	f/8	f/5.6	·f/4	f/2.8	f/2

Bracketing helps if you are not sure about the exposure. To bracket, you make several photographs of the same scene, increasing and decreasing the exposure by adjusting the aperture or shutter speed. Among several different exposures, there is likely to be at least one that is correct. It's not just beginners who bracket exposures. Professional photographers often do it as protection against having to repeat a whole shooting session because none of their exposures was quite right.

To bracket, first make an exposure with the aperture and shutter speed set by the automatic system or manually set by you at the combination you think is the right one. Then make a second shot with one stop more exposure and a third shot with one stop less exposure. This is easy to do if you set the exposure manually: for one stop more exposure, either set the shutter to the next slower speed or the aperture to the next larger opening (the next smaller f-number); for one stop less exposure, either set the shutter to the next faster speed or the aperture to the next smaller opening (the next larger f-number).

How do you bracket with an automatic exposure camera? In automatic operation, if you change to the next larger aperture, the camera may simply shift to the next faster shutter speed, resulting in the same overall exposure. Instead, you have to override the camera's automatic system. See page 64 for how to do so.

EXPOSURE 63

Overriding an automatic exposure camera

Many cameras with automatic exposure have some means of overriding the automatic system when you want to increase the exposure to lighten a picture or decrease the exposure to darken it. The change in exposure is measured in "stops." A one-stop change in exposure will double (or halve) the amount of light reaching the film. Each aperture or shutter speed setting is one stop from the next setting.

Exposure lock. An exposure lock or memory switch temporarily locks in an exposure, so you can move up close to take a reading of a particular area, lock in the desired setting, step back, and then photograph the entire scene.

Exposure compensation dial. Moving the dial to +1 or +2 increases the exposure and lightens the picture. Moving the dial to -1 or -2 decreases the exposure and darkens the picture.

Backlight button. If a camera does not have an exposure compensation dial, it may have a backlight button. Depressing the button adds a fixed amount of exposure, 1 to $1\frac{1}{2}$ stops, and lightens the picture. It cannot be used to decrease exposure.

Film speed setting. If the film speed can be manually set on your camera, you can increase or decrease exposure by changing the setting of the film speed. The camera then responds as if the film were slower or faster than it really is. Doubling the film speed (for example, from ISO 100 to ISO 200) darkens the picture by decreasing the exposure one stop. Halving the film speed (for example, from ISO 400 to ISO 200) lightens the picture by increasing the exposure one stop.

Even if you can't manually change a film speed dial or other camera mechanism, there may still be a way to change the film speed for a whole roll of film. Some camera stores sell foil stickers that let you change the DX coding on the film cassette. Doing so rearranges the black and silver squares that tell the camera's electronics the film speed.

Manual mode. In manual mode, you adjust the shutter speed and aperture yourself. You can increase or decrease the exposure as you wish.

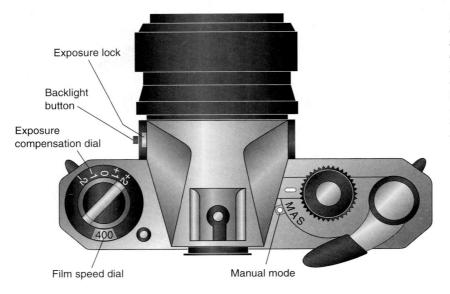

One or more means of changing the exposure are found on most

cameras. These features let you override automatic exposure when you want to do so. Don't forget to reset the camera to its normal mode of operation after the picture is made.

You can use manual mode to set the shutter speed and aperture for photographs at night, like this campfire scene. More about exposures for unusual lighting situations on page **71**.

Making an exposure of an average scene

An overall meter reading works well when most of a directly lit scene is evenly illuminated as seen from camera position. When light is shining directly on a subject, even illumination occurs when the main source of light is more or less behind you as you face the subject. Shadows may be dark but probably will not obscure important parts of the scene.

What exactly do you need to do to produce a good exposure, one that lets just enough light into the camera so that the film is neither underexposed, making the picture too dark, nor overexposed, making the picture too light? All meters built into cameras (and most hand-held meters) measure reflected light, the lightness or darkness of objects. In many cases, you can simply point the camera at a scene, activate the meter, and set the exposure (or let the camera set it) accordingly.

A reflected-light meter averages the light entering its angle of view. The meter is calibrated on the assumption that in an average scene all the tones—dark, medium, and light—will add up to an average medium gray. So the meter and its accompanying circuitry set, or recommend, an exposure that will record all of the light that it is reading as a middle gray in the photograph.

This works well if you are photographing an "average" scene, one that has an average distribution of light and dark areas, and if the scene is evenly illuminated as viewed from camera position, that is, when the light is coming more or less from behind you or when the light is evenly diffused over the entire scene (see photographs this page). See opposite for how to meter this type of average or low-contrast scene.

A meter can be fooled, however, if your subject is surrounded by a much lighter area, such as a bright sky, or by a much darker area, such as a large dark shadow. See pages **68–69** for what to do in such cases.

A scene in diffused light photographs well with an overall reading, for example, outdoors in the shade or on an overcast day, or indoors when the light is coming from several light sources. Diffused light is indirect and soft. Shadows are not as dark as they would be in direct light.

Using a meter built into a camera for exposure of an average scene Set the film speed into the camera. Some cameras do this automatically when you load the film.

 $2^{\mbox{Select}}$ the exposure mode: automatic (aperture-priority, shutter-priority, or programmed) or manual. Activate the meter as you look at the subject in the viewfinder.

B *In aperture-priority mode,* you select an aperture. The camera will select a shutter speed; make sure that it is fast enough to prevent blurring of the image caused by camera or subject motion. *In shutter-priority mode,* you select a shutter speed. The camera will select an aperture; make sure that it gives the desired depth of field. *In programmed (fully automatic) mode,* the camera selects both aperture and shutter speed. *In manual mode,* you set both aperture and shutter speed based on the readout in the viewfinder.

Calculating exposure of an average scene with a hand-held, reflected-light meter

Set the film speed into the meter.

Fredrik D. Bodin

2 Point the meter's photoelectric cell at the subject at the same angle seen by the camera. Activate the meter to measure the amount of light reflected by the subject.

3 Line up the number registered by the indicator needle with the arrow on the meter's calculator dial. (Some meters do this automatically.)

4 Set the camera to one of the combinations of f-stops and shutter speeds shown on the meter. Any combination shown lets the same quantity of light into the camera and produces the same exposure.

Calculating exposure of an average scene with an incident-light meter

◀ Set the film speed into the meter.

2 Position the meter so that the same light is falling on the meter's photoelectric cell as is falling on the part of the subject seen by the camera. To do this, point the meter's photoelectric cell away from the subject, in the opposite direction from the camera lens. Activate the meter to measure the amount of light falling on the subject. Make sure that the same light that is falling on the subject is falling on the meter. For example, take care not to shade the meter if the subject is brightly lit. Proceed as in steps 3 and 4 for reflected-light meter.

EXPOSING SCENES WITH HIGH CONTRAST

"It came out too dark." Sometimes even experienced photographers complain that they metered a scene carefully, but the picture still wasn't properly exposed. All a meter does is measure light. It doesn't know what part of a scene you are interested in or whether a particular object should be light or dark. You have to think for the meter and sometimes change the exposure it recommends, especially with a scene of high contrast, in which light areas are much lighter than dark ones.

The most common exposure problem is a backlit subject, one that is against a much lighter background, such as a sunny sky. Because the meter averages all the tonal values—light, medium, and dark—in the scene, it assumes that the entire scene is very bright. Consequently, it sets an exposure that lets in less light, which makes the entire picture darker and your main subject too dark. Less common is a subject against a very large, much darker background. The meter assumes that the entire scene is very dark, so it lets in more light, which makes the main subject too light.

To expose the main subject correctly in a contrasty scene, measure the light level for that part of the scene only. If you are photographing a person or some other subject against a much darker or lighter background, move in close enough so that you exclude the background from the reading but not so close that you meter your own shadow. If your main subject is a landscape or other scene that includes a very bright sky, tilt the meter or camera down slightly so you exclude most of the sky from the reading.

But suppose a bright sky with interesting clouds is the area in which you want to see detail and there are much darker land elements silhouetted against it (see page **56**). In that case, the sky is your main subject, the one you should meter to determine your camera settings.

An underexposed (too dark) photograph can result when the light is coming from behind the subject or when the subject is against a much brighter background, such as the sky. The problem is that a meter averages all the tonal values that strike its light sensitive cell. Here the photographer pointed the meter so that it included the much lighter tone of the sky as well as the person. The resulting exposure of ½50 sec. shutter speed at f/11 aperture produced a correct exposure for an average scene but not a correct exposure for this scene.

A better exposure for contrasty scenes results from moving up close to meter only the main subject, as shown above. This way you take your meter reading from the most important part of the scene—here, the person's face. The resulting exposure of 1‰ sec. at f/11 let in two more stops of exposure and made the final picture (right) lighter, especially the important part of it, the person's face.

A substitution reading is possible if you can't move in close enough to the important part of a contrasty scene. Look for an object of about the same tone in a similar light and read it instead. For exact exposures, you can meter the light reflected from a gray card, a card of standard middle gray of 18 percent reflectance (meters are designed to calculate exposures for subjects of this tone). The last page of this book is printed to this tone of gray and can be used for substitution readings. You can also meter the light reflected by the palm of your hand (see right). Make sure you hold the card or your hand in the same light that is falling on the subject.

How do you set your camera after you have metered a high-contrast scene? If your camera has a manual exposure mode, set the shutter speed and aperture to expose the main subject correctly, using the settings from a reading made up close or from a substitution reading. In automatic operation, you must override the automatic circuitry (see page 64). Don't be afraid to do this; only you know the picture you want.

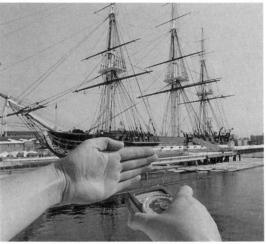

Fredrik D. Bodin

A substitution reading, such as one taken from the palm of your hand or a gray card, will give you an accurate reading if you can't get close enough to a subject. Make sure you are metering just the palm (or the card) and not the sky or other background of a different tone. A hand-held, reflected-light meter is shown here, but you can also use a meter built into a camera.

If you meter from the palm of your hand, try the exposure recommended by the meter if you have very dark skin, but give one stop more exposure if you have light skin, as here. If you make a substitution reading from a photographic gray card, use the exposure recommended by the meter.

Move in close to meter a high-contrast scene. With a built-in meter, move in (without blocking the light) until the important area just fills the viewfinder. Set the shutter speed and aperture and move back to your original position to take the picture.

With a hand-held, reflected-light meter, move in close enough to read the subject but not so close as to block the light. A spot meter, which reads light from a very narrow angle of view, is particularly useful for metering high-contrast scenes.

EXPOSING SCENES THAT ARE LIGHTER OR DARKER THAN AVERAGE

Scenes that are light overall, such as a snow scene, can look too dark in the final photograph if you make just an overall reading or let an automatic camera make one for you. The reason is that the meter will make its usual assumption that it is pointed at a scene consisting of light, medium, and dark tones, and it will expose the film accordingly. But this will underexpose a scene that consists mostly of light tones, resulting in a too-dark final photograph. Try giving one or two stops extra exposure to such scenes.

Scenes that are dark overall are less common, but can occur. Try reducing the exposure one or two stops.

In a silhouette, a subject is underexposed against a much lighter background. This can happen unintentionally if the subject is against a bright sky and you don't override the automatic exposure (see page 68). When you want a silhouette against a bright background, try giving several stops less exposure than the meter recommends for the main subject.

You can make some adjustments in tone when you print a negative, but it is easier to get good results if you start with a negative exposed for the effect you want. Bracket your exposures if you are not sure. If you are shooting transparencies, the film in the camera is the final product; you can't make adjustments after the fact, unless you later work with the image using digital imaging software, or make a negative or duplicate transparency from the original.

Snow scenes or bright beach scenes are often lighter than average. Adding an extra stop or two of exposure to an overall reading will help keep the final photograph light in tone.

cott Goldsm

EXPOSURES IN HARD-TO-METER SITUATIONS

Donald T. Young

What do you do when you want to make a photograph but can't make a meter reading—photographing fireworks, for instance, or a city skyline at night? Using a chart, like the one at right, or simply guessing and making a couple of experimental tries may produce an image you'll like very much. If you keep a record of the scene and your exposures, you will have at least an idea about how to expose such a scene the next time.

Bracketing is a good idea: make at least three shots—one at the suggested exposure, a second with 1 or 1½ stops more exposure, and a third with 1 or 1½ stops less exposure. Not only will you probably make one exposure that is acceptable, but each different exposure may be best for a different part of the scene. For instance, at night on downtown city streets a longer exposure may show people best, whereas a shorter exposure will be good for brightly lit shop windows.

Exposures in Hard-to-Meter Situations/ISO 400 Film

Outdoor scenes at night		
Brightly lit downtown streets	1/60 sec.	f/2.8
Brightly lit nightclub or theater districts, e.g., Las Vegas	1/60 Sec.	f/4
Neon signs and other lit signs	1/125 Sec.	f/4
Store windows	1/60 Sec.	f/2
Holiday lighting, Christmas trees	1/15 sec.	f/2
Subjects lit by streetlights	1/15 sec.	f/2
Floodlit buildings, fountains	1/15 sec.	f/2
Skyline-distant view of lit buildings	1 sec.	f/2.8
Skyline—10 min. after sunset	1/60 sec.	f/5.6
Fairs, amusement parks	1/30 sec.	f/2.8
Amusement-park rides—light patterns	1 sec.	f/16
Fireworks—displays on ground	1/60 Sec.	f/4
Fireworks—aerial displays (Keep shutter open for		
several bursts.)		f/16
Lightning (Keep shutter open for one or two streaks.)		f/11
Burning buildings, campfires, bonfires	1/60 Sec.	f/4
Subjects by campfires, bonfires	1/30 sec.	f/2
Night football, baseball, racetracks *	1/125 SeC.	f/2.8
Niagara Falls—white lights	4 sec.	f/5.6
Light-colored lights	8 sec.	f/5.6
Dark-colored lights	15 sec.	f/5.6
Moonlit landscapes	8 sec.	f/2
Moonlit snow scenes	4 sec.	f/2
Indoor scenes *		
Home interiors at night—average light	1/30 sec.	f/2
Candlelit close-ups	1/15 SeC.	f/2
Indoor holiday lighting, Christmas trees	1/15 SeC.	f/2
Basketball, hockey, bowling	1/125 Sec.	f/2
Boxing, wrestling	1/250 SeC.	f/2
Stage shows—average	1/60 Sec.	f/2.8
Circuses—floodlit acts	1/60 sec.	f/2.8
Ice shows—floodlit acts	1/125 Sec.	f/2.8
Interiors with bright fluorescent light ⁺	1/60 sec.	f/4
School—stage, auditorium	1/30 sec.	f/2
Hospital nurseries	1/60 sec.	f/2
Church interiors—tungsten light	1/30 sec.	f/2
* Use indoor (tungsten-balanced) film for color pictures † Use daylight-balanced film for color pictures © Eastman Kodak Company. 1978		

In hard-to-meter situations, try these manually set exposures for films rated at ISO 400. Give twice as much exposure (one stop more) for films rated at ISO 125 to ISO 200. Give half as much exposure (one stop less) for films rated at ISO 1000.

Solving exposure problems

See below if your negatives don't look right or are difficult to print. See also Solving Camera and Lens Problems, page **45**; Negative Development Problems, page **92**; Printing Problems, page **117**; Flash Problems, page **140**; and Evaluating Your Negatives, page **88**.

If you are evaluating a color slide, remember that it is the reverse of a negative. If your negative is too light or your slide is too dark, the problem is underexposure: too little light reached the film. If your negative is too dark or your slide is too light, the problem is overexposure: too much light reached the film.

No Picture, Frame Numbers Appear

No Picture, No Frame Numbers

Negative Thin

No picture at all. Image area and negative edges are clear, but film frame numbers are visible.

Cause: If the entire roll is blank, it was not put into the camera. If you are sure that it was, then it did not catch on the film advance sprockets and so did not move through the camera. If only a few frames are blank, the shutter was accidentally released with the lens cap on, the flash failed to fire, the shutter failed to open, or, in a single-lens reflex camera, the mirror failed to move up.

Prevention: To make sure film is advancing, check that the camera's rewind lever (if it has one) rotates when you advance the film. In an automated camera without a rewind lever, check that the frame-number counter advances. Have camera checked if film advance or other problems persist.

No picture at all. Image area and negative edges are completely clear, no film frame numbers are visible.

Cause: A film development problem; nothing is wrong with the camera. The film was put into fixer before it reached the developer, or it was not developed at all. **Prevention:** If you developed the film yourself, review film processing, page **85**.

Negative thin-looking, too light overall. With a too-thin negative it is difficult to produce a print that is not too dark.

Cause: Most likely, the negative was underexposed: film speed set too high, shutter speed too fast, aperture too small, or all of the above, resulting in not enough light reaching the film. See Evaluating Your Negatives, page **88**. Less likely, a film development problem; film received too little development. If your exposure was longer than 1 sec., reciprocity effect may have caused underexposure (see page **144**). Occasionally exposure problems are caused by camera malfunction, such as the shutter or lens diaphragm not working correctly.

Prevention: The best prevention for occasional exposure problems is simply to meter scenes more carefully and to make sure you correctly set all camera controls. Bracket your exposures (one or two with more exposure, one or two with less exposure) if you are not sure of the camera settings.

If your negatives frequently look underexposed, including entire rolls, your meter is probably inaccurate: if your camera lets you adjust the film speed setting (not all cameras do), set it to a number lower than the film's stated speed. For example, with ISO 400 film, set the camera to half that rating, 200, to get one stop more exposure. **Negative dense-looking**, **too dark overall**. With a too-dense negative it is difficult to produce a print that is not too light.

Cause: Most likely, the negative was overexposed: film speed set too low, shutter speed too slow, aperture too wide, or all of the above, resulting in too much light reaching the film. See Evaluating Your Negatives, page **88**. Less likely, a film development problem: film received too much development.

Prevention: If your negatives frequently look overexposed, including entire rolls, and your camera lets you adjust the film speed setting, set the camera to a film speed number higher than the film's stated speed. For example, if you are using ISO 400 film, set the film speed to double that rating, 800, to get one stop less exposure.

Snow scene (or other very bright scene) too dark. Negative appears thin, print or slide too dark.

Cause: The meter averaged all the tones in its angle of view, then computed an exposure for a middle-gray tone. The problem is that the scene was lighter than middle gray, so appears too dark.

Prevention: When photographing scenes that are very light overall, such as snow scenes or sunlit beach scenes, give one or two stops more exposure than the meter recommends. This will give the scene a realistically light tonality overall. See page **70**.

Subject very dark against lighter background.

Cause: Your meter was overly influenced by the bright background and underexposed the main subject.

Prevention: Don't make an overall reading when a subject is against a bright background. Instead, move in close to meter just the subject, then set your shutter speed and aperture accordingly (see page **68**).

Subject very light against darker background.

Cause: Your meter was overly influenced by the dark background and overexposed the main subject.

Prevention: This happens less often than the preceding problem, but it can occur if the subject is small and very light against a much larger, very dark background. In such cases, don't make an overall reading. Move in close to meter just the subject, then set your shutter speed and aperture accordingly.

Double exposures.

Cause: If images overlap on the entire roll, the film was put through the camera twice. If images overlap on one or a few frames, the film did not advance properly between exposures.

Prevention: Rewind 35mm film entirely back into the cassette, including the film leader; if you leave the film leader hanging out, you can mistake an exposed roll of film for an unexposed one and put it through the camera again. Accidentally pushing the film rewind button would let you release the shutter without having advanced the film. If double exposures are a repeated problem, have the film advance mechanism checked.

Negative Dense

Snow Scene Too Dark

Subject Too Dark Against Lighter Background

PROCESSING FILM: Equipment and chemicals you'll need 76
MIXING AND HANDLING CHEMICALS 78
PROCESSING FILM STEP BY STEP: Setting out materials needed 79 Preparing the film 80 Development 82

Stop bath and fixer **83** Washing and drying **84** SUMMARY OF FILM PROCESSING 85 How Chemicals Affect Film 86 Evaluating Your Negatives 88 Push Processing 90 Solving Negative Development Problems 92

DEVELOPING THE NEGATIVE

This chapter describes how to process black-and-white film. The film is immersed in chemicals that transform the invisible image on the film to a permanent, visible one. After you have developed a roll or two of film, you'll find that the procedure is relatively easy, and the principles are the same if you want to try developing your own color film.

Familiarize yourself with the steps involved before you develop your first roll, because the process begins in the dark and then proceeds at a brisk pace. Read through the step-by-step instructions on pages **79–84**, check the manufacturer's instructions, and make sure you have ready all the materials you'll need. Sacrifice a roll of unexposed film to practice loading the developing reel (steps 4-8); you'll be glad you did when you step into the darkroom to load your first roll and you turn out the lights.

Consistency and cleanliness pay off. If you want to avoid hard-to-print negatives, mysterious stains, and general aggravation, be sure to follow directions carefully; adjust temperatures exactly; and keep your hands, equipment, and the film clean. Darkrooms generally have a dry side where film is loaded and printing paper is exposed, and a wet side with sinks where chemicals are mixed and handled. Always keep chemicals and moisture away from the dry side and off your hands when you are loading film. (See Avoid Contamination, page **78**.)

You get your first chance to see the results of your shooting when you unwind the washed film from the developing reel. But when film is wet, the emulsion is soft and relatively fragile; dust can easily stick to the film, become embedded in the emulsion, and then appear in your print as white specks on the image. Resist the temptation to spend much time looking at the film until it is dry.

PROCESSING FILM Equipment and chemicals you'll need

EQUIPMENT TO LOAD FILM

Developing reel holds and separates the film so that chemicals can reach all parts of the emulsion. Choose a reel to match the size of your film, for example, 35mm, or the larger 120 roll-film size. Some plastic reels can be adjusted to different sizes. Stainless steel reels are not adjustable and are somewhat more difficult to learn to load than are plastic reels. However, they are the choice of many photographers because they are durable and easy to clean of residual chemicals.

Developing tank with light-trap cover accepts the reel loaded with film. Loading has to be done in the dark, but once the film is inside and the cover in place, processing can continue in room light. A light-tight opening in the center of the cover lets you pour chemicals into and out of the tank without removing the cover. Larger tanks are made that hold two or more reels, if you want to process more than one roll at a time.

Bottle cap opener pries off the top of a 35mm film cassette. Special cassette openers are also available.

Scissors trim the front end of 35mm film square and cut off the spool on which the film was wound.

Optional: **Practice roll of film** lets you get used to loading the developing reel in daylight before trying to load an actual roll of film in the dark. Useful for developing your first roll of film or when loading a different size of film for the first time.

A completely dark room is essential for loading the film on the reel. Even a small amount of light can fog film. If you can see objects in a room after 5 min. with lights out, the room is not dark enough. If you can't find a dark enough room, use a changing bag, a light-tight bag into which fit your hands, the film, reel, tank, cover, opener, and scissors. After the film is in the tank with the cover on, you can take the tank out of the bag into room light.

EQUIPMENT TO MIX AND STORE CHEMICALS

Source of water is needed for mixing solutions, washing film, and cleaning up. A hose on a faucet splashes less than water straight from the faucet.

Photographic thermometer measures the temperature of solutions. An accurate and easy-to-read thermometer is essential because temperatures must be checked often and adjusted carefully. You will need a temperature range from about 50° to 120°F (10° to 50°C).

Graduated containers measure liquid solutions. Two useful sizes are 32 oz (1 liter) and 8 oz (250 ml). Graduates can be used for mixing and for holding the working solutions you will need during processing.

Mixing containers

hold solutions while you mix them. You can use a graduated container for smaller quantities or a storage container with a wide mouth.

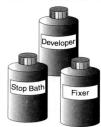

Storage containers

hold chemical solutions between processing sessions. They should be of dark glass or plastic to keep out light and have caps that close tightly to minimize contact with air, which causes oxidation and deterioration of the chemicals. Some plastic bottles can be squeezed and capped when partially full to expel excess air.

Stirring rod mixes chemicals into solution. The rod should not be made of wood but of an inert and nonabsorbent material such as hard plastic that will not react with or retain chemicals.

Optional: **Funnel** simplifies pouring chemicals into storage bottles.

Optional: Rubber

gloves protect your hands from potential allergic reactions to processing chemicals.

EQUIPMENT TO PROCESS FILM

Tri-X film	<u>65°F</u> min.	<u>68°F</u> min.
HC-110		
(Dilution B)	81/2	71/2
D-76	9	8
D-76 (1:1)	11	10
Microdol-X	11	10
DK-50 (1:1)	7	6

Manufacturer's instructions included with film or developer give recommended combinations of development time and developer temperature.

Containers for working solutions must be large enough to contain the quantity of solution needed during processing. Graduates are convenient to use. Have three for the main solutions-developer, stop bath, and fixer. It is a good idea to reserve a container for developers only; even a small residue of stop bath or fixer can keep the developer from working properly.

Optional: **Tray** or pan can be used as a water bath for the containers of working solutions to keep them at the correct temperature.

Timer with a bell or buzzer to signal the end of a given period is preferable to a watch or clock that you must remember to consult. An interval timer can be set from 1 sec. to 60 min. and counts down to zero, showing you the amount of time remaining.

Film clips attach washed film to a length of string or wire to hang to dry. Spring-loaded clothespins will do the job. A dust-free place to hang the wet film is essential. A school darkroom usually has a special drying cabinet; at home, a bathroom shower is good.

Optional: **Photo sponge** wipes down wet negatives so that they dry evenly.

Negative storage pages protect the dry film.

CHEMICALS

There are three essential and two optional (but recommended) solutions that you will need to process blackand-white film. For more information, see Mixing and Handling Chemicals (page **78**) and manufacturer's instructions.

Developer converts the latent (still invisible) image in exposed film to a visible image. Choose a developer designed for use with film, not for prints. For general use and for your first rolls of film, choose an all-purpose developer such as Kodak D-76, (T-Max developer if you use T-Max films), Ilford ID-11, or Edwal FG7.

The length of time that a developer can be stored depends on the developer and on storage conditions. A stock solution of Kodak D-76, for example, lasts about 6 months in a full container, 2 months in a half-full container. Some developers are reusable. See Replenishing-Type Developers and One-Shot Developers, page **78**.

Stop bath stops the action of the developer. Some photographers use a plain water rinse. Others prefer a mildly acid bath prepared from about 1 oz of 28 percent acetic acid per quart of water.

If you are using plain water as a stop bath, simply discard it after processing. An acetic acid stop bath is reusable. Working solution lasts about a month if stored in a full, tightly closed bottle, and treats about 20 rolls of film per quart. An indicator stop bath changes color when it is exhausted.

Fixer (also called hypo) makes film no longer sensitive to light, so that when fixing is complete the negative can be viewed in ordinary light. A fixer that contains a hardener makes film more resistant to scratching and surface damage. Regular fixer takes 5-10 min. to fix film; rapid fixer takes 2-4 min.

Fixer treats about 25 rolls of film per quart of working-strength solution, and lasts a month or more in a full container. The best test of fixer strength is to use an inexpensive testing solution called hypo check or fixer check. A few drops of the test solution placed in fresh fixer will stay clear; the drops will turn milky white in exhausted fixer.

Optional: Clearing

bath (also called a washing aid, fixer remover, or hypo neutralizer), such as Heico Perma Wash or Kodak Hypo Clearing Agent, followed by washing in running water, clears film of fixer more completely and faster than washing alone. The shortened wash time also reduces swelling and softening of the emulsion and makes the wet film less likely to be damaged.

Different brands vary in capacity and storage; see manufacturer's instructions.

Optional: Wetting agent, such as Kodak Photo-Flo, reduces the tendency of water to cling to the surface of the film and helps prevent water spots during drying, especially if you have hard water.

A very small amount of wetting agent treats many rolls of film. Discard the diluted solution periodically.

MIXING AND HANDLING CHEMICALS

Mixing dry chemicals.

Transfer dry chemicals carefully from package to mixing container so that you do not create a cloud of chemical dust that can contaminate nearby surfaces or be inhaled. Mix chemicals with water that is at the temperature suggested by the manufacturer; at a lower temperature, they may not dissolve. Stir the mixture of dry chemical and liquid aently until the chemical dissolves.

Stock and working

solutions. Chemicals are often sold or stored as concentrated (stock) solutions. Before use, the stock solution is diluted further to bring it to the correct working strength.

Dilution of a liquid from a more concentrated stock solution to its working strength is often given in instructions as a ratio, such as 1:4. The concentrated chemical is listed first, followed by the diluting liquid, usually water. A developer to be diluted 1:4 means add 1 part concentrated stock solution to 4 parts water. Always add concentrate to water rather than water to concentrate so that any splashes will be mostly water.

Replenishing-type developers can be

reused if you add replenisher chemicals after each developing session to bring the solution back to working strength. To get consistent results, follow the manufacturer's instructions for use, and keep an exact record of the number of rolls processed and the replenishment. Also record the date the developer was mixed, and discard any solution stored longer than recommended. If in doubt about the age or strength of any solution-throw it out.

One-shot developers

are used once, then discarded. They are often used in school darkrooms so that there is no question about developer replenishment, age, or strength. They are also a good choice if a relatively long time passes between your developing sessions because stored developer deteriorates with time, and rapidly so if it is diluted to working strength.

Raising or lowering temperatures will take

less time if the solution is in a metal container rather than a glass or plastic one. To heat a solution, run hot water over the sides of the container. To cool a solution, place the container for a short time in a tray of ice water. Stir the solution occasionally to mix the heated (or cooled) solution near the outside of the container into the solution at the middle.

Avoid unnecessary

oxidation. Contact with oxygen speeds the deterioration of most chemicals, as does prolonged exposure to light or heat. Stir solutions gently to mix them rather than shaking them. Don't let chemicals sit for long periods of time in open tanks or trays. Store in tightly covered, dark-colored containers of the right size. Chemicals last longer in full or nearly full containers.

Avoid contamination.

Getting chemicals where they don't belong is a common cause of darkroom problems and an easy one to prevent.

Keep work areas clean and dry. Wipe up spilled chemicals and rinse the area thoroughly with water. Keep chemicals away from the dry side of the darkroom, where you load film and make prints. Measure and mix chemicals and do all your processing on the wet side of the darkroom.

Chemicals on your fingers, even in small amounts, can cause spots and stains on film or paper. Rinse your hands well when you get chemicals on them, then dry them on a clean towel.

Rinse tanks, trays, and cther equipment well. The remains of one chemical in a tank can affect the next chemical that comes in contact with it. Be particularly careful to keep stop bath and fixer out of the developer.

Wear old clothes or a work apron in the darkroom. Developer splashed on your clothes will darken to a stain that is all but impossible to remove, and fixer can bleach colors.

Handle chemicals

safely. Photographic chemicals, like any chemical, should be handled with care. Note the following precautions and read manufacturer's instructions before using a new chemical.

Mix and handle chem cals only in areas where there is adequate ventilation and a source of running water. Do not inhale chem cal dust or vapors or get chemicals in your mouth or eyes. Wash hands carefully before eating.

Some people are allergic to certain chemicals and can develop skin rashes or other symptoms, especially with repeated exposure. See a doctor if you suspect this is happening to you. Using rubber gloves and tongs will minimize chemical contact.

Special safety cautions with acids.

Follow the basic rule when diluting concentrated acids: ALWAYS ADD ACID TO WATER, NOT WATER TO ACID. Stop bath is an acid.

Concentrated acids that come in contact with your skin can cause serious burns. Immediately flush well with cold water. Do not scrub. Do not use ointments or other preparations. Cover with dry, sterile cloth until you can get medical help.

If you get chemicals in your eye, immediately flush the eye with running water for at least 15 min. Then get to a doctor immediately.

If you swallow any chemicals, do not induce vomiting. Drink a neutralizing agent such as milk or milk of magnesia. See a doctor immediately.

PROCESSING FILM STEP BY STEP Setting out materials needed

1 Determine the developer time and temperature. The warmer the developer, the faster it works, so the less time needed to develop the film. Manufacturers provide charts recommending time-and-temperature combinations in the instructions that come with developers and films. Darker, **boldface** type usually indicates the optimum combination. If the chart lists different times for large tanks and small tanks (sometimes called reel-type tanks), use the small-tank times. Select a time-and-temperature combination for your film and developer.

KODAK T-MAX 400 Professional Film

Kodak Developer	Small-Tank Development Time in Minutes (Use vigorous agitation at 30-second intervals)				EI	
Kouak Developei	65°F (18°C)	68°F (20°C)	70°F (21°C)	72°F (22°C)	75°F (24°C)	LI
T-Max RS Developer		_				
and Replenisher		7	6	6	5	400/27°
T-Max	-	7	61/2	61/2	6	400/27°
D-76	9	8	7	61/2	51/2	400/27°
D-76 (1:1)	141/2	121/2	11	10	9	400/27°
HC-110 (Dil B)	61/2	6	51/2	5	41/2	320/26°
Microdol-X	12	101/2	9	81/2	71/2	200/24°
Microdol-X (1:3)	_		20	181/2	16	320/26°

The development times in **bold type** are the primary recommendations.

The developer you use determines the exposure index (EI). Set your camera or meter (marked for ISO or ASA speeds) at the speed shown for your developer.

2 Mix the solutions and adjust their temperatures. Dilute the developer, stop bath, and fixer to working strength recommended by the manufacturer. Make at least enough solution to completely cover the reel (or reels, if you are developing more than one) in the tank; it's better to have too much solution than too little. Check temperatures (rinse the thermometer between solutions). Adjust the developer temperature exactly, and the stop bath and fixer within 3 degrees of the developer temperature. In a cold darkroom, put the containers of solutions into a tray of water at the developing temperature; this will prevent them from cooling down before you are ready to use them. Or, you can mix the chemicals after loading the film.

3 Arrange materials for loading film. In a dry, clean, light-tight place, set out your exposed roll of black-and-white film, the developing tank and its cover, a reel, a pair of scissors, and a bottle cap opener. Make sure the tank, its cover, and, particularly, the reel are clean and dry.

If this is your first roll of film, practice steps 4-8 (shown on pages **80–81**). Film has to be loaded onto the reel and put into the tank in complete darkness, so if you are developing your first roll of film, practice locating things with your eyes shut. Use a junked roll of film to practice loading the reel.

Each coil of film must be wound into a separate groove. If two or more coils wind onto the same groove or part of a coil jumps its track, different sections of film can come in contact with each other and prevent development at those points.

When you practice, particularly if you are using a stainless-steel reel, see how much of the reel the film fills. A 36-exposure roll of 35mm film will fill a reel completely: a 12- or 24-exposure roll will fill it part way. Knowing how full the reel should be will help you check that it is correctly loaded when you are in the dark.

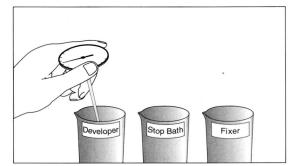

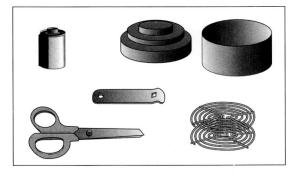

PROCESSING FILM STEP BY STEP Preparing the film

Before opening the film cassette, make sure your hands are clean and dry, with no residue from any chemicals that you have been handling. Check that everything you will need is in place (see step 3). Lock the door and turn off the lights. Keep lights off until the film is in the tank with the cover on.

Note: The gray tone over the drawings in this chapter means that the room must be completely dark.

4 Open a 35mm film cassette. Use the rounded end of the bottle cap opener to pry off the flat end of the cassette. From the other end, gently push out the film, together with the spool on which it is wound.

Opening other types of roll film. With larger sizes of roll film, which are wrapped in paper, break the seal and let the film roll up loosely as you unwind it from the paper. When you reach the end of the film, gently pull it loose from the adhesive strip that attaches it to the paper. To open film that is in a plastic cartridge, twist the cartridge apart and remove the spool of film.

5 Trim 35mm film square. 35mm film has a tongue of film leader at its front end. Cut off this tongue to make the end of the film square.

Handle film carefully. Hold the film loosely by its edges. This helps prevent oil from your skin getting on the image area of the film and causing uneven development or fingerprints. Do not unroll film too fast or rip off an adhesive strip with a quick snap. Doing so can generate a flash of static electricity that may streak the film with light.

6 Loading a stainless-steel reel. The reel shown here consists of wire spirals running from the core of the reel to the outside. The film loads into the grooves between the spirals.

Hold the reel vertically in your left hand and feel for the blunt ends of the wire on the outermost spirals. Position the reel with the ends on top, pointing toward your right hand. Hold the film in your right hand so that the film unwinds from the top, pointing toward the reel. (If you are lefthanded, hold the reel in your right hand, the film in your left hand.) **Thread the film into the reel.** Unwind 2 or 3 inches of film and bow it slightly upward by squeezing the sides gently (extreme flexing can crimp the film and cause marks). Insert the end of the film into the core of the reel. Feed the film in straight so that it goes squarely into the center of the reel. Attach the film to the clip at the center of the reel, if there is one.

Wind the film on the reel. Rest the reel edgewise on a flat surface. Keeping the film bowed slightly upward, rotate the top of the reel away from the film to start the film feeding into the innermost spirals. Hold the film loosely and let it be drawn from your fingers, rather than poking or forcing the film into the reel. If the film kinks, unwind past the kink, then rewind. When all the film is wound, cut the spool free with the scissors.

Check that the film is wound correctly by feeling how full the reel is. If you find more—or fewer—empty grooves than should be there, gently unwind the film from the reel, rolling it up as it comes, and begin again.

B Alternate procedure: Loading a plastic reel. To load this type of plastic reel, first run your finger along the squared-off end of the film to make sure you have cut between the sprocket holes, not through them. The film may snag if the end is not smooth. Hold the film in either hand so it unwinds off the top. Hold the reel vertically in your other hand with the entry flanges at the top, evenly aligned and pointing toward the film. Insert the end of the film just under the entry flanges. Push the film forward about half a turn of the reel. Now hold the reel in both hands (shown at right); turn the two halves of the reel back and forth in opposite directions to draw the film into the reel.

O Put the reel in the tank and cover it. The cover shields the film from light, so when the loaded reel is in the tank with the cover securely in place you can turn on the room lights or take the tank to the developing area.

Important: Do not remove the entire cover to add or pour out solutions. The tank shown here has a pouring opening at the center of the cover with a small cap that is removed to add or pour out solutions. The cap is put back during agitation so that chemicals do not spill out.

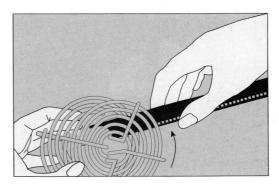

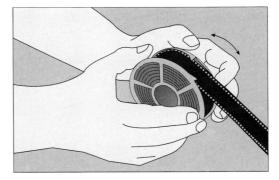

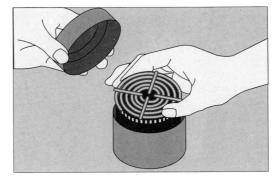

PROCESSING FILM STEP BY STEP Development

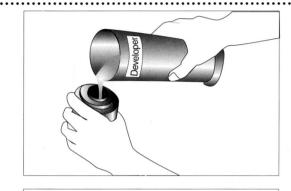

10 Before pouring the developer into the tank, check the developer temperature. If the temperature has changed, readjust it and the other solution temperatures, or select the corresponding development time from the time-and-temperature chart. Set the timer.

Start the timer and pour the developer into the tank. To fill the tank, remove only the small cap at the center of the lid, not the entire lid. Tilt the tank slightly to help it accept the liquid quickly, and pour in developer until the tank is completely full.

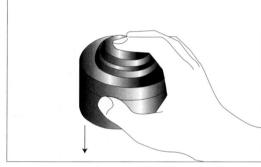

Begin agitation immediately. Quickly replace the cap on the tank cover and hold the tank so that its cover and cap won't fall off.

Rap the bottom of the tank once or twice sharply against a solid surface to dislodge any air bubbles that might be clinging to the film surface. Do this only at the start of development.

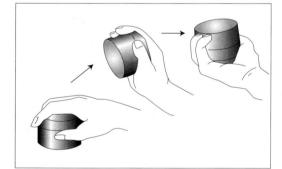

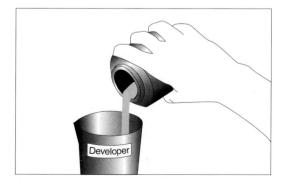

12 Agitate the developer in the tank by turning the tank upside down and right side up again. Each complete movement should take about 1 sec. Provide an initial agitation of 5 sec., then repeat the agitation for 5 sec. out of every 30 sec. during the development time. (Check instructions for the developer you are using. Follow manufacturer's recommendations if they differ from these.) Put the tank down between agitation periods so that your hands don't warm or further agitate the solution within.

Some plastic tanks have a crank in the lid that rotates the reel to agitate it. Do not invert this type of tank or it may leak.

 $13 B^{\rm Pour}$ out the developer. 10-15 sec. before the end of the development time, remove only the small cap from the pouring opening. Do not remove the entire tank cover.

Hold the tank so the cover won't come off. Pour the developer out of the tank, draining it completely. Discard the solution if you are using a one-shot developer; save it if it can be replenished and used again (see page **78**).

Stop bath and fixer

14 **Pour the stop bath into the tank.** Immediately pour the stop bath through the pouring opening in the tank cover. As before, tilt the tank to help it accept the liquid quickly and fill the tank completely. Replace the small cap over the pouring opening.

Agitate the stop bath. Agitate continuously for about 30 sec. by gently swirling and inverting the tank, holding the tank cover and its cap so they won't fall off.

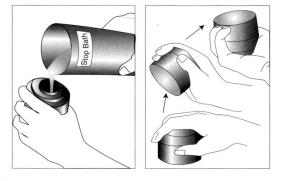

15 Pour out the stop bath. Remove only the small cap from the pouring opening. Do not remove the entire tank cover. Hold the tank so that the cover won't come off and pour out the stop bath, draining the tank completely. Discard a plain water stop bath; save an acetic acid stop bath, which can be reused.

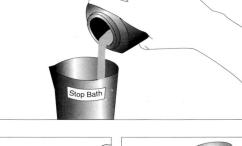

16 Pour the fixer into the tank. Pour the fixer through the pouring opening in the tank cover until the tank is full. Replace the small cap over the pouring opening.

Agitate the fixer. Agitate continuously for the first 30 sec. of the fixing time recommended by the manufacturer, then at 30-sec. intervals. Fixing time will be about 5–10 min. with regular fixer, 2–4 min. with rapid fixer.

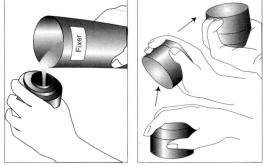

17 Check that the film is clearing. Halfway through the fixing time, lift the tank cover and take a quick look at the film. Film should be fixed for about twice the time it takes to clear of any milky appearance. If the film still has a milky look after fixing for more than half the maximum time recommended by the manufacturer, the fixer is exhausted and should be discarded. Keep the tank covered and refix the film in fresh fixer.

Pour out the fixer, saving it for future use. Once the film has been fixed, it is no longer sensitive to light, and the tank cover can be removed.

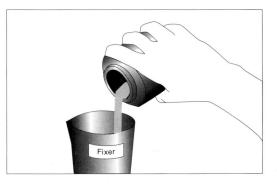

PROCESSING FILM STEP BY STEP Washing and drying

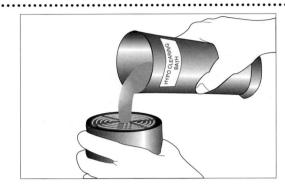

18 Treating the film with a clearing bath is an optional but recommended step that will greatly reduce the washing time. With Kodak Hypo Clearing Agent, first rinse the film in running water for 30 sec. Immerse in the working solution of clearing bath, agitating first for 30 sec., then at 30-sec. intervals for $1\frac{1}{2}$ min. more. (Check manufacturer's instructions if you are using a different brand.)

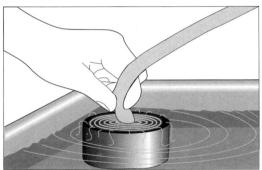

19 Wash the film in running water at about the development temperature. Leave the film on the reel in the tank and, after adjusting the water temperature, insert the hose from the faucet into the core of the reel. Run the wash water at least fast enough to completely change the water in the tank several times in 5 min. Also dump the water completely several times. Wash for 5 min. if you have used a hypo clearing bath, 30 min. if you have not.

Treating the film with a wetting agent is optional but highly recommended to help prevent spotting as the film dries. Immerse film in diluted solution for 30 sec., agitating gently for about 5 sec.

20 Hang the film to dry in a dust-free place. Hang a clip or clothespin on the bottom end to keep the film from curling. Handle the film as little as possible and very carefully at this stage; the wet emulsion is soft and easily damaged.

Wiping down the film gently can speed drying and discourage spotting or streaking if that is a problem even though you use a wetting agent. Use only a clean sponge made for photo purposes and dampened with diluted wetting agent. Keep the sponge in good condition by squeezing (not wringing or twisting) out excess moisture. The risk of wiping the film is that you may scratch it; don't wipe it if it dries well without wiping.

21 Clean up. Discard a one-shot developer or save and replenish a developer that can be reused (see page 78). Store solutions that you want to save in tightly closed containers. Rinse well your hands, the reel, tank, containers, and any other equipment that came in contact with chemicals.

When the film is completely dry it will curl slightly toward its emulsion, the less shiny side. Cut the film into strips of five or six frames, depending on the size of the storage pages you have. Insert individual strips gently into the page's sections, handling the film by its edges. Store in a dust-free place, away from extremes of temperature or humidity.

SUMMARY OF FILM PROCESSING

Step	Time	Procedure
Prepare chemicals		Mix the developer, stop bath, and fixer, plus optional clearing bath and wet- ting agent and dilute to working strength. Select a developer time and temperature from the film or developer man- ufacturer's instructions. Adjust the temperature of all the solutions accord- ingly.
Load film	_	IN TOTAL DARKNESS, load the film onto the developing reel. Put the loaded reel into the tank and put on the tank's cover. Lights can be turned on when tank is covered.
Development	Varies with film, developer, and temperature	Check the solution temperatures and adjust if necessary. Start timer. Pour developer into the tank through the pouring opening in the tank cover. DO NOT REMOVE ENTIRE COVER. Rap tank bottom once or twice on a solid surface. Agitate by inverting the tank several times during 5 sec., then during an additional 5 sec. out of every 30 sec. of development time. 10–15 sec. before the development time is over, pour out developer through the pouring opening in tank cover. DO NOT REMOVE ENTIRE COVER.
Stop bath	30 sec.	Immediately fill tank through pouring opening with stop bath. Agitate for the entire time. Pour out through pouring opening. DO NOT REMOVE ENTIRE COVER.
Fixer	5-10 min. with regular fixer; 2-4 min. with rapid fixer	Fill tank through pouring opening with fixer. Agitate for 30 sec., then at 30- sec. intervals. Pour out fixer.
Clearing bath (recommended)	30 sec. rinse in running water. Then 2 min. in clearing bath.	Agitate in the clearing bath for 30 sec., then at 30-sec. intervals for another $1\frac{1}{2}$ min. (Check manufacturer's instructions.)
Wash	5 min. if you used a hypo clearing bath; 30 min. if you did not	Wash water should flow fast enough to fill tank several times in 5 min. Dump water out of the tank several times during wash period.
Wetting agent (recommended)	30 sec.	Immerse the film in the wetting agent, agitating gently for about 5 sec. Mix the wetting agent with distilled water, if you live in a hard-water area.
Dry	1 or more hours. Less in a heated film drying cabinet.	Remove film from reel and hang to dry in a dust-free place. When completely dry, cut into convenient lengths and store strips in storage pages.

HOW CHEMICALS AFFECT FILM

What developer does. Even after film has been exposed to light, the image is latent, not yet visible. Developer chemicals take the film to its next step by converting the exposed crystals of silver halide in the film emulsion to visible metallic silver. The active ingredient in the developer that does this is the reducing agent. Metol and hydroquinone, often used in combination, are two common reducers.

Other chemicals enhance the action of the reducer. Most reducers work only in an alkaline solution. This is provided by the accelerator, an alkaline salt such as borax or sodium carbonate. Some reducers are so active that they can develop the unexposed as well as the exposed parts of the film, fogging the film with unwanted silver. To prevent this, a restrainer, usually potassium bromide, is added to some developers. A preservative, such as sodium sulfite, prevents oxidation and premature deterioration of the developer solution.

Developer time and temperature are critical. The longer the film is in the developer at a given temperature or the higher the temperature of the developer for a given time, the more of the silver halide crystals that will be converted to metallic silver and the denser and darker the negative will be. As little as 30 sec. or a few degrees temperature change can make a significant difference in the resulting image. Charts (such as the one on page **79**) show the combinations of time and temperature for various films and developers.

The stop bath is a simple acid solution (sometimes plain water is used) that neutralizes and partially removes the alkaline developer. Fixer is also acidic, so use of an acid stop bath helps extend the life of the fixer.

Fixer makes the image permanent by dissolving out of the emulsion any undeveloped crystals of silver halide. These are still sensitive to light and, if exposed, would darken the negative overall. This is why the cover must stay on the developing tank until well into the fixing stage of development (step 17, page 83). Once the fixing is complete, a permanent image of metallic silver remains. Fixer time is not as critical as developer time, but the film should not be underfixed or overfixed, so follow the time limits set by the manufacturer.

The active chemical in fixer is usually sodium thiosulfate. An early name for this chemical was sodium hyposulfite, which is why fixer is still often referred to as hypo. Ammonium thiosulfate is a similar but faster-acting chemical used in rapid fixers. A hardener is also usually part of the fixer formula. It prevents the emulsion from softening and swelling during the washing that follows fixing.

Washing removes chemicals left in the film after fixing, such as sulfur compounds that can damage the image if allowed to remain. Simple immersion in running water will adequately wash the film, but treatment with a clearing bath speeds up the process and does a better job than using water alone, leaving the film as permanent as possible.

Fresh solutions are vital. Chemicals gradually deteriorate, particularly once they are diluted to working strength with water and exposed to air. Processing film in exhausted chemicals can produce stains, fading images, uneven development, or no image at all. When you store chemical solutions for future use, keep a written record of the date you mixed the solution and how many rolls of film you processed with it. Don't store chemicals longer than the manufacturer recommends or try to use them to process more rolls of film than recommended. **As development begins**, the developer solution goes to work first on exposed crystals of silver near the surface of the film.

As development continues, the developer solution soaks deeper into the emulsion and the film becomes denser with developed silver.

With even more development, bright highlight areas, which received the most exposure to light in the camera, continue to increase in density at a more rapid rate than dark shadow areas that were exposed to less light.

Developer time and temperature affect how dense a deposit of silver will be created in the film emulsion. The image gradually increases in density during development.

Evaluating your negatives

You can make a print from a negative that is less than perfect, such as one that is overexposed or overdeveloped and so has too much density in the highlights (see the negatives opposite, far right). But if a negative is correctly exposed and developed, it will be easier to print and you will usually get a better print from it.

Negatives are affected by both exposure and development. An old photographic rule is: Expose for the shadows, develop for the highlights. You can change the density of bright highlights during development, but you must give adequate exposure in the camera to dark shadow areas if you want them to show texture and detail in the print. In photographic terms, shadows are the darkest parts of a scene, even if they are not actually in the shade. Highlights are the lightest-toned areas.

Development controls highlight density.

The longer the development time (at a given temperature), the denser and darker a negative will be, but that density does not increase uniformly over the entire negative. During extended development, the density of highlights, such as a sunlit white wall, increases quickly. The density of medium tones, such as a gray rock, increases at a moderate rate. The darkest tones, such as a deeply shaded area, change very slowly. Increasing the development time increases the contrast, the difference between the densities of bright highlight areas and dark shadow areas.

Exposure controls shadow density. Since development time has relatively little effect on the thinner areas in a negative (the darker parts of the original scene), they must be adequately exposed to begin with if you want them to show texture and detail. If you frequently have trouble getting enough detail in darker parts of your prints, try giving your negatives more exposure by resetting the film

speed dial to a speed lower than that recommended by the film manufacturer or by bracketing to give the film extra exposure. (If you have an automatic camera, you'll need to override its automatic settings. Page **64** gives general information on how to do this, or see your camera's instruction manual.)

Follow recommended development times exactly at first. Ordinarily, you should use the recommended times, but you can change them if you find that roll after roll of your negatives are difficult to print. If your negatives are often high in contrast, so that you print most negatives on a low-contrast paper, try decreasing the development time 20 to 30 percent (more about paper contrast grades in Chapter 6, Printing). If your negatives are often low in contrast, so that you have to print most of your negatives on a high-contrast paper, try increasing the time 25 to 40 percent.

You can change the development for individual scenes. Just as you can adjust the exposure for different scenes, you can change the development time for a scene as well. In a very contrasty scene, for example, in a forest on a sunny day, sunlit foliage can measure six or more stops brighter than dark shadows. Given normal exposure and development, such a scene will produce very contrasty, hard-to-print negatives. You can decrease the density of highlights and so decrease the contrast by decreasing the negative development to about three-quarters the normal time.

In a scene with little contrast, perhaps at dusk or on an overcast day, the difference between highlights and shadows may be only two or three stops. If you think such a scene will be too flat, with too little contrast, try increasing the negative development time by 50 percent.

With roll film, changing the development affects the entire roll, so it's best to shoot the whole roll under the same conditions.

How do you tell the difference between an underexposed negative and an underdeveloped one? Or between an overexposed negative and an overdeveloped one? It's useful to be able to recognize which is which in order to prevent problems with future negatives.

Underexposed. If your negatives are consistently too thin and lack detail in shadow areas, increase future exposures. One way to do this is by setting the camera to a lower film speed. For one stop more exposure, divide the normal film speed by two.

Overexposed. If many of your negatives are too dense overall with more than adequate detail in shadow areas, decrease future exposures, such as by setting the camera to a higher film speed. For one stop less exposure, multiply the film speed by two.

A normally exposed, normally developed negative (made of a scene with a normal range of contrast) should have good separation in highlights, mid-tones, and shadows. The negative will make a good print on a normal contrast grade of paper.

Barbara Jaguzny/Monica Jaguzny

Underdeveloped. If many negatives seem flat, with good shadow detail but not enough brilliance in highlights, increase the development time for future rolls. Try developing for 50 percent more than the normal time.

Overdeveloped. If negatives are often too contrasty, with good shadow detail but highlights that are overly dense (particularly if you make prints on a condenser enlarger), decrease the development time for future rolls. Try developing for three-quarters the normal time.

PUSH PROCESSING

Push processing can help you shoot in very dim light. Sometimes the light on a scene is so dim that you cannot use a fast enough shutter speed even at the widest lens aperture. Pushing the film lets you shoot at a film speed higher than the normal rating by, in effect, underexposing the film. For example, if you are using an ISO 400 film, you can reset your film speed dial to ISO 800 or even ISO 1600. This underexposes the film, but lets you shoot at a faster shutter speed. To compensate for the underexposure, you overdevelop the film, either by increasing the development time or by using a special high-energy developer, such as Acufine, Diafine, or Microphen.

To double the film speed, such as from ISO 400 to ISO 800, try increasing your normal development time by about 50 percent. Kodak T-Max films need less increase in development time. See chart at right for manufacturer's instructions. The times of the other processing steps (stop bath, fixer, and wash) stay the same.

Push processing does not actually increase the film speed. It does, however, increase the density of highlight areas enough to produce a usable image, which you might not have if you exposed and developed the film normally. Dark tones, such as shadowed areas, will be darker and less detailed than in a normally exposed scene because they will be underexposed and the increased development time will not have much effect on them. With push processing, you deliberately sacrifice shadow detail to get a usable highlight image.

Push processing has some side effects. The more you push the film by increasing the working film speed and subsequently overde-veloping, the more that graininess and contrast increase, and sharpness and shadow detail decrease.

Pushing Black-and-White Films

Film (normal speed ISO 400)	Developer	To push film speed one stop to 800	To push film speed two stops to 1600
Kodak T-Max 400	Kodak T-Max 75°F (24°C)	Develop normally 6 min.	8 min.
	Kodak D-76 68°F (20°C)	Develop normally 8 min.	10½ min.
Kodak Tri-X	Kodak T-Max 75°	Develop normally 5½ min. (or in- crease time to 6½–7 min.)	8 min.
	Kodak D-76 68°	Develop normally 8 min. (or increase time to 9½–11 min.)	13 min
llford HP5 Plus	Ilford Microphen 68°	8 min.	11 min.
Fuji Neopan 400	Kodak T-Max 75°	5¼ min.	8 min.
Film (normal speed ISO 3200)	Developer	To push film speed one stop to 6400	To push film speed two stops to 12,500
Kodak T-Max P3200	Kodak T-Max 75°	11 min.	12½ min.

Sometimes you don't need to change the development time: you can push film one stop by underexposing it and developing normally. Kodak recommends this for a one stop push of its T-Max 400 film. Simply expose at ISO 800, instead of the standard ISO 400. Kodak feels that this film has enough exposure latitude to accept one stop of underexposure without the need for extra development. Kodak also recommends normal development for a one stop push of Tri-X film. However, many photographers still prefer the results they get from increasing the development for a one stop push of Tri-X.

Pushing film speed. The chart shows some manufacturers' development recommendations for pushing film. The development times shown are a starting point from which you should experiment to determine your own combinations.

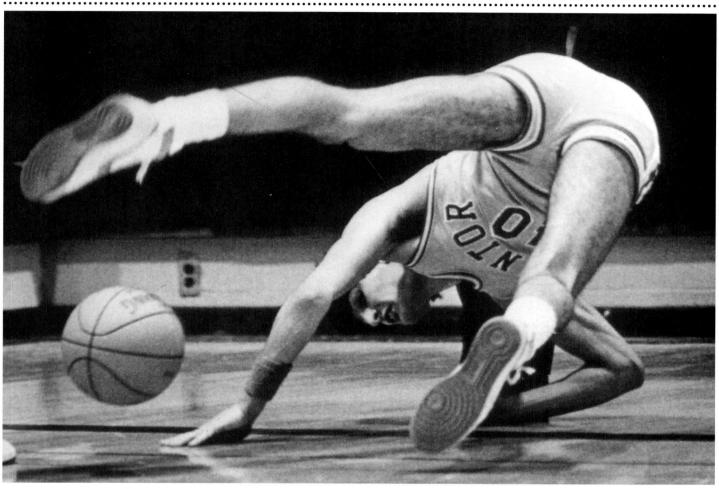

Pushing film, underexposing the film then giving it greater-than-normal development, lets you expose film at a higher-than-normal film speed. It can save the day when the available light isn't bright enough for you to use as fast a shutter speed as you want. Lois Bernstein rated Kodak Tri-X film at ISO 1600 instead of the standard ISO 400 and gave the film special development. This gave her two extra stops of film speed and let her shoot at a ½500 sec. shutter speed, fast enough to freeze the basketball player and ball as they both bounced out of bounds. Pushing increases graininess and contrast in a photograph, but is valuable when you must have more film speed than normal processing can provide.

Solving negative development problems

Patches of Undeveloped Film

Alan Uransk

Partial Development

Alan Oransky

Overdevelopment on Edges of Film

Check the following list if your negatives show spots, stains, or other disorders. The most common problems are described, along with suggestions on how to prevent them from happening again. See also Solving Camera and Lens Problems, page **45**; Exposure Problems, page **72**; Printing Problems, page **117**; Flash Problems, page **140**; and Evaluating

Patches of undeveloped film. Irregular in shape, usually on more than one frame of film.

Cause: Two loops of film came in contact with each other during processing, either by being wound together onto the same loop of the developing reel or by being squeezed together after reeling. As a result, chemicals did not reach the film emulsion where it was touching. Most often the patches will be totally unprocessed and opaque (light in print). Less likely, but possible if the film comes unstuck during fixing, are clear patches on film (dark in print).

Prevention: Check the positioning of the film with a fingertip as you wind it onto the reel. If it feels wrong, unwind a few loops and start again (see steps 7 and 8, page **81**).

Cinch marks. Small, dark marks (light in print), often with the crescent-moon shape and approximate size of a fingernail clipping.

Cause: Film was pinched or squeezed too tightly while it was being loaded onto the reel.

Prevention: Handle film gently during loading, without pinching or crumpling it, especially if you have to unreel and re-reel it. Bow film only slightly to feed it onto the reel.

Partial development. A strip along one edge of the entire roll of film is lighter than the rest of the film (darker in print).

Cause: Developer did not entirely cover reel of film.

Your Negatives, page 88.

Prevention: Check the amount of developer needed to cover reel in tank (or reels, in a tank that accepts more than one reel), or fill tank to overflowing. Mix up a bit more developer than you need in case you spill some when filling the tank.

Overdevelopment on edges of film. Streaks on the edge of the film are somewhat darker than the surrounding area (lighter in print). Streaks are coming from sprocket holes of 35mm film.

Cause: Excessive agitation in developer forced solution along spirals of developing reels and through the sprocket holes of 35mm film, overdeveloping the edges of film. **Prevention:** Do not agitate film in developer longer than the recommended amount or with excessive vigor: only a gentle motion is needed (see step 12, page **82**). If you develop one reel of film in a two-reel tank, put an empty reel on top so the loaded one doesn't bounce back and forth.

Uneven, streaky development, not just at edges.

Cause: Too little agitation in developer let exhausted chemicals accumulate and slide across the surface of the film, retarding development in those areas. *Prevention:* Agitate regularly, as directed.

Reticulation. Image appears crinkled, cracked, or patterned overall.

Cause: Extreme difference between temperatures of processing solutions: for example, taking film from very warm developer and putting it into very cold stop bath. Less extreme changes can cause an increase of graininess in the image. Prevention: Keep all solutions, from developer to wash water, within a few degrees of each other.

Air bells. Small, round, clear spots on negative (dark in print).

Cause: Small bubbles of air sticking to the surface of the film prevented developer from reaching the emulsion.

Prevention: At the start of the development period, rap tank sharply on a solid surface (step 11, page 82). Presoaking the film in plain water for about a minute with occasional agitation before development might help if you have persistent problems. Although presoaking is a common practice. Kodak warns that it may cause uneven development with certain films, such as Technical Pan 2415 film.

Pinholes. Tiny clear specks on negative (dark in print).

Cause: Most likely caused by dust on film that keeps light from reaching the film during exposure. Less likely, but possibly due to dust on film keeping developer away from emulsion. Could be due to acetic acid stop bath solution being mixed too strong or undissolved particles in the fixer.

Prevention: Blow or brush dust out of the inside of the camera, and load film onto the developing reel on a dust-free surface. Check that you are mixing stop bath correctly: use a more diluted solution or just plain water instead. Filter any undissolved particles out of the fixer.

Specks, scratches, fingerprints.

Cause: Rough handling during processing. Dirt on squeegee or sponge. Dirt on the felt light-trap opening of the film cassette.

Prevention: Handle film gently, by edges as much as possible. Be particularly careful when emulsion is wet and more sensitive to surface damage. Hang film to dry in as dust-free a place as possible, where it will not be jostled or moved around.

Faint streaks on the surface of film.

Cause: Uneven drying or water splashed on film during drying. Using tap water in a hard-water area.

Prevention: After washing, treat film in a wetting agent, such as Kodak Photo-Flo, and wipe film gently with photo sponge (steps 19-20, page 84). If you live in a hardwater area, dilute the Photo-Flo with distilled water instead of tap water. Don't let water from one roll of film drip onto another roll hanging to dry. Rewashing and redrying the film or cleaning it with a film cleaner may remove the marks.

Cloudy look overall.

Cause: Probably due to inadequate fixing, but possibly caused by using old, lightstruck, or X-raved film.

Prevention: Refixing film in fresh fixer may help if due to inadequate fixing; rewash completely.

PRINTING: Equipment and materials you'll need 96
MAKING A CONTACT PRINT STEP BY STEP 98
PROCESSING A PRINT STEP BY STEP: Development 100 Stop bath and fixer 101 Washing and drying 102
SUMMARY OF PRINT PROCESSING 103
MAKING AN ENLARGED PRINT STEP BY STEP: Setting up the enlarger 104 Exposing a test print 106 Exposing a final print 107
EVALUATING YOUR PRINT FOR DENSITY AND CONTRAST 108 More About Contrast: How to control it in a print 110 LOCAL CONTROLS: Burning in and dodging 112 More About Local Controls: Burning in and dodging 114 CROPPING 115 SPOTTING 116 SOLVING PRINTING PROBLEMS 117 MOUNTING A PRINT: 118 Equipment and materials you'll need 119 DRY MOUNTING A PRINT STEP BY STEP 120 BLEED MOUNTING/OVERMATTING 122

PRINTING

Now comes the fun. Developed negatives in hand, you finally get to examine your pictures closely, first in a contact print that is the same size as the negative, then in enlarged prints. This chapter describes how to print black-and-white film. Many of the procedures are the same if you make color prints. Pages **152–155** show prints made using digital imaging.

The negative has the opposite tones of the original scene. Where the scene was bright, such as white clouds, that part of the film received a great deal of exposure and produced an area in the negative that is dense and dark with silver. Where the scene was dark, such as in a shadowed area, the film received little exposure, resulting in a lessdense or even clear area in the negative.

When you make a positive print, the tones are reversed again, back to those of the original scene. The densest and darkest parts of the negative will hold back the most light from the paper, producing a light area in the print. Less-dense parts of the negative will pass the most light, producing the darkest parts of the print.

Avoid chemical contamination to avoid printing problems. Think of your printing darkroom as having a dry side and a wet side; you will be moving repeatedly from one side to the other. On the dry side, you handle negatives, adjust the enlarger, and expose paper. On the wet side, you mix chemicals and process prints. It is vital to prevent wet-side procedures from contaminating the dry side. Even a small amount of a chemical straying over to the dry side on your fingertips can leave finger-prints on your next print, permanently damage negatives, and more. See page 78 for how to avoid contamination, mix chemicals, and handle them safely.

Positive

Negative

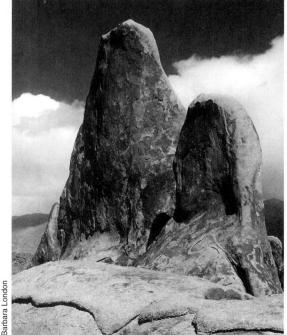

PRINTING Equipment and materials you'll need

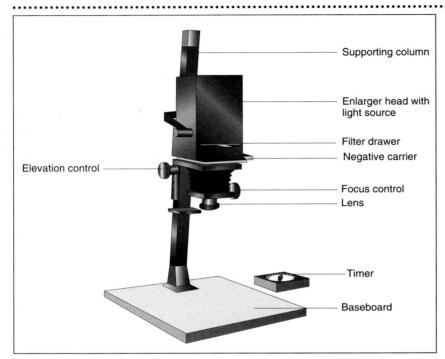

DRY-SIDE EQUIPMENT

Enlarger (shown above) projects light through a negative onto photographic paper.

Supporting column holds the enlarger head out over the baseboard.

Enlarger head contains the light source, negative carrier, lens, and other components.

Light source spreads light from a lamp over the negative. A condenser source concentrates light on the negative through a pair of lenses. A diffusion source scatters light onto the negative, producing less contrast. Some designs combine characteristics of these two systems.

Filter drawer holds filters that affect the color of the light source for variable-contrast blackand-white paper or for color printing. A dichroic enlarger head has builtin filters; you simply dial in different colors.

Negative carrier holds the negative flat and in place.

Lens focuses the image from the negative onto the baseboard. The lens aperture is adjustable to control the brightness of the light passing through the lens. The focal length of the lens must match the size of the negative: a 50mm lens is normally used with a 35mm negative, 80mm lens with $2^{1/4}$ -inch-square negative, 150mm lens with 4 x 5-inch negative.

Focus control focuses the image projected by the enlarger by adjusting the distance from negative to lens.

Elevation control adjusts the image size by moving the enlarger head up or down a track on the supporting column.

Baseboard supports enlarger and printing frame or easel.

Enlarger timer activates the enlarger light source, turning it on, then off when the set time has expired.

Printing frame holds negatives and paper tightly together for contact prints. A sheet of plain glass can be used as a substitute.

Easel holds printing paper flat on the enlarger's baseboard for enlargements. This easel has adjustable sides for cropping the image and creating white borders.

Focusing magnifier enlarges the projected image when setting up an enlargement so you can focus sharply. **Dodging and burningin tools** let you selectively lighten or darken parts of a print (see pages **112** and **114**).

Miscellaneous: marking pen, scissors. For cleaning negatives, use a clean, soft brush, or, if you use compressed gas, buy a type such as Dust-Off Plus, which does not contain environment-damaging chlorofluorocarbon.

PRINTING PAPER

Printing paper (for conventional black-andwhite or color prints) is coated with a lightsensitive emulsion onto which the image is exposed.

Fiber base or resin coated. Resin-coated (RC) papers have a water-resistant coating that lets processing chemicals reach the paper's emulsion but not the paper fibers in its base. RC paper does not become saturated with liquid, so less processing time is required for fixing, washing, and drying. Nevertheless, many photographers still prefer fiber-base papers, which are available in a wider range of surface finishes, are more permanent, and have what many feel is a better finish.

Graded contrast or variable contrast. To change the contrast of your print, you change the contrast grade of the printing paper. Each grade of a graded-contrast paper produces a single level of contrast. A variable-contrast paper produces different levels of contrast depending on the filtration of the enlarger's light. See pages **110–111**.

Surface finish and image tone. Characteristics vary widely, from smooth to rough finishes, glossy to matte (dull) surface sheen, x cool blue-black to warm brown-black image color.

Size. Readily available sizes include 8 x 10, 11 x 14, and 16 x 20 inches; some papers are available in additional sheet sizes and rolls. The most popular size is 8 x 10.

Weight refers to the thickness of the paper base. Fiber-base papers come in single weight (suitable for contact prints or smallsize prints) and double weight (sturdier and easier to mount). RC papers come only in a medium weight that is between single and double weight.

WET-SIDE EQUIPMENT

Trays hold solutions during processing. For 8 x 10-inch prints, you'll need three trays of that size, plus one larger tray for washing.

Optional: **Tongs** lift prints into and out of solutions, keeping your hands clean so that you don't need to wash and dry them so often. You'll need one for developer, another for stop bath and fixer.

Timer or clock with sweep second hand times the processing.

Safelight provides dim, colored light that lets

you see well enough to work without fogging the printing paper with unwanted exposure.

Washing siphon

clamps onto a tray. It pumps water into the top of a tray and removes it from the bottom so that fresh water circulates around the washing prints. Special print washers are also available.

Photo sponge or squeegee wipes down wet prints to remove excess water before drying.

Drying racks or other devices dry prints after processing (see page **102**).

Mixing and storing equipment is similar to that used for film chemicals (page 76): mixing container, thermometer, stirring rod, storage bottles.

CHEMICALS

Most of the chemical solutions used in paper processing, including stop bath, fixer, and clearing bath, are the same as those used in film processing. Only the developer is different. Average storage times and capacities are given here; see manufacturer's directions for specifics.

Developer converts into visible metallic silver those crystals in the paper's emulsion that are exposed to light. Choose a developer specifically made for use with paper.

Stock solution lasts from 6 weeks to 6 months, depending on the developer and how full the storage container is; the more air in the container, the faster the solution deteriorates. Discard working solution after developing fifteen to twenty 8 x 10 prints per quart (liter), or at the end of one working day.

Stop bath halts the action of the developer. A simple stop bath can be prepared from about 1½ oz (46 ml) 28 percent acetic acid to 1 quart (1 liter) of water. Stop bath stock solution lasts indefinitely.

Discard working solution after about a month or after treating twenty prints per quart. An indicator stop bath changes color when exhausted.

Fixer removes undeveloped silver halides from the emulsion. A fixer with hardener prevents softening and possible damage to the emulsion during washing.

Fixer stock solution lasts 2 months or more. Working solution lasts about a month in a full container and will process about twentyfive 8 x 10-inch prints before it should be discarded. A testing solution called hypo check (or fixer check) is the best test of fixer exhaustion.

Optional: **Clearing bath** (also called *washing aid, fixer remover,* or *hypo neutralizer*) is highly recommended when you are using fiber-base papers. It removes fixer better and faster than washing alone. Capacity and storage time vary depending on the product; see manufacturer's instructions.

MAKING A CONTACT PRINT STEP BY STEP

A contact print is made with the negative in contact with the printing paper; the print is the same size as the negative. A contact sheet of all the negatives on a roll makes it possible to examine and compare different frames so you can choose the ones to enlarge. Then you can store the contact with the negatives for later reference. Contact prints of 35mm negatives are too small for you to evaluate each image critically, but they do give you a first look at sharpness, exposure, lighting, and other factors.

The following method uses an enlarger as the light source and a contact printing frame to hold the negatives and printing paper. See Equipment and Materials You'll Need, pages **96–97**, and Processing a Print Step by Step, pages **100–102**. A 36-exposure roll of 35mm film (or a roll of 2¹/₄-inch 120 film) will just fit on an 8 x 10-inch sheet of printing paper. Use a grade 2 or normal contrast paper. (Contrast grades are explained on pages **110–111**.)

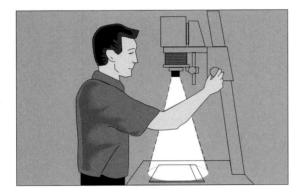

1 Position the enlarger. Close the slot where the negative carrier is inserted in the enlarger head so that light will shine only on the baseboard and is not coming out of the slot. This is particularly important in a school's group darkroom because stray light can fog other people's prints. Switch on the enlarger lamp. Place the printing frame on the enlarger baseboard. Raise the enlarger head until the light covers the entire printing frame.

Note: The gray tone over the drawings in this chapter means that the room lights should be off, darkroom safelights on.

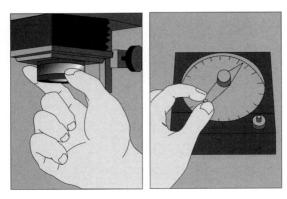

2 Set the lens aperture and the enlarger timer. As a trial exposure, set the enlarger lens aperture to f/8 and the timer to 5 sec. You may want to change these settings after developing and evaluating the print (see step 6, opposite). You can, if you wish, make a test print, using a range of different exposures as described on page **106**.

B ldentify the emulsion sides of the negatives and paper. The negative emulsion must face the paper emulsion or prints will be reversed left-to-right. Film tends to curl toward its emulsion side, which is usually duller than the backing side. You are looking at the emulsion if the frame numbers on the edge of the film read backwards.

Turn on the darkroom safelights and TURN OFF THE ROOM LIGHTS AND ENLARGER LAMP before opening the package of paper. The emulsion side of the paper is shinier and, with glossy papers, smoother than the back side. Fiber-base paper curls toward the emulsion side; RC paper curls much less and may curl in either direction, but may have a visible manufacturer's imprint on the back side.

4 Insert the negatives and one sheet of paper in the printing frame. The paper goes inside the frame, emulsion side up. The negatives go above the paper, emulsion side down. The glass top of the frame sandwiches the negatives and paper together tightly. If you don't have a printing frame, you can simply put the paper on the enlarger baseboard, the negatives on top of it, and a plain sheet of glass over all.

You can, if you wish, make contact prints of negatives while still in their plastic storage pages. The contact print will not be quite as sharp, but leaving the negatives in the pages minimizes handling and protects them from accidental damage.

 5^{Expose} and process the print. With the printing frame in place under the enlarger head, push the timer button to turn the enlarger light on and expose the print.

Process the paper as shown on pages **100–102**. After fixing, evaluate the print in room light. If you are the only person using the darkroom, you can simply turn on the lights there. BEFORE YOU TURN ON ROOM LIGHTS, make sure the package of unexposed printing paper is closed. If you are in a school darkroom used by others at the same time, bring the print into another room for evaluation. Put it in an extra tray or on a paper towel so fixer doesn't drip on other surfaces.

6 Evaluate the print. Some of the frames will be lighter, others darker, depending on the exposure each received in the camera. To judge print exposure overall, examine the film edges in the print. They should be black but with the edge numbers legible and, with 35mm film, a very slight difference between the edges and the darker sprocket holes. If the edges of the film look gray, many frames will probably be very light; make another print with the enlarger lens opened to the next larger aperture. If the edges of the film are so dark that you can't see edge numbers or sprocket holes, many frames will probably be very dark; close the enlarger lens to the next smaller aperture for the next print.

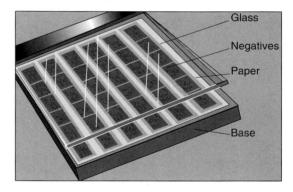

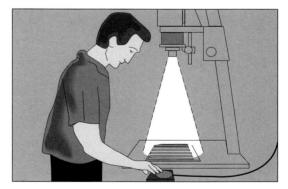

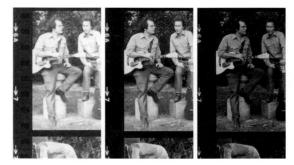

PROCESSING A PRINT STEP BY STEP Development

Processing a print is not unlike processing film: the exposed print is immersed and agitated in developer, stop bath, and fixer, then washed and dried. Until the print is fixed, don't expose it to ordinary room light, only to darkroom safelights. They are bright enough so that you can see what you are doing and see the image as it emerges—one of the real pleasures of printing.

See Equipment and Materials You'll Need, pages **96–97**. Notice that resin-coated (RC) paper needs less time in the stop bath and fixer, no clearing bath, and less washing than fiber-base paper does.

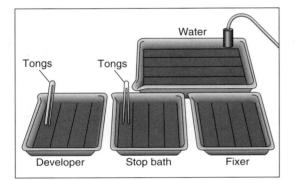

Set up the wet-side materials. Set up the processing solutions in four trays (one each for developer, stop bath, and fixer, plus one filled with water to hold prints after fixing until washing).

If you use tongs to lift the paper out of the solutions, reserve one set exclusively for the developer, another for stop bath and fixer. Label them so you do not accidentally interchange them.

Temperatures are not as critical as for film, but the recommended print developer temperature is often $68^{\circ}F$ ($20^{\circ}C$). Have other solutions between $65^{\circ}-75^{\circ}F$ ($18^{\circ}-24^{\circ}C$).

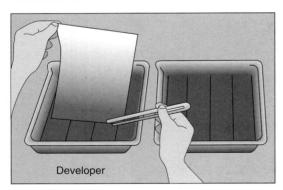

 $2^{\text{Immerse the print in the developer.}}$ Slip the exposed paper quickly into the solution, emulsion side up, so the developer covers the entire surface of the print.

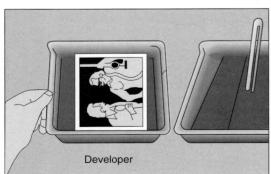

3 Agitate the print in the developer. Agitate continuously for the time recommended by the manufacturer for the particular paper you are using, typically 1–3 min. Time the development from the moment you slip the print into the developer until you slip it into the stop bath.

Agitate by rocking the tray gently, doing so in different directions, so you don't set up a constant flow pattern of developer. In an oversize tray, as is sometimes used in school darkrooms, you may have to use tongs to agitate the print. If so, touch the surface of the print as little as possible; the tongs can leave marks.

Stop bath and fixer

A Remove the print from the developer. Let it drain for a few seconds into the developer tray so you don't carry too much developer into the stop-bath tray.

5 Immerse the print in the stop bath. Agitate continuously for at least 15 sec. (at least 10 sec. for RC paper). Use only the stop-bath/fixer tongs in this solution, not the developer tongs. If you accidentally get stop bath on the developer tongs, rinse them well before putting them back into the developer.

Remove the print from the stop bath. Let the print drain for a few seconds into the stop-bath tray. Don't let stop-bath solution splash into the developer.

6 Immerse the print in the fixer. Agitate the print frequently for 5-10 min. (2 min. for RC paper). If several prints are in the fixer, rotate individual prints from the bottom to the top of the tray. You can look at the print in ordinary room light after about 2 min., but be sure to return the print to the fixer to complete the fixing time.

7 Remove the print from the fixer at the end of the recommended time and drain briefly. Transfer fiber-base paper to a large tray filled with water until the end of your printing session, when you can wash all the prints at once. In the meantime, run water gently into the tray, or dump and refill from time to time.

Wash RC paper promptly for best results; ideally, total wet time should not exceed 10 min. to prevent solutions from penetrating the paper at the edges of the print. See Washing and Drying, next page.

Fixe

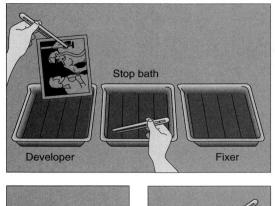

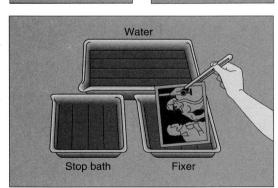

Water

Stop bath

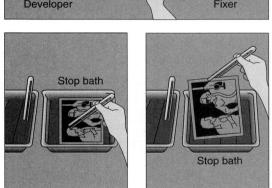

PROCESSING A PRINT STEP BY STEP Washing and drying

Orreating prints with a clearing bath is optional for fiber-base paper, but it is highly recommended. (RC paper should not be treated with a clearing bath; go directly to step 9.)

Rinse fiber-base paper in running water with continuous agitation for 1 min. Then agitate in the clearing bath continuously for 15–30 sec., then occasionally for 2–3 min. more, or as directed by the manufacturer. When processing several prints at a time, rotate individual prints from the bottom of the tray to the top during agitation.

O Wash prints in running water. If fiber-base paper has been treated with a hypo clearing bath, wash single-weight paper for 10 min., double-weight paper for 20 min.; if untreated, wash for 1 hour. Wash RC paper for 4 min. A wash water temperature of $50^{\circ}-86^{\circ}F$ ($10^{\circ}-30^{\circ}C$) is acceptable; $75^{\circ}F$ ($24^{\circ}C$) is optimum.

A washing siphon is best if you wash prints in a tray. Run the wash water fast enough to fill the tray several times in 5 min., or dump and refill the tray several times. Rotate individual prints from top to bottom, and keep prints separated so that they circulate freely in the water. Some print washers are designed to keep prints separated; in a tray, do this by hand. Prints won't wash if they just sit in the tray.

10 Wipe off excess water. Put one print at a time on a clean sheet of plastic or glass. An overturned tray will do if you clean it well and the tray bottom is not ridged. Use a clean photo sponge or squeegee (an automobile windshield-wiper blade works well) to gently wipe down first the back of the print, then the front.

11 RC pr with a specie A fixer a from 1

11 Dry prints. You can dry fiber-base prints face down on racks of fiberglass screens, in a heated dryer, or between photo blotters. RC prints dry well face up on a rack or clean towel, or hung from a line with a clothespin. Do not dry them in a heated dryer unless it is designed specifically for drying RC prints.

An improperly washed print will contaminate its drying surface with fixer and cause stains on the next prints dried there. If blotters or cloths from heat dryers become tinged with yellow, they are contaminated with fixer. Blotters should be discarded and replaced with new ones; heat dryer cloths can be washed. Wash drying-rack screens occasionally.

Summary of print processing

Step	Time	Procedure
Prepare chemicals	_	Mix developer, stop bath, and fixer, and dilute to working strength. Pour each into a tray; fill a fourth tray with water. Temperatures are not as criti- cal as for film, but the recommended developer temperature is often 68°F (20°C), with other solutions at 65°–75°F (18°–24°C). Keep the dry side of the darkroom free of chemical contamination. If your hands get wet, rinse and dry them well before handling items on the dry side, especially film or paper.
Expose the print	_	Expose a piece of printing paper to make a contact print (page 98), test print (page 106), or final print (page 107). Open printing paper package only under darkroom safelight. Do not turn on room lights until print has been fixed.
Development	1-3 min. (see manufacturer's instructions)	Agitate continuously for the time recommended by the manufacturer. Drain print briefly before transferring it to the stop bath.
Stop bath	At least 15 sec. with fiber-base paper, at least 10 sec. with RC paper	Agitate continuously. Drain print briefly before transferring it to the fixer.
Fixer	5-10 min. with fiber-base paper, 2 min. with RC paper	Agitate frequently. If more than one print is in tray, rotate each from bot- tom to top of stack.
Holding until wash	As needed with fiber-base paper	If you have additional prints to make, transfer fiber-base prints into a tray of water until all are ready to wash. Run water gently into tray, or dump and refill occasionally. Wash RC paper promptly (total wet time ideally should be not more than 10 min.).
Clearing bath (recommended for fiber-base paper only)	Water rinse: 1 min.	Agitate continuously in running water.
	Clearing bath: 2-3 min. (Check manufac- turer's instructions.)	Agitate continuously for the first 15-30 sec., occasionally thereafter. Do not use with RC paper.
Wash	If hypo clearing bath was used with fiber- base paper: 10 min. with single-weight pa- per, 20 min. with double-weight paper	Wash in running water at a temperature between 50°-86°F (10°-30°C) Keep prints separated. Rotate prints; dump and refill tray several times
	If no clearing bath was used with fiber-base paper: 60 min.	
	4 min. with RC paper	
Dry	1 or more hours	Wipe down front and back of print with clean squeegee or photo sponge Dry fiber-base paper on racks, in heated print dryer, or in photo blotters Dry RC prints on racks, on a line, or on any clean surface, but not in heated dryer unless you are sure it is safe for RC prints. Make sure drying surface is free of fixer or other chemical residues.

MAKING AN ENLARGED PRINT STEP BY STEP Setting up the enlarger

An enlarged print finally gives you a good look at your photograph and the chance to show it to others. Making an enlargement is shown here in three steps: Setting Up the Enlarger (on this page and the one opposite), Exposing a Test Print and Exposing a Final Print, pages **106–107**. See Equipment and Materials You'll Need, pages **96–97**, and Processing a Print Step by Step, pages **100–102**.

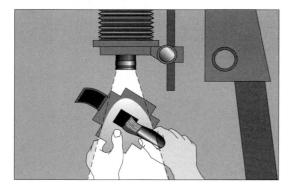

1 Select a negative for printing. Examine the contact sheet with a magnifying glass or loupe. If you have several shots of the same scene, which has the best light or action or expressions? Evaluate the images technically as well. Is the scene sharp or is it slightly blurred because the camera or subject moved during the exposure? Maybe you have another frame that is sharper. Is the scene overexposed and very light or underexposed and very dark? Check the negatives to make sure this isn't just a problem with the contact sheet. You can correct minor exposure variations during printing, but massive exposure faults will make the negative difficult, if not impossible, to print. Use a white grease pencil to mark the frames on the contact sheet that you want to enlarge.

2 Dust the negative and insert in the negative carrier. Use an antistatic brush or compressed air to dust the negative and the enlarger's negative carrier (usually two metal pieces that hold the negative between them). Look for dust by holding the negative at an angle under the enlarger lens with the lamp on; it is often easier to see dust with room lights off. Dusting is important because enlargement can make even a tiny speck of dust on the negative big enough in the final print to be visible.

Position the negative in the carrier window so that the (duller) emulsion side faces the easel.

 $3^{\mbox{Open the enlarger's lens}}$ to its largest opening to produce the brightest image for focusing. Turn the enlarger lamp on and the room lights off.

Adjust the easel. Position the easel under the projected image. Insert a piece of plain white paper or the back of an old print in the easel so you can see the projected image clearly. Adjust the movable sides of the easel to hold the size of paper being used.

C Adjust the enlarger head. Raise or lower the enlarger head to get O the amount of image enlargement that you want. Readjust the position of the easel or the easel blades to crop the image exactly as you want. (More about cropping on page 115.)

Focus the image. Focus by turning the knob that raises or lowers O the enlarger lens. A focusing magnifier will help you make the final adjustments of focus. The best focusing magnifiers enlarge the image enough for you to focus on the grain in the negative.

Set the enlarger aperture and timer. Stop down the aperture to a setting (you can try f/11 as a start) that is at least two stops from the widest aperture. This gives good lens performance plus enough depth of focus to minimize slight errors in focusing the projected image.

Set the enlarger timer to 5 sec. The first print will be a test that receives several different exposures (see next page).

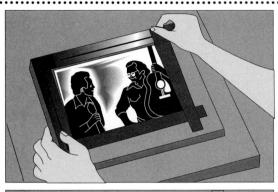

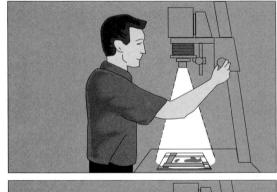

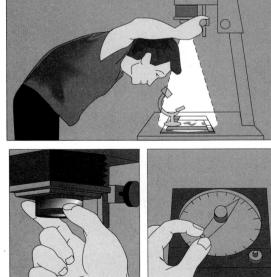

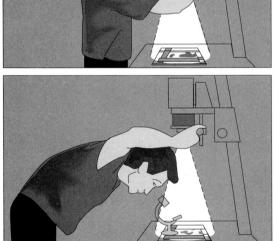

MAKING AN ENLARGED PRINT STEP BY STEP Exposing a test print

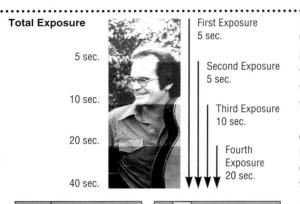

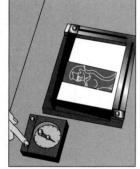

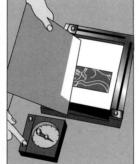

A test print has several exposures of the same negative on one piece of paper so that you can determine the best exposure for the final print. The print shown here received four exposures to produce a test with 5-, 10-, 20-, and 40-sec. exposures. Turn on the enlarger and estimate where you will place the strip. It should go across the most important parts of the image, ideally showing both highlight and shadow areas.

Make the test on a medium-contrast, grade 2 paper or on a variablecontrast paper with a number 2 filter in the enlarger. TURN OFF THE ROOM LIGHTS AND ENLARGER before opening the package of paper. Cut a sheet of 8 x 10-inch paper into four equal strips. Put all but one of the strips back in the paper package and close it.

9 Make the first exposure. Put one strip, emulsion side up, on the easel. If you can, secure at least one end of the strip under the easel blades so that the strip will stay in place. Have an opaque piece of cardboard at hand, but don't cover any of the test strip yet. For this test strip, the timer is set for 5 sec. and the enlarger lens aperture is set to f/11. Push the timer button.

Make the second exposure. Use the cardboard to cover one quarter of the test strip. Push the timer button again for another 5-sec. exposure. Try not to move the test strip when you move the cardboard.

1 Make the third exposure. Reset the timer to 10 sec. Cover one half of the test strip. Push the timer button.

Make the fourth exposure. Reset the timer to 20 sec. Cover all but one quarter of the test strip. Push the timer button.

Tip: Use black or very dark cardboard to avoid reflecting unwanted light.

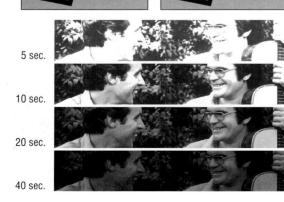

1 An alternate way to test. Instead of one strip with four exposures on it, use four strips, each one exposed in the same position for a single exposure time. This uses more paper but lets you see the same areas in each exposure. It also makes it easier to position the strips to show both highlight and shadow areas.

Remove one strip of paper from the package and expose it for 5 sec. Place each exposed strip in a covered place, so it doesn't get exposed to additional light or mixed up with unexposed strips. You can identify the exposure of each strip by writing on the back with pencil. Expose the second strip for 10 sec., the third strip for 20 sec., and the fourth strip for 40 sec.

Exposing a final print

12 Process the test. Develop the strip (or strips) for the full time. Do not remove a print from the developer early if it looks too dark or leave it in longer than the recommended time if it is too light. After fixing, evaluate the test.

Evaluating the test. Always judge prints under room light because they will look much darker under darkroom safelight. If you turn on room lights in the darkroom, make sure the package of unexposed paper is closed. In a school darkroom used by others at the same time, bring the test into another room. If you do so, put the wet paper in an extra tray or on a paper towel so that you don't drip fixer onto other surfaces.

Judging exposure. If all the test segments are too light, retest using longer times or a larger aperture. One stop wider aperture darkens the print the same as doubling the time. If the segments are all too dark, use shorter times or a smaller aperture. One stop smaller aperture lightens the same as halving the time.

Judging contrast. Is the test too contrasty, with inky black shadows and overly light highlights? If so, retest using a lower contrast grade of paper. Is the test too flat, with dull gray shadows and muddy highlights? If so, retest with a higher contrast grade of paper. See pages **108–109** for how to evaluate a print.

13 Expose and process the final print. Recheck the focus, then reclose the aperture. Set the timer to the best exposure time shown on the test (often a midpoint between two of the exposures). Insert a full sheet of paper in the enlarger easel and expose.

Develop for the full time. After fixing for about 2 min., you can evaluate the print under room lights.

14 **Evaluate the final print.** Don't be disappointed if this print is not really final because it often takes several trials to get a good print. Are exposure and contrast about right? You can't always tell from a test print how the full print will look. Also, most prints require some dodging, holding back light from part of the image during the initial exposure, or burning in, exposing an area for extra time. See pages **112–114** for more about these local controls.

When you are satisfied with a print, complete the fixing, washing, and drying. Make a note of the final aperture and exposure time for reprints.

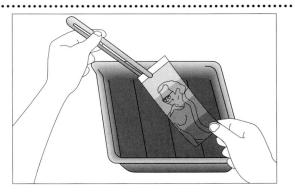

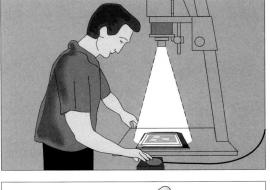

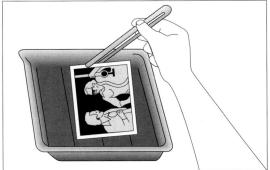

Evaluating your print for density and contrast

Now that you have a print, how good is it technically? The goal in most cases is a fullscale print, one that has a full range of tones: rich blacks, brilliant, textured highlights, and good separation in middle tones. Look at your print under room light; safelight makes prints seem darker than they really are. You'll be evaluating two elements: density and contrast.

Density is the lightness or darkness of a print. It is controlled by the print exposure the size of the enlarger lens aperture and the length of the exposure time. More exposure makes a print darker, less exposure makes it lighter. A test strip with a series of exposures on it (like the one on page **106**) helps you evaluate density and determine the basic exposure for a print, although you may not be able to evaluate density completely until you see an entire print at one exposure.

Contrast is the difference in darkness between light and dark parts of the same print. Contrast is controlled by the contrast grade of the paper or, with variable-contrast paper, by the printing filter used (see pages **110–111**).

Adjust density first, then contrast. The photographic rule of thumb for *negative* exposure and development is: Expose for the shadows, develop for the highlights. The rule for *prints* is: Expose for the highlights, adjust paper contrast for the shadows.

First, examine the highlights in your print, particularly large areas that should be light but that should still show texture and detail, such as skin or light clothing. (For the moment, ignore areas that should be white or extremely light, such as light sources or their reflections, sunlit snow, or very bright sky.) If light areas seem too dark, make another print giving less exposure; if they are too light, make another print with more exposure. Prints tend to "dry down" slightly in tone, so

that a dry print will appear slightly darker overall than a wet one.

When highlight density in the print seems about right, examine the shadow areas. Again, look at larger areas that should have some sense of texture and detail, such as dark clothing or leaves, but not those that should be completely black. If shadows are weak and gray rather than substantial and dark, make another print on the next higher contrast grade of paper. If shadows are extremely dark, so that details that appeared in the negative are obscured in the print, make another print at the next lower contrast grade.

Different contrast grades of paper usually have different printing speeds, so if you change to another contrast grade of paper, make another test strip to find the best exposure time. Find the exposure that produces correct highlights, then examine the shadows. When one exposure gives you good tones both in highlights *and* shadows, you are printing on the correct contrast grade of paper.

Last adjustments. When the print looks about right overall, examine it for individual areas that you might want to lighten by dodging or darken by burning in. For example, you can lighten a person's face slightly by dodging it during part of the basic exposure. Sky areas often benefit from burning in because they are often so much brighter than the rest of the scene. (More about dodging and burning on pages **112–114**.)

If a photograph is important to you, don't be satisfied with a print that only more or less shows the scene. For example, skin tones are important in a portrait, and they should not be pale and washed out or murky dark. Many beginners tend to print too light, with too little contrast, a combination that produces poor texture and detail. You will find a big difference in satisfaction between a barely acceptable print and one that conveys a real sense of substance. Keep trying. A full-scale print with normal density and contrast shows good texture and detail in important light highlights and dark areas.

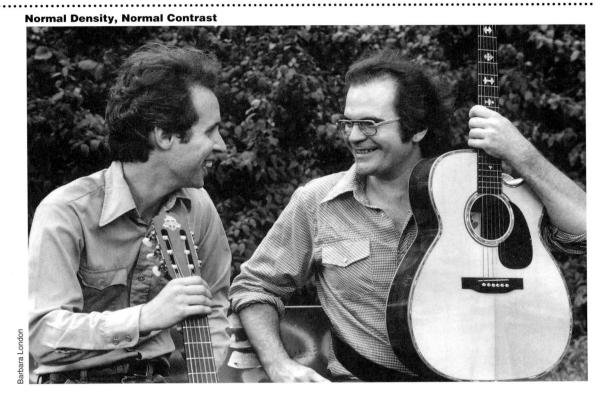

Density: Too Light

Too Dark

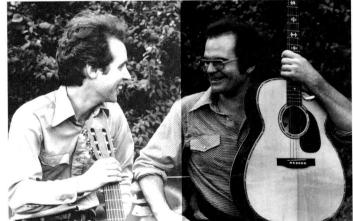

Evaluate density by looking at the important lighter parts of the print. If they look too light, make another print with more exposure (longer exposure time or wider aperture). If they look too dark, make another print with less exposure (shorter time or smaller aperture).

Contrast: Too Flat

Too Contrasty

Evaluate contrast (after the density of the highlights is about right) by looking at the important darker parts of the print. If they look muddy gray, the print is too low in contrast or flat; to correct, use a higher contrast grade of paper. If they look too black, the print is too contrasty; use a lower contrast grade.

MORE ABOUT CONTRAST How to control it in a print

Contrast is the relative lightness and darkness of different parts of a scene. It is different from density, which is the darkness of the print overall. Most often, you will want a normal range of contrast: deep blacks, brilliant whites, plus a full range of gray tones. But how much contrast is best depends on the scene and how you want to print it. Too little contrast makes most prints look muddy and dull. However, in a scene such as a foggy landscape, low contrast can enhance the impression of soft, luminous fog. Too much contrast, for example in a portrait, can make the photograph—and your subject—look gritty and harsh. However, high contrast with dense blacks, bright whites, and few or no middle-gray tones might convey just the feeling you want in certain scenes.

You can change contrast during printing. The contrast of your negative is set by the contrast of the scene, the film type, exposure, and processing. But you can change the contrast of a print made from that negative to a considerable extent by changing the contrast of the paper used during printing. You can lower the contrast of a print by using a lowcontrast paper. You can increase the contrast by using a high-contrast paper (see opposite).

Other factors also affect print contrast. A condenser enlarger produces about one grade more contrast than a diffusion enlarger with the same negative. A highly textured paper surface reduces contrast, as do some paper developers, such as Kodak Selectol Soft. However, the contrast grade of the paper is the main method of control.

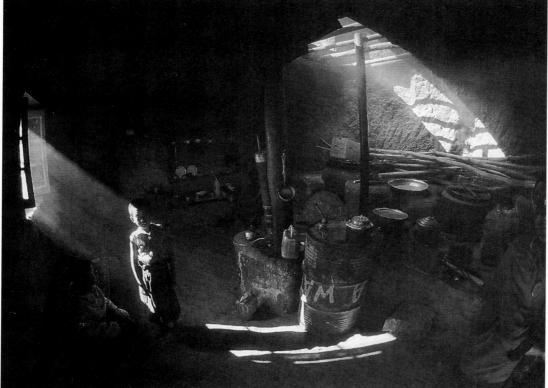

High contrast dominates this scene shot in India of a child standing by a window. The sunlight on the child was very bright compared to the darkest parts of the room, where objects are just distinguishable. Printing on a lower contrast grade of paper would have made both the lightest and darkest areas less intense, but that is not necessarily the best choice. Here, the high contrast conveys the cavernous darkness of the room, which is lit during the day only through its small openings.

Grade 1 Paper (or Filter) Produces Low Contrast

Grade 2 Paper (or Filter) Produces Moderate or Normal Contrast

Variable-contrast papers can change contrast grade, so you have to purchase only one type of paper. Each sheet of paper is coated with two emulsions. One is sensitive to yellow-green light and produces low contrast; the other is sensitive to blue-violet light and produces high contrast. You control the contrast by inserting appropriately colored filters in the enlarger, or, with certain enlargers, by dialing in the correct filtration. The filters affect the color of the light reaching the paper and so the contrast of the print.

Variable-contrast filters are numbered with the contrast grade that they produce: a number 1 filter produces low contrast, 2 and 3 medium contrast, and 4 and 5 high contrast. Numbers 1½, 2½, and 3½ filters produce intermediate contrast grades. During printing, if you change from one filter to another, you may also need to adjust the exposure because some filters pass less light to the print overall. See manufacturer's instructions.

Using digital-imaging software is another way to adjust contrast, as well as the lightness or darkness of a print. Changes can be made either in the print overall or in selected areas. See pages **152–155**.

To change the contrast in a print, change the contrast grade of the printing paper or, with variablecontrast paper, change the filter. Here, the same negative was printed with different levels of contrast.

Grade 4 Paper (or Filter) Produces High Contrast

CAL CONTROLS Burning in and dodging

Once the overall density (the lightness or darkness) of a print is right, you will often find smaller areas that could be a little lighter or darker. For example, a face might be too dark or the sky too light, even though most of the scene looks good. Burning in (shown below and opposite) adds light after the basic exposure is made in order to darken an area. Dodging (shown on page **114**) holds back light during the basic exposure to lighten an area.

Many prints are both dodged and burned. Whatever manipulation you do, keep it subtle

so that the scene looks natural. An obviously dodged or burned-in area is more of a distraction than an improvement. See Tips for Burning In and Dodging, page **114**.

Burning in darkens part of a print by adding light to an area after the basic exposure. The edge of a piece of cardboard, a piece of cardboard with a hole in the center, your hands, or any opaque object can be used as long as it shields light from the rest of the print while you are adding exposure to the part you want darker.

> The lighter parts of a photograph attract the eye, sometimes to the point of distracting the viewer from the main subject. You can often lessen such a problem by burning in overly light areas to slightly darken them.

Burn in a print to make part of it darker. After the basic exposure is complete, give more light to the part of the print you want to darken, while shielding the rest of the print from additional exposure.

A piece of cardboard with a hole cut in the center (shown above) is a useful tool. The closer you bring the cardboard to the lens, the larger the circle of light that will be cast and the more diffuse its edges.

For large areas, such as the sky in a landscape, try using the edge of a piece of cardboard (shown below).

Here, the window, couch, and rumpled blanket were burned in to make them less conspicuous. In addition, the edges of the print were darkened a little. Many photographers slightly burn in the top, bottom and sides of their prints to move viewers' eyes to the center of the image. Only a subtle change is needed, about 10-20 percent of the basic exposure.

Darkening a too-light sky is the most common use of burning in. In nature, the sky is often much brighter than any other part of a scene. Its blue color can also make the sky appear too light in a black-and-white photograph because most black-and-white films are somewhat more sensitive to blue than to other colors. If you are shooting in black and white, a yellow filter over the lens (page 149) darkens the sky, but often you will still want to improve the appearance of a sky in a photograph by burning it in slightly when you make the print.

Don't make your burning in too complicated. There is no need to cut an outline of every tree and building that projects into your sky. The edge of a plain piece of cardboard will do. You are helped by nature: in the real world, skies appear slightly lighter at the horizon. Even if the sky in your photograph is pure white at the horizon, it will look natural if it gradually gets darker toward the top of the print. Here, after the basic overall exposure, the sky was burned in for an additional 25 percent of the basic time.

MORE ABOUT LOCAL CONTROLS Burning in and dodging

Dodging lightens part of a print by holding back light from that area during some of the basic exposure. You can use a dodging tool like the one shown at right, your hands, a piece of cardboard, or any other object that casts a shadow of the appropriate size. The longer you hold back the light, the lighter that part of the print will be. However, there is a limit to the amount of dodging that you can do. Too much dodging will make a dodged area look murky gray rather than realistically lighter.

Ar. Whitekeys

Tips for Burning In and Dodging_

Blend in the edges of the dodged or burned-in area. Keep your dodging or burning tool in smooth, steady motion during the exposure so that the dodged or burned-in area blends into the rest of the print. If you don't move the tool enough, you are likely to print its outline onto the paper. You don't need to shake the tool back and forth quickly; a slow, steady movement will make your adjustments more precise.

Make your dodging and burning-in tools black on one side, white on the other. Light reflects up from the surface of printing paper during exposure. The black surface of the tool facing the paper will absorb that light so it doesn't bounce back down to the printing paper and fog or gray the print overall. The white upper surface of the tool lets you see the part of the image that the card is blocking from the printing paper, and so lets you judge better how to move the card in order to blend the edge. After Dodging

Dodge a print to make part of it lighter. Hold an object (here, a piece of cardboard attached to a stiff wire) underneath the enlarger lens during some of the basic exposure time to block light from the part of the print that you want to lighten. The closer the dodging tool is to the enlarger lens, the larger and more diffuse the shadow it casts.

 At left, the face was dodged just enough to make features visible.

Learn to judge your burning and dodging times as a percentage of the primary exposure. Dodging an area for 20 percent of the exposure time will result in the same change, whether your primary exposure was 5 seconds or 60 seconds. When you look at the test print for which you have the overall exposure and contrast correct, try to estimate whether you want, for example, the sky 30 percent darker or the face 10 percent lighter. Learning to do this is more efficient than making changes by trial and error.

Digital imaging makes dodging and burning more precise and repeatable (see page **154**). Imageediting software lets you select even very small areas to be lightened or darkened. Once you save the computer file containing the changes, you have those changes permanently recorded and exactly repeatable every time you make a print.

Cropping can perform

major surgery, such as on the picture below left, which started out as a grab shot by photographer Bill Byers. He saw the diver poised on the board, raised his camera, and shot almost at once. When printing, he realized it was the swirl of the diver's shadow and the swirls in the water that had caught his eye, and cropped the picture down to that (below right). Is there something sticking into the corner of an image that you didn't notice when you shot the picture? Is the horizon tilted when you want it straight? You can often improve a print by cropping it, cutting into the image at the edges to remove distracting elements or to focus attention on the most important part of the picture.

The best time to crop is when you take the picture, by composing the viewfinder image until it is the way you want it. You have an-

other chance to crop when you make the print, by adjusting the blades of the printing easel. Be aware, though, that enlarging a very small part of an image during printing can result in a loss of sharpness. When you mount the print, you have a chance to trim it and fine-tune the cropping again.

Keep horizon lines straight unless you deliberately want to call attention to the tilt. Even if a horizon line is not visible, an image can look off balance if it is tilted even slightly.

A more common use for cropping is to eliminate distracting elements from the edges of the image, leaving the picture you thought you were making at the time. For example, how would you crop the photograph at left?

Cropping L's, two L-shaped pieces of cardboard, laid over a print will let you try out possible croppings.

SPOTTING

Spotting is almost always needed to finish a print. No matter how careful you have been during film development and printing, there are likely to be a few specks on a print that shouldn't be there.

Spotting is done after the print is dry. Practice before you work on a good print; it takes some experience to learn how to blend a tone into the surrounding area. Do the minimum amount of spotting needed to make the blemish inconspicuous; too much spotting can look worse than not enough.

Use dyes to remove white spots. Liquid photographic dyes, such as Spotone, sink into the emulsion and match the surface gloss of the print. They are available in three (sometimes more) colors to match paper tones: neutral-black, brown-black, and blueblack. In addition to the dye, you will need a very fine brush, such as an artist's watercolor brush of size 000 or smaller. Place a drop of neutral-black dye on a small dish. Test the color of the dye on the margin of a scrap print. Add a bit of brown-black or blue-black dye if needed to match the image color of your print. You need only a very small amount of color in the neutral dye to match the color of most papers.

Spot the darkest areas first. Pick up a bit of undiluted dye on the tip of the brush and spot out any specks visible in the darkest parts of the print. Use a dotting or stippling motion with an almost-dry brush; too much liquid on the brush will make an unsightly blob.

Then mix water into part of the dye on the dish to dilute it for lighter areas. The dye makes a permanent change in the print, so start with a lighter tone than you think you need and darken it if necessary. Test the tone of the dye on the margin of a scrap print.

Small black specks or scratches can be etched off. Use the tip of a new mat knife blade (such as an X-acto blade) or singleedge razor blade to gently stroke the spot until enough of the emulsion density has been etched away to match the surrounding area. Etching is easier to do with fiber-base papers than with resin-coated (RC) papers, and with matte papers than with glossy papers.

Other spotting techniques. Local reduction or bleaching, with products such as Farmer's Reducer or Spot Off, is a chemical treatment that bleaches out larger areas than can be etched with a knife blade.

Digital-imaging software gives you the computer equivalent of spotting. Once you correct a photograph using digital imaging, you can make a permanent record of the change, so that all future prints are automatically corrected.

Before Spotting

After Spotting

Spotting corrects small imperfections in a print by adding dyes to cover up white specks or by etching off dark ones. Left, a section of an unspotted print. Right, the same print after spotting.

Solving printing problems

Check below if your prints have technical problems. See also Solving Camera and Lens Problems, page **45**; Exposure Problems, page **72**; Negative Development Problems, page **92**; Flash Problems, page **140**; and Evaluating Your Print for Density and Contrast, page **108**.

Uneven, mottled, or mealy appearance

Cause: Too little time or not enough agitation in developer. Exhausted developer. *Prevention:* Develop prints with constant agitation in fresh developer for no less than the recommended time. Do not pull a print out of the developer early if it starts to look too dark; remake with less exposure.

Fingerprints

Cause: Touching film or paper with chemical-laden or greasy fingers. Fixer is the usual chemical culprit.

Prevention: Rinse and dry hands before handling film or paper, especially after handling fixer. Handle film and paper by edges.

Prints fade

Cause: Prints that fade immediately were bleached by too much time in fixer or an overly strong fixer. Later fading is due to inadequate fixing or washing.

Prevention: Review and follow fixing and washing procedure, pages 101-102.

Yellowish or brownish stains

Cause: Processing faults of numerous kinds, such as too much time in developer, exhausted developer, exposing developing print to air by lifting it out of the developer for too long to look at it, delay in placing print in stop bath or fixer, exhausted stop bath or fixer, inadequate agitation in fixer, too little fixing, inadequate washing. Inadequate fixing also causes brownish-purple stains.

Prevention: Review and follow processing procedure, pages 100-102.

Fogging (gray cast in highlights or paper margins)

Cause: Usually due to exposure of paper to unwanted light before fixing, such as from light leaking into darkroom from outside, light from safelight too strong or too close, paper stored in package that is not light-tight, turning on room light too soon after print is placed in fixer. May be caused by too much time in developer, by old paper, or by paper stored near heat.

Prevention: Check all the above.

Entire print out of focus, negative is sharp

Cause: Vibration of enlarger during exposure. Enlarger never focused properly. Buckling of negative during exposure due to heat from enlarger lamp can cause all or part of the print to go out of focus.

Prevention: Avoid jostling the enlarger or its base just before or during the exposure; push the timer button gently. Focus carefully. Avoid extremely long exposures.

White specks

Cause: Most likely, dust on negative. Possibly, dust on printing paper during exposure. *Prevention:* Blow or brush dust off negative and negative carrier before printing. Keep the enlarger area as free of dust and dirt as possible.

Dark specks or spots. See Pinholes and Airbells, page 93.

MOUNTING A PRINT

Why mount a print? Besides the fact that mounting protects a print from creases, dents, and tears, you'll find that you (and your viewers) are likely to give more serious attention to and spend more time looking at a finished and mounted final print than at an unmounted workprint.

There are several ways to mount a print. Dry mounting is the most common. A sheet of dry-mount tissue bonds the print firmly to a piece of mount board when the sandwich of board, tissue, and print is heated in a mounting press. You can dry mount a print with a border or without one (pages **120–122**).

Overmatting (pages **122–123**) provides a raised border that helps protect the surface of the print. If you frame a print, the overmat will keep the print surface from touching and possibly sticking to the glass.

If you are mounting prints from digitalimaging output, overmat rather than use heat with dye-sublimation or thermal-wax prints. Heat-mounting will not physically damage an ink-jet print, but the heat may shorten the display life of its colors.

You have quality choices in the materials you use. Archival mounting stock (also called museum board) is the most expensive. It is made of rag fiber, instead of wood pulp. It is free of the acids that in time can cause paper to deteriorate, and is preferred by museums, collectors, and others concerned with longterm preservation. Most prints, however, can be happily mounted on less-expensive but good-quality stock available in most art supply stores. If you want a print to last for even a few years, avoid long-term contact with materials such as brown paper, ordinary cardboard, most cheap papers, and glassine. Don't use directly on the print brown paper tape, rubber cement, animal glues, spray adhesives, or any kind of pressure-sensitive tape, such as masking tape or cellophane tape.

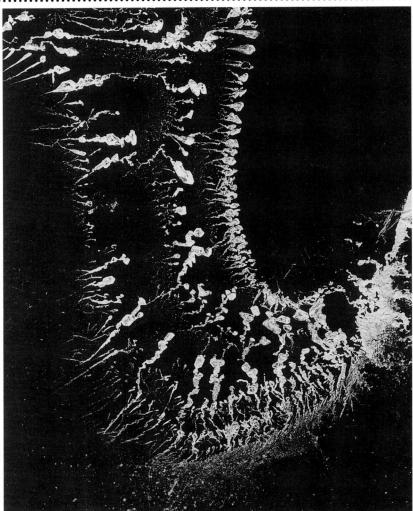

What should you photograph? The answer is anything you like. Photographs are waiting in unexpected places, so don't limit your pictures to landscapes, portraits, and other predictable subject matter. Here, chemicals in the bottom of a black plastic processing tray had crystallized into an abstract pattern.

Equipment and materials you'll need

MOUNTING EQUIPMENT

4 0 0

Utility knife with sharp blade trims the mounting stock and other materials to size. A paper cutter can be used for lightweight materials, but make sure the blade is aligned squarely and cuts smoothly.

Mat cutter holds a knife blade that can be rotated to cut either a perpendicular edge or a beveled (angled) one. It can be easier to use than an ordinary knife, especially for cutting windows in overmats.

Metal ruler measures the print and board and acts as a guide for the knife or mat cutter. A wooden or plastic ruler is not as good because the knife can cut into it.

Miscellaneous: pencil, soft eraser. *Optional:* fine sandpaper or an emery board for smoothing inside edges of overmat window, Tsquare to make it easier to get square corners. For archival or other purposes where extra care is required, cotton gloves protect mat or print during handling.

Mounting press heats and applies pressure to the print, dry-mount tissue, and mounting board to bond the print to the board. It can also flatten unmounted fiberbase prints, which tend to curl. You can use an ordinary household iron to mount prints if no press is available, but the press does a much better job.

Tacking iron bonds a small area of the drymount tissue to the back of the print and the front of the mounting board to keep the print in position until it is put in the press. Again, you can use a household iron, but the tacking iron works better.

MOUNTING MATERIALS

Mount board (also called *mat board*) is available in numerous colors, thicknesses, and surface finishes.

Color. The most frequent choice is a neutral white, because it does not distract attention away from the print. However, some photographers prefer an off-white, gray, or black mount.

Thickness. The thickness or weight of the board is stated as its ply: 2-ply (singleweight) board is lightweight and good for smaller prints; more expensive, 4-ply (doubleweight) board is better for larger prints.

Surface finish. Finishes range from glossy to highly textured. A matte, not overly textured surface is neutral and unobtrusive.

Size. Boards are available precut in standard sizes or an art supply store can cut them for you, but it is often less expensive to buy a large piece of board and cut it down yourself. A full sheet is usually 30 x 40 inches.

Quality. See information opposite about quality choices in mounting materials. Archival quality is best but not a necessity for most prints.

Dry-mount tissue is a thin sheet of paper coated on both sides with a waxy adhesive that becomes sticky when heated. Placed between the print and the mount board, the tissue bonds the print firmly to the board.

Several types are available, including one for fiber-base papers and one used at lower temperatures for either RC or fiber-base papers. Some are removable, which lets you readjust the position of a print; others make a permanent bond.

Cold-mount tissues do not require a heated mounting press. Some adhere on contact, others do not adhere until pressure is applied, so that, if necessary, they can be repositioned.

A cover sheet protects the print or mount from surface damage. Use a light-weight piece of paper as a cover sheet between each print in a stack of mounted prints to prevent surface abrasion if one print slides across another. Use a heavy piece of paper or piece of mount board as a cover sheet over the surface of the print when in the mounting press.

Release paper can be useful, for example, between the cover sheet and a print in the mounting press. It will not bond to hot drymount tissue in case a bit of tissue protrudes beyond the edge of the print.

Tape hinges a print or an overmat to a backing board. Gummed linen tape is best and should always be used for hinge mounting a print. Ideally, use linen tape to hinge an overmat to a backing board, but less expensive tape is also usable.

DRY MOUNTING A PRINT STEP BY STEP

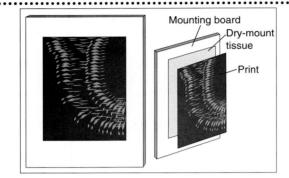

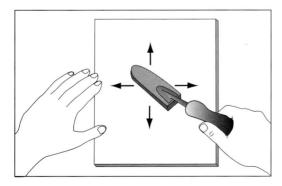

Dry mounting provides a good-looking, stable support for a print. Shown here is a mount with a wide border around the print. Bleed mounting, a borderless mounting, is shown on page **122**. The mounting materials, the print, and the inner surfaces of the press should be clean; even a small particle of dirt can create a bump or dent when the print is put under pressure in the press.

Wearing cotton gloves when handling the print will keep smudges and fingerprints off the surface. When cutting, use a piece of cardboard underneath to protect the surface on which you are working. Several light cuts often work better than just one cut, especially with thick mounting board. The blade must be sharp, so be careful of your fingers.

1 Cut the mounting board to size using the knife or mat cutter and the metal ruler as a guide. Press firmly on the ruler to keep it from slipping. A T-square can help you get corners square.

Standardizing the size of your mount boards makes a stack of mounted prints somewhat neater to handle, and makes it easier to switch prints in a frame. 8 x 10-inch prints are often mounted on 11 x 14-inch or 14 x 17-inch boards. Generally, the board is positioned vertically for a vertical print, horizontally for a horizontal print. Some photographers like the same size border all around; others prefer the same size border on sides and top, with a slightly larger border on the bottom.

2 Heat the press and dry the materials. If you are mounting a fiberbase print, heat the dry-mount press to $180^{\circ}-210^{\circ}F(82^{\circ}-99^{\circ}C)$ or to the temperature recommended by the dry-mount tissue manufacturer. Put the board, with a protective cover sheet on top, in the heated press for a minute to drive out any moisture. Repeat with the print. The heating will also take any curl out of the print, making it easier to handle.

For a resin-coated (RC) print, use low-temperature dry-mount tissue made for RC papers. The press must be no hotter than 210°F (99°C) or the print may melt. Temperature control is inaccurate on many presses, so 200°F (93°C) is safer. There is no need to preheat an RC print, just the board and cover sheet.

3 Tack the dry-mounting tissue to the print. Heat the tacking iron (be sure to use a low setting for RC prints). Put the print face down on a clean, smooth surface, such as another piece of mounting board. Cover the back of the print with a piece of dry-mount tissue. Tack the tissue to the print by moving the hot iron smoothly from the center of the tissue a little way toward the sides. Do not tack at the corners. Do not wrinkle the tissue or it will show as a crease on the front of the mounted print.

4 Trim the print and dry-mount tissue. Turn the print and dry-mount tissue face up. Use the knife or mat cutter to trim off the white print borders, along with the tissue underneath them. Cut straight down so that the edges of the print and tissue are even. Press firmly on the ruler when making the cut, and watch your fingers.

5 Position the print on the mount board. First, position the print so that the side margins of the board are equal. Then adjust the print top to bottom. Finally, remeasure the side margins to make sure that they are even. Measure each side two times, from each corner of the print to the edge of the board. If the print is slightly tilted, it will be noticeable at the corners even though the print measures evenly at the middle.

To keep the print from slipping out of place, hold the print down gently with one hand or put a piece of paper on the print and a weight on top of that.

6 Tack the dry-mount tissue and print to the board. Slightly raise one corner of the print and tack that corner of the tissue to the board by making a short stroke toward the corner with the hot tacking iron. Keep the tissue flat against the board to prevent wrinkles, and be careful not to move the print out of place on the board. Repeat at the diagonally opposite corner.

7Mount the print. Put the sandwich of board, tissue, and print in the heated press with the protective cover sheet on top. If you have release paper, put it between the print and the cover sheet. Clamp the press shut for about 30 sec. or until the print is bonded firmly to the board. You can test the bond by flexing the board slightly after it has cooled.

Both time and temperature in the press affect the bonding. If the print does not bond, first try more time in the press. If the print still does not bond, increase the press temperature slightly.

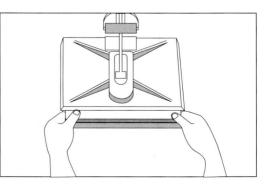

Bleed mounting/overmatting

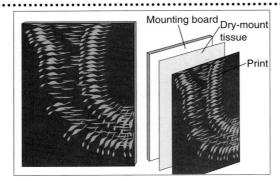

A bleed-mounted print is even with the edges of the mount.

1 Prepare the print and mount board. Cut the mount board, dry the materials, and tack the mounting tissue to the print (steps 1, 2, and 3 on page **120**). In step 1, the board can be the same size or slightly larger than the print.

Trim off any excess dry-mount tissue so that the edges of the tissue are even with the edges of the print. Then tack the dry-mount tissue and print to the board, and heat in the press (steps 6 and 7, page **121**).

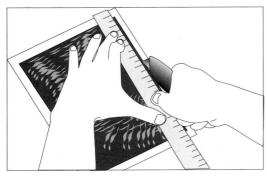

2 Trim the mounted print. Place the mounted print face up and trim off the white print borders, along with the mount board underneath, using the ruler as a guide. A T-square can help you get the corners square. Hold the knife blade vertically so that it makes an edge that is perpendicular to the surface of the print. Press firmly on the ruler, and watch your fingers.

Because the edges of a bleed-mounted print come right up to the edges of the mount board, be careful when handling the mounted print so you don't accidentally chip or otherwise damage the edges.

.....

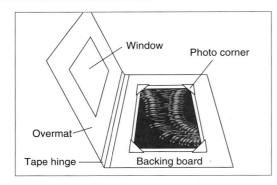

An overmatted print has a raised border around the print. It consists of an overmat (a piece of mount board with a hole cut in it) placed over a print that is attached to another piece of mount board (the backing board). The overmat helps protect the print and can be easily replaced if it becomes soiled or damaged. After overmatting, the print can be framed or displayed as is.

Overmatting is the preferred means of mounting a print if you are interested in archival preservation, or if a print will be framed behind glass. A photograph pressed directly against glass can in time stick permanently to the glass.

Mark the window on the mount board. First, measure the dimensions of the image to show through the window.

Cut two pieces of mount board. To find the size of the boards, add the dimensions of the window to that of the borders. A 7 x 9-inch vertical window, with a 2-inch border on sides and top and a 3-inch border on the bottom, will require an 11 x 14-inch mount (7 + 2 + 2 = 11; 9 + 2 + 3 = 14).

Mark the back of one board for the inner cut. Be sure the window aligns squarely to the edges of the board. A T-square, if you have one, will help.

2 Cut the window. It takes practice to cut the inner edges of the overmat, especially at the corners, so practice with some scraps before you cut into good board. Press firmly on the metal ruler so it does not slip, and take care to keep the cutting blade at the same angle for each cut. You can tilt the blade to make a beveled cut or hold it straight. A mat cutter, which holds a blade at a fixed angle, is easiest to use for this.

Cut each side of the window just to the corner, not past it. You may want to stop very slightly short of the corner, then finish the cut with a separate, very sharp blade. If the cut edges of the window are a bit rough, you can smooth them with very fine sandpaper or an emery board.

Busice the second stogether by running a strip of tape along a back edge of the overmat and a front edge of the backing board (see illustration on opposite page, second from bottom). You may not need to hinge the boards together if you intend to frame the print.

Position and attach the print. Slip the print between the backing board and the overmat. Align the print with the window. The print can be dry mounted to the backing board or attached with photo corners or hinges (see below).

4 Photo corners, like the ones used to mount pictures in photo albums, are an easy way to attach a print to a backing board. The print can be taken out of the corners and off the mount at any time. The corners are hidden by the overmat. You can buy corners or make your own from paper (right) and attach them to the board with a piece of tape.

5 Hinges hold the print in place with strips of tape attached to the upper back edge of the print and to the backing board.

A folded hinge (left) is hidden when the print is in place. Use a piece of tape to reinforce the part of the hinge that attaches to the mounting board.

A pendant hinge (right) is hidden by the overmat.

QUALITIES OF LIGHT: From direct to diffused 126 EXISTING LIGHT: Use what's available 128 THE MAIN LIGHT: The strongest source of light 130 FILL LIGHT: To lighten shadows 132 SIMPLE PORTRAIT LIGHTING 134 USING ARTIFICIAL LIGHT: Photolamp or flash 136 More About Flash: How to position it 138 Solving Flash Problems 140

LIGHTING

Changes in lighting will change your picture. Outdoors, if clouds darken the sky, or you change position so that your subject is lit from behind, or you move from a bright area to the shade, your pictures will change as a result. Light changes indoors, too: your subject may move closer to a sunny window, or you may turn on overhead lights or decide to use flash lighting.

Light can affect the feeling of the photograph so that a subject appears, for example, brilliant and crisp, hazy and soft, stark or romantic. If you make a point of observing the light on your subject, you will soon learn to predict how it will look in your photographs, and you will find it easier to use existing light or to arrange the lighting yourself to get just the effect you want.

Look at the light on your subject. Light can be as important a part of the picture as the subject itself. Below, a bright pattern of light pierces the darkness under Chicago's elevated transit tracks. Opposite, lights themselves add interest to the picture. Stage lighting is often very contrasty, with spotlit areas surrounded by a black background.

QUALITIES OF LIGHT From direct to diffused

Whether indoors or out, light can range from direct and contrasty to diffused and soft. Here's how to identify these different qualities of light and predict how they will look in your photograph.

Direct light is high in contrast. It creates bright highlights and dark shadows with sharp edges. Photographic materials, particularly color slides, cannot record details in very light and very dark areas at the same time, so directly lit areas may appear brilliant and bold, with shadowed ones almost entirely black. If you are photographing in direct light, you may want to add fill light (pages **132–133**) to lighten shadows. Because direct light is often quite bright, you can use a small aperture to give plenty of depth of field, a fast shutter speed to stop motion, or both, if the light is bright enough.

The sun on a clear day is a common source of direct light. Indoors, a flash or photolamp pointed directly at your subject (that is, not bounced off another surface) also provides direct light.

Diffused light is low in contrast. It bathes subjects in light from all sides so that shadows are weak or even absent. Colors are less Direct Light

Compare the qualities of light in these pictures. Direct light—contrasty, with hard-edged shadows. Diffused light—indirect and soft. Directional/diffused light—some shadows, but softer-edged than indirect light.

PROJECT THE SAME SUBJECT IN DIFFERENT LIGHT

PROCEDURE Photograph the same person in several different lighting situations. For example, on a sunny day begin by photographing outdoors in the sun. Try not to work at noon, when the sun is directly overhead. Light usually appears more interesting in the morning or afternoon, when the sun is at an angle to the subject. Make several exposures in each situation.

Work relatively close: head-and-shoulders rather than full-length views. First, have the sun behind your back, so it shines directly into the person's face. Then move your subject so that the sun is shining on them from the side. Then have the sun behind the person, so he or she is backlit. (Page **68** tells how to meter backlit scenes.)

Make several photographs in diffused natural light, for example, under a tree or in the shade of a building. Make some indoors, with the person illuminated by light coming from a window.

As a comparison to sunlight in the morning or afternoon, you could also make some photographs at noon with the subject lit by the sun overhead. Select the best portrait in each type of light.

HOW DID YOU DO? What do you see that is different among the various photographs? Is there more texture visible in some shots? Do the shadows seem too dark in some? (Pages **132–133** tell how to use fill light to make shadows lighter.) How does the light affect the modeling (the appearance of volume) of the face? Light not only changes the way a subject appears in a photograph, it can change the way we perceive or feel about them. Do some of the portraits appear softer? Harsher? More dramatic?

likely to be pastel or muted in tone. Because diffused light is likely to be dimmer than direct light, you might not be able to use a small aperture with a fast shutter speed. A heavily overcast day creates diffused

brilliant than they are in direct light and are

light because the light is cast evenly by the whole dome of the sky rather than, as it is on a sunny day, mostly by the small disc of the sun. Indoors, diffused light can be created with a very broad source of light used close to the subject (such as light bounced into a large umbrella reflector) plus additional fill light. (Page **135** shows an umbrella reflector used in a lighting setup.)

Directional/diffused light is intermediate in contrast. It is partly direct and partly diffused. Shadows are present, but they are softer and not as dark as those cast by direct light.

You will encounter directional/diffused light on a hazy day when the sun's rays are somewhat scattered so that light comes from the surrounding sky as well as from the sun. A shaded area, such as under trees or along the shady side of a building, can have directional/diffused light if the light is bouncing onto the scene primarily from one direction. Indoors, a skylight or other large window can give this type of light if the sun is not shining directly on the subject. Light from a flash or photolamp can also be directional/diffused if it is softened by a translucent diffusing material placed in front of the light or if it is bounced off another surface such as a wall or an umbrella reflector.

Diffused Light

Don't wait for a bright, sunny day to go photographing. You can take pictures even if the light is dim: indoors, in the rain or snow, at dawn or dusk. If you see a scene that appeals to you, you can find a way to photograph it. A fast film, one with an ISO rating of at least 400, is useful when light is dim. It will help you shoot at a fast enough shutter speed to stop motion, or at a small enough aperture to give adequate depth of field. A tripod can steady a camera for long exposures.

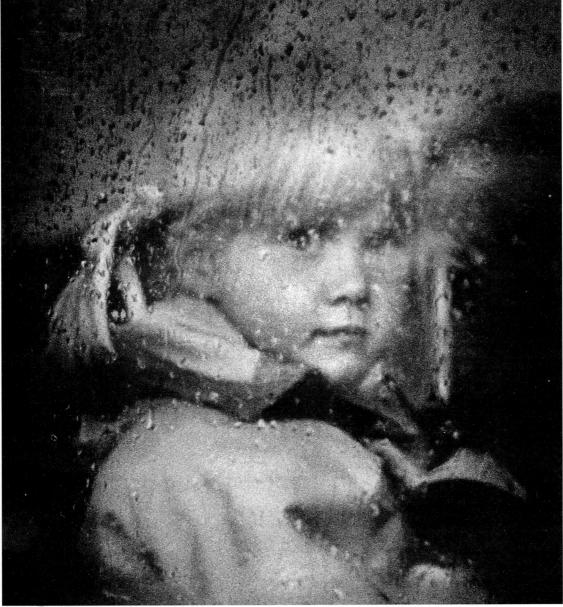

Rain as it is actually falling is difficult to photograph. but you have other options, such as people in the rain, reflections in rain puddles, or rain dripping from leaves and other objects. Michele McDonald, a photojournalist, was on assignment looking for a "rain picture" for her newspaper when she saw a little girl and her mother. She photographed them as they ran down the sidewalk to their car, then took this last-and best-picture through the car window.

Michele McDonale

At dusk, look for objects that are still reflecting light. This picture was made late in the evening after a rain. The road and wires were still wet and reflected the last of the day's light, making them stand out against the dark surrounding area.

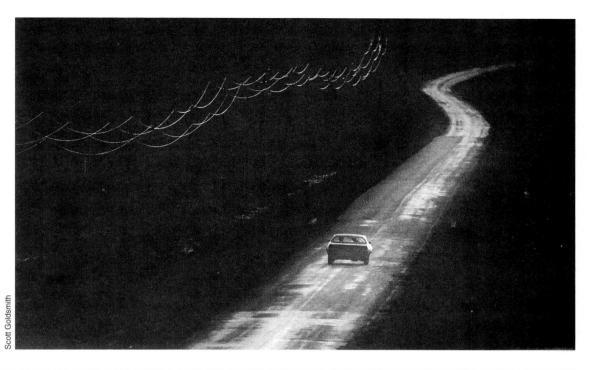

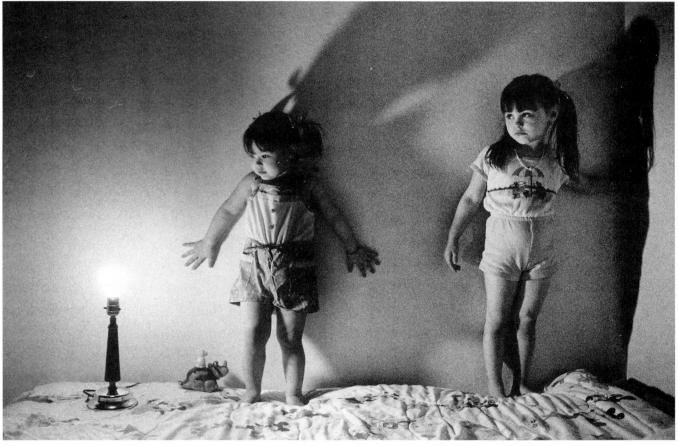

In extremely dim light, here a single light bulb, try an ultra-fast film like Kodak T-Max P3200, which has a film speed of 3200. Bracketing is always a good idea in marginal lighting situations. Make several extra shots, increasing the exposure, then decreasing it.

THE MAIN LIGHT The strongest source of light

The most realistic and usually the most pleasing lighting resembles daylight, the light we see most often: one main source of light from above creating a single set of shadows. Lighting seems unrealistic (though there may be times when you will want that) if it comes from below or if it comes from two or more equally strong sources that produce shadows going in different directions.

Shadows create the lighting. Although photographers talk about the quality of light coming from a particular source, it is actually the shadows created by the light that can make an image harsh or soft, menacing or appealing. To a great extent, the shadows determine the solidity or volume that shapes appear to have, the degree to which texture is shown, and sometimes the mood or emotion of the picture.

Front lighting. Here the main light is placed close to the lens, as when a flash unit attached to the camera is pointed directly at the subject. Fewer shadows are visible from camera position with this type of lighting than with others and, as a result, forms seem flattened and textures less pronounced. Many news photos and snapshots are frontlit because it is simple and quick to shoot with the flash on the camera.

The main light, the brightest light shining on a subject, creates the strongest shadows. If you are trying to set up a lighting arrangement, look at the subject from camera position. Notice the way the shadows shape or model the subject as you move the main light around or as you change the position of the subject in relation to a fixed main light.

Direct light from a 500-watt photolamp in a bowl-shaped metal reflector was used for these photographs, producing shadows that are hard-edged and dark. Direct sunlight or direct flash will produce similar effects. The light would be softer if it were bounced onto the subject from another surface, such as an umbrella reflector (shown on page **135**), or if it were diffused. Fill light (see next pages) would lighten the shadows.

High 45° lighting. If the main light is moved high and to the side of the camera, not precisely at 45° but somewhere in that vicinity, shadows model the face to a rounded shape and emphasize textures more than with front lighting. This is often the main light position used in commercial portrait studios; fill light would then be added to lighten the shadows.

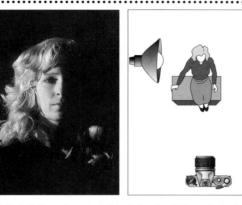

Side lighting. A main light at about a 90° angle to the camera will light the subject brightly on one side and cast shadows across the other side. When the sun is low on the horizon at sunset or sunrise, it can create side lighting that adds interest to landscapes and other outdoor scenes. Side lighting is sometimes used to dramatize a portrait.

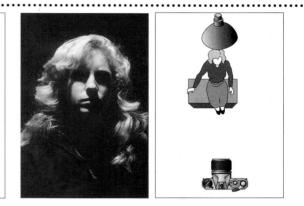

Top lighting. With the light directly overhead, long dark shadows are cast into eye sockets and under nose and chin, producing an effect that is seldom appealing for portraits. Unfortunately, top lighting is not uncommon—outdoors at noon when the sun is overhead or indoors when the main light is coming from ceiling fixtures. Fill light added to lighten the shadows can help (see next page).

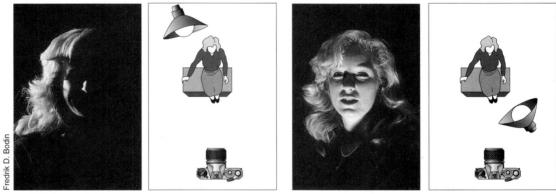

Back lighting. Here the light is moved around farther to the back of the subject than it is for side lighting. If the light were directly behind the subject, the entire face would be in shadow with just the hair outlined by a rim of light. Back lighting, also called edge or rim lighting, is used in multiple-light setups to bring out texture or to separate the subject from the background.

Bottom lighting. Lighting that comes from below looks distinctly odd in a portrait. This is because light on people outdoors or indoors almost never comes from below. This type of light casts unnatural shadows that often create a menacing effect. Some products, however—glassware, for example—are effectively lit from below; such lighting is often seen in advertising photographs.

FILL LIGHT To lighten shadows

Fill light makes shadows less dark by adding light to them. Photographic materials can record detail and texture in either brightly lit areas or deeply shadowed ones but generally not in both at the same time. So if important shadow areas are much darker than lit areas—for example, the shaded side of a person's face in a sunlit portrait—consider whether adding fill light will improve your picture. The fill light should not overpower the main light but simply raise the light level of shadow areas so that you can see clear detail in the final print.

When do you need fill light? Color transparencies need fill light more than prints do. As little as two stops difference between lit and shaded areas can make shadows very dark, even black, in a color slide. The film in the camera is the final product when shooting slides, so corrections can't be made later during printing. Color prints are also sensitive to contrast, though somewhat less so than slides.

Black-and-white prints can handle more contrast between highlights and shadows than color materials can. In a black-and-white portrait of a partly shaded subject, shadows that are two stops darker than the lit side of the face will be dark but still show full texture and detail. But when shadows get to be three or more stops darker than lit areas, fill light becomes useful. You can also control contrast between highlights and shadows in black-and-white prints in other ways. You can, for example, print on a paper of a lower contrast grade (see pages 110-111). However, results are often better if you control the contrast by adding fill light, rather than trying to lighten a too-dark shadow when printing.

Fill light indoors. Light from a single photoflood or flash often produces a very con-

trasty light in which the shaded side of the face will be very dark if the lit side of the face is exposed and printed normally. Notice how dark the shaded areas are in the single-light portraits on pages **130–131**. You might want such contrasty lighting for certain photographs, but ordinarily fill light should be added to make the shadows lighter.

Fill light outdoors. It is easier to get a pleasant expression on a person's face in a sunlit outdoor portrait if the subject is lit from the side or from behind and is not squinting directly into the sun. These positions, however, can make the shadowed side of the face too dark. In such cases, you can add fill light to decrease the contrast between the lit and shadowed sides of the face (see right). You can also use fill light outdoors for close-ups of flowers or other relatively small objects in which the shadows would otherwise be too dark.

Sources of fill light. A reflector, such as a white card or cloth, is a good way to add fill light indoors or out. An aluminized "spaceblanket" from a camping-supply store is easy to carry and highly reflective. Holding the reflector at the correct angle, usually on the opposite side of the subject from the main light, will reflect some of the light from the main light into the shadows.

A flash can be used for fill light indoors or outdoors. A unit in which the brightness of the flash can be adjusted is much easier to use than one with a fixed output. Some flash units designed for use with automatic cameras provide fill flash automatically.

In indoor setups, light from a photoflood can be used for fill light. To keep the fill light from overpowering the main light, the fill can be farther from the subject than the main light, of lesser intensity, bounced, or diffused. See photographs opposite.

Front light. The man's face is lit by sunlight shining directly on it. Facing into the sun caused an awkward squint against the bright light.

Back light. Here he faces away from the sun and has a more relaxed expression. Increasing the exposure would lighten the shadowed side of his face but make the lit side very light.

Back light plus fill light. Here he still faces away from the sun, but fill light has been added to lighten the shaded side of the face.

Using a reflector for fill light. A large white cloth or card can lighten shadows in backlit or sidelit portraits by reflecting onto the shaded side of the subject some of the illumination from the main light. Sometimes nearby objects will act as natural reflectors, such as sand, snow, water, or a lightcolored wall. At left, an assistant holds the reflector for the photographer, but in many cases the reflector can simply be propped up. The closer the reflector is to the subject, the more light it will reflect into the shadows.

For a portrait, try to angle the reflector to add enough fill light so that the shadowed side of the face is one to two stops darker than the sunlit side. Here's how to count the number of stops' difference. Meter only the lit side and note the shutter-speed and aperture settings. Meter only the shadowed side and note the shutter speed and aperture. The number of f-stops (or shutter-speed settings) between the two exposures equals the number of stops' difference.

Using flash for fill light. To lighten the shadows on the man's face, the photographer attached a flash unit to her camera. If the flash light is too bright, it can overpower the main light and create an unnatural effect. To prevent this, the photographer set the flash for manual operation and draped a handkerchief over the flash head to decrease the intensity of the light. She could also have stepped back from the subject (although this would have changed the framing of the scene), or, with some flash units, decreased the light output of the flash.

See your owner's manual for instructions on how to set your camera and flash for fill lighting. In general, for a subject that is partly lit and partly shaded, decrease the brightness of the flash on the subject until it is one to two stops less than the basic exposure from the sun.

Using a photoflood for fill light. The photographer placed the main light at about a 45° angle to the left, then positioned a second photoflood on the right side of the camera so that it increased the brightness of the shadows. This fill light was placed close to the camera's lens so that it did not create secondary shadows that would be visible from camera position. The main light was placed closer to the subject so that it would be stronger than the fill light.

Meter the lit side of the scene and the shaded side, then adjust the lights until the shaded side is one to two stops darker than the lit side. To get an accurate reading, you must meter each area separately without including the background or other areas of different brightness. If you are photographing very small objects, you can use a spot meter or make substitution readings from a photographic gray card positioned first on the lit side, then on the shadowed side.

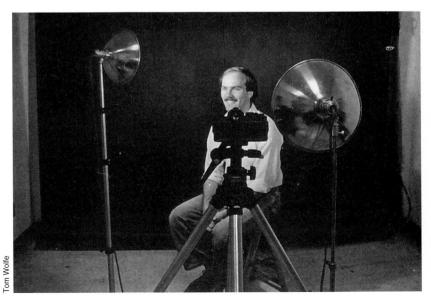

SIMPLE PORTRAIT LIGHTING

Many fine portraits have been made using simple lighting setups. You don't need a complicated arrangement of lights to make a good portrait. In fact, the simpler the setup, the more comfortable and relaxed your subject is likely to be. (See pages **168–171** for more about photographing people.)

Outdoors, open shade or an overcast sky surrounds a subject in soft, even lighting (photograph this page). In open shade, the person is out of direct sunlight, perhaps under a tree or in the shade of a building. Illumination comes from light reflected from the ground, a nearby wall, or other surfaces. If the sun is hidden by an overcast or cloudy sky, light is scattered over the subject from the entire sky. Indirect sunlight is relatively bluish, compared with direct sunlight. If you are shooting color film, a 1A (skylight) or 81A (yellowish) filter on the camera will help remove excess blue.

Indoors, window light is a convenient source of light during the day (see opposite, top). The closer your subject is to the window, the brighter the light will be. If direct sunlight is shining through the window and falls on the subject, contrast will be very high: lit areas very light, unlit areas very dark. Unless you want extreme contrast, it's best to have the subject lit by indirect light bouncing off other surfaces first. A reflector opposite the window can lighten shadows by adding fill light to the side of the person facing away from the window.

A main light—photoflood or flash—plus reflector fill is a simple setup when available light is inadequate (see opposite bottom). Bouncing the light into an umbrella reflector provides a softer light than shining it directly onto the subject.

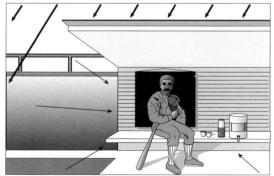

In open shade outdoors, a building, tree, or other object blocks the direct rays of the sun. Softer, indirect light bounces onto the subject. Here, the ballplayer was shaded by the dugout roof. The photographer hung a black cloth on the dugout wall to provide a plain background.

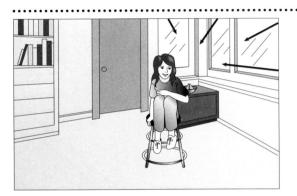

Window light is bright on the parts of the scene that face the window but is usually dark in areas that face away from the window. Here the light was indirect, bouncing into the room from nearby areas outside. Contrast between light and dark tones would have been even greater if direct rays of light from the sun had been shining through the window.

If contrast seems too strong between the lit and shaded sides of the face, use a reflector card to bounce some of the window light onto the shaded side (see the card used for fill in the portrait below).

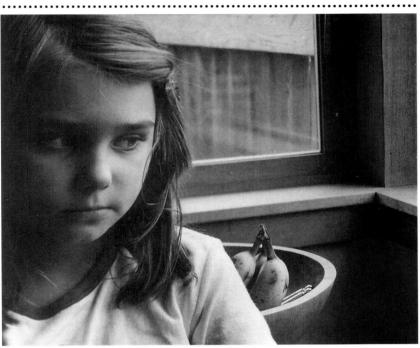

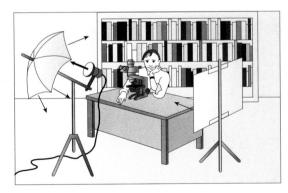

A main light plus reflector fill is the simplest setup when you want to arrange the lighting yourself. The main source of light is from a photoflood or flash pointed into an umbrella reflector that is then pointed at the subject. A reflector on the other side of the subject bounces some of the light back to lighten the shadows.

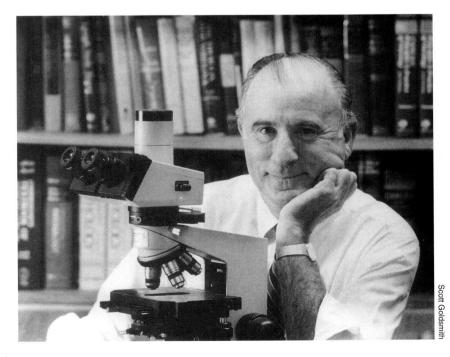

USING ARTIFICIAL LIGHT Photolamp or flash

Artificial light sources let you bring your own light with you when the sun goes down, when you photograph in a relatively dark room, or when you need just a little more light than is available naturally. Artificial sources are consistent and never go behind a cloud just when you're ready to take a picture. You can manipulate them to produce any effect you want—from light that looks like natural sunlight to underlighting effects that are seldom found in nature. Different sources produce light of different color balances, an important factor if you are using color films.

Continuously burning (incandescent) lamps such as photolamps and quartz lamps plug into an electrical outlet. Because they let you see how the light affects the subject, they are excellent for portraits, still lifes, and other stationary subjects that give you time to adjust the light exactly. Determining the exposure is easy: you meter the brightness of the light just as you do outdoors.

Flashbulbs are conveniently portable, powered by small battery units. Each bulb puts out one powerful, brief flash and then must be replaced. Not so many years ago, press photographers could be followed by the trail of spent flashbulbs they left as they threw away a bulb after each shot. Today, flashbulbs are still in use for some special purposes, but are mainly used with snapshot cameras that accept flashcube or flipflash units.

Electronic flash or strobe is the most popular source of portable light. Power can come from either batteries or an electrical outlet. Some units are built into cameras, but the more powerful ones, which can light objects at a greater distance, are a separate accessory. Because electronic flash is fast enough to freeze most motion, it is a good choice when you need to light unposed shots or moving subjects. Flash must be synchronized with the camera's shutter so that the flash of light occurs when the shutter is fully open. With a 35mm single-lens reflex or other camera that has a focal-plane shutter, shutter speeds of 1/60 sec. or slower will synchronize with electronic flash; some models have shutters that synchronize at speeds up to 1/300 sec. At shutter speeds faster than that, the camera's shutter curtains are open only part of the way at any time so only part of the film would be exposed. Cameras with leaf shutters synchronize with flash at any shutter speed. See your owner's manual for details on how to set the camera and connect the flash to it.

Automatic flash units have a sensor that measures the amount of light reflected by the subject during the flash; the unit terminates the flash when the exposure is adequate. Even if you have an automatic unit, sometimes you will want to calculate and set the flash exposure manually, such as when the subject is very close to the flash or very far from it and not within the automatic flash range.

Determining your own exposure with flash

is different from doing so with other light sources because the flash of light is too brief to measure with an ordinary light meter. Professionals use a special flash meter, but you can calculate your own flash exposure without one. The farther the subject is from a

Automatic electronic flash is a standard accessory for an automatic exposure 35mm camera. The flash has a light-sensitive cell and electronic circuitry that sets the duration of the flash by metering the amount of light reflected by the subject during the exposure.

The inverse square law is the basis for flash exposure calculations. The farther that light travels, the more the light rays spread out and the dimmer the resulting illumination. The law states that at twice a given distance, an object receives only one fourth the light (intensity of illumination is inversely proportional to the square of the distance from light to subject). In the illustration here, only one fourth the amount of light falls on an object at 10 ft. from a light source as on an object at 5 ft. from the source.

To calculate your own flash exposure, you need to

f-stop that should be used.

know two things: the distance that the light travels to the subject and the guide number (a rating given by the manufacturer for the flash when used with a specific film speed). Divide the distance that the light travels from flash unit to subject into the guide number. The result is the lens

Some flash units have a calculator dial that will do the division for you. Dial in the film speed and the flash-to-

subject distance and the dial will show the correct f-stop.

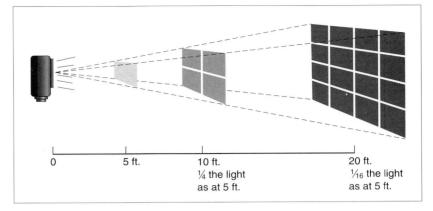

Manually Calculating a Direct Flash Exposure

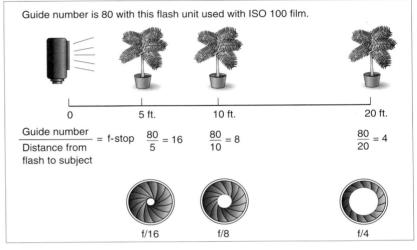

Manually Calculating a Bounce Flash Exposure

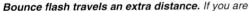

calculating a bounce flash exposure, measure the distance not from flash to subject but from flash to reflecting surface to subject. In addition, open the lens aperture an extra onehalf stop or full stop to allow for light absorbed by the reflecting surface. Open even more if the reflecting surface is not white or is very light in tone.

Some automatic flash units have a head that can be swiveled to the side or above for bounce flash while the flash sensor remains pointed at the subject. This type of unit can automatically calculate a bounce flash exposure because no matter where the head is pointed, the sensor will read the light reflected from the subject toward the camera. Some cameras can measure flash light through the lens: these also can be used automatically with bounce flash.

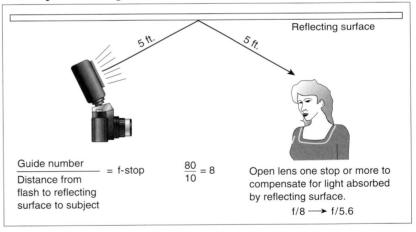

given flash unit, the dimmer the light that it receives and so the more you need to open the lens aperture. (Changing the shutter speed, within the acceptable range for synchronization, does not affect a flash exposure.)

You determine the amount of light falling on the subject by dividing the distance to the subject into the flash unit's output (its guide number). Then you set the aperture accordingly (see illustrations above). Some manufacturers overrate guide numbers a bit (in order to make their products sound more powerful than they actually are), so it's a good idea to try out a new flash unit with a roll of test film or a professional flash meter before you use it for anything important.

MORE ABOUT FLASH How to position it

Light gets dimmer the farther it travels.

Light from any source—a window, a continuously burning lamp, a flash—follows the same general rule: The light falls off (gets dimmer) the farther the light source is from an object. You can see and measure that effect if, for example, you meter objects that are near a bright lamp compared to those that are farther away. But light from a flash comes and goes so fast that you can't see the effect of the flash on a scene at the time you are taking the picture. Special exposure meters are designed for use with flash; you can't use an ordinary exposure meter to measure the flash.

A flash-lit scene may not be evenly illuminated. Because light from a flash gets dimmer the farther it travels, you have to use a smaller lens aperture for subjects close to the flash, a wider aperture for subjects farther away. But what do you do if different parts of the same scene are at different distances from the flash?

Sometimes you can rearrange the subject, such as the people in a group portrait, so

that all are more or less at the same distance from the flash. Sometimes you can change your own position so that the flash more evenly reaches various parts of the scene, such as by bouncing the light onto the subject or by using more than one flash unit. If this is not possible, you simply have to work with the fact that those parts of the scene that are farther from the flash will be darker than those that are closer. If you know that the light falls off and gets dimmer the farther it travels, you can at least predict how the flash will illuminate a scene.

Flash portraits. In one way, flash is easy to use for portraits: the flash of light is so fast that you don't have to worry about the subject blurring because it moved during the exposure. But the light from the flash is so quick (1/1000 sec. or shorter) that you can't really see what the subject looks like when lit. However, with some practice you can predict the qualities of light that are typical of different flash positions. Shown on the opposite page are some simple lighting setups for portraiture.

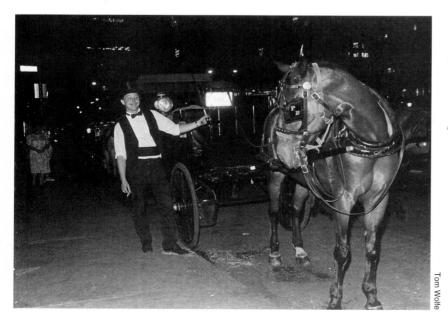

When objects are at different distances from a flash, those that are closer will be lighter than those that are farther away. Notice how dark the people in the background are compared to the driver. Try to position the most important parts of a scene (or position the flash) so that they are more or less at the same distance from the flash.

If this were your photograph, would you crop out the people in the background or leave them there?

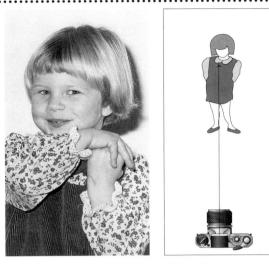

Direct flash on camera is simple and easy to use because the flash is attached to the camera. The light shining straight at the subject from camera position, however, tends to flatten out roundness and gives a rather harsh look.

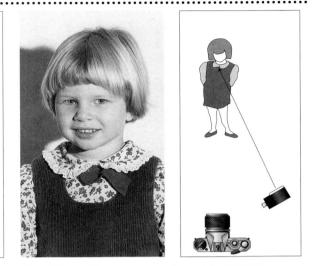

Direct flash off camera—usually raised and to one side—gives more roundness and modeling than does flash on camera. A synchronization (or sync) cord lets you move the flash away from the camera. To avoid a shadow on the wall, move the subject away from it or raise the flash more.

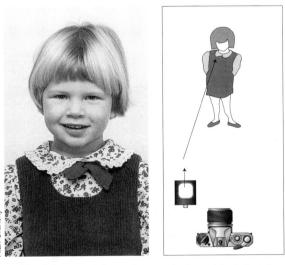

Flash bounced from above onto the subject gives a softer, more natural light than direct flash. Light can also be directed into a large piece of white cardboard or an umbrella reflector and then bounced onto the subject. Bouncing the flash cuts the amount of light that reaches the subject. Some flash units automatically compensate for this, or you can make the exposure adjustment yourself (see page 137).

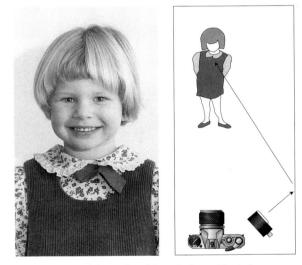

Flash bounced from the side onto the subject gives a soft, flattering light. You can use a light-colored wall, a large piece of white cardboard, or an umbrella reflector. The closer the subject is to the reflector, the more distinct the shadows will be. To avoid a shadow on the back wall, move the subject away from it.

Solving flash problems

Unwanted Reflection

Reflection Eliminated

Only Part of Scene Exposed

Flash can give some unpredictable results when you first start to use it because reflections, shadows, or other effects are almost impossible to see at the time you take the picture. Check below if a flash picture did not turn out the way you expected. See also Solving Camera and Lens Problems, page **45**; Exposure Problems, page **72**; Negative Development Problems, page **92**; and Printing Problems, page **117**.

Unwanted reflection

Cause: Light bouncing back from reflective surfaces such as glass, mirror, or shiny walls (see left, top).

Prevention: Position the camera at an angle to highly reflective surfaces or angle the flash at the subject from off camera. The light will be reflected away at an angle (see left, center).

Red eye. A person's or animal's eyes appear red or amber in a color picture.

Cause: Light reflecting from the blood-rich retina inside the eye.

Prevention: Hold the flash away from the camera or have the subject look slightly to one side. This also prevents bright reflections from eyeglasses, if your subject wears them.

Only part of scene exposed

Cause: Shooting at too fast a shutter speed with a camera that has a focal plane shutter, such as a single-lens reflex camera. The flash fired when the shutter was not fully open (see left, bottom).

Prevention: Check manufacturer's instructions for the correct shutter speed to synchronize with flash, and set the shutter-speed dial accordingly. For most cameras, 1/60 sec. is safe; faster speeds are usable with some cameras. The flash shutter speed may appear on your camera's shutter-speed dial in a different color from the other shutter speeds, or it may be marked with an X.

Part of scene exposed correctly, part too light or too dark

Cause: Objects in the scene were at different distances from the flash, so were exposed to different amounts of light.

Prevention: Try to group important parts of the scene at about the same distance from the flash (see page **138**).

Entire scene too dark or entire scene too light

Cause: Too dark—not enough light reached the film. Too light—too much light reached the film.

Prevention: An occasional frame that is too dark or too light probably results from calculating the lens aperture based on the wrong film speed or making an exposure before the flash is fully charged. If flash pictures are consistently too dark, try setting the flash unit's film-speed dial to one half the speed of the film you are using; the film will then receive one additional stop of exposure. When calculating exposures manually using a guide number, divide the guide number by 1.4 to give one extra stop of exposure. If pictures are consistently too light, try setting the dial to twice the speed of the film you are using or multiplying the guide number by 1.4 to give the film one less stop of exposure.

Flash stops motion. Suspended animation is easy with flash photography. The duration of the flash is so short, ¹/₁₀₀₀ sec. or less, that almost all moving subjects will be sharp.

Notice that the background did not receive enough light from the flash to be seen clearly. The fluorescent lighting fixtures, however, which were themselves emitting light, were bright enough to be recorded.

CLOSE-UPS 144 MORE ABOUT CLOSE-UPS 146

USING FILTERS: How to change film's response to light 148 LENS ATTACHMENTS: Polarization and other effects 150 DIGITAL IMAGING 152 Equipment and materials you'll need 153 EDITING A DIGITAL IMAGE 154

TECHNIQUES

Many special techniques are possible with photography. This chapter concentrates on three major areas: close-ups, filters, and digital imaging.

Close-ups. We are used to seeing and photographing things from viewing distances of several feet or more. But many subjects—a tiny insect, the swirling petals of a flower—have a beauty and intricacy that are seen best from up close. Magnifying a detail of an object can reveal it in a new and unusual way.

A camera that views through the lens, like a single-lens reflex camera or view camera, is excellent for close-up work because you see the exact image that the lens "sees" (cameras without through-the-lens viewing show a slightly different viewfinder angle from the one the lens projects onto the film). Depth of field is usually very shallow when you photograph up close, and through-the-lens viewing lets you preview which parts of the close-up will be sharp. Through-the-lens metering, which you often have with a single-lens reflex, helps you calculate exposures accurately when you are using close-up accessories such as extension tubes or bellows that decrease the amount of light reaching the film. The next pages tell more about close-ups and how to make them.

Bigger is better with close-ups. The photographer needed a sharp knife as well as a macro lens for the close-up of kiwi fruit, opposite. She sliced the kiwi thin, then placed them on a sheet of glass. She lit them from beneath the glass to produce a slight translucence, as well as from the front to bring out surface detail.

This page, a tin funnel produced circular reflections of the mushroom inside it.

arbara London

CLOSE-UPS

Close-up equipment. Shown opposite are different types of close-up equipment you can use to produce a larger-than-normal image on your negatives. All of them do the same thing: they let you move in very close to a subject.

Whether or not to use a camera support, such as a tripod, depends on what and where you are photographing. You will be more mobile without one—ready to photograph an insect that has just alighted on a branch or to get down very close to a low-growing wildflower. Close-up exposures, however, are often longer than normal, and a tripod helps prevent blur caused by camera motion during exposure.

Increased exposures for close-ups. Placing extension tubes or bellows between the lens and the camera body moves the lens farther from the film to let you focus close to a subject. But the farther the lens is extended, the dimmer the light that reaches the film, and the more you must increase the exposure so that the film will not be underexposed.

A camera that meters through the lens increases the exposure automatically if you use compatible extension tubes or bellows. But if the close-up attachment breaks the automatic coupling between lens and camera or if you are using a hand-held meter, you must increase the exposure manually. To do so, follow the recommendations given by the manufacturer of the tubes or bellows, or use the method shown opposite, bottom. Close-up lenses that you attach to the front of a camera lens do not require an exposure increase.

Preventing underexposure. Exposures of one sec. or longer cause the film to respond to light less than it does with shorter exposures. This reciprocity effect, or reciprocity failure, causes the film to be underexposed. To compensate for reciprocity effect, increase the exposure an additional amount: one half to one stop for 1-sec. exposures, one to two stops for 10-sec. exposures, two to three stops for 100-sec. exposures.

Bracket—to be sure. Any exposure problem with close-ups is likely to be underexposure, so, for safety, bracket your basic exposure with additional shots at wider apertures or slower shutter speeds. Don't be daunted by exposure calculations. A rough estimate combined with bracketing will probably serve.

Life Size (1:1) on Film, Shown Here 2x Life Size

 $^{1}\!\!\!/_{10}$ Life Size (1:10) on Film, Shown Here $^{1}\!\!\!/_{4}$ Life Size

Close-up terms. The closer your camera is to a subject, the larger the image on the film. A close-up is any picture taken from closer than normal to the subject- specifically, when the image on the film ranges from about 1/10 life size (1:10) to as big as life size (1:1). Macro-photography generally refers to an image on film that is anywhere from life size (1:1) to as big as ten times life size (10:1). Photomicrography, photographing through a microscope, is usually used to get a film image larger than 10:1.

Alan Oransky

A close-up lens attaches to the front of a camera lens and lets you focus up close without using extension tubes or bellows. Close-up lenses come in different strengths (diopters); the higher the diopter number, the closer you can focus and the larger the image. Close-up lenses are relatively inexpensive, small, and easy to carry in your camera bag. They do not require additional exposure as do extension tubes or bellows. However, image quality may not be as good as with other close-up methods.

A macro lens is your best choice for sharp close-ups. It produces a very sharp image at close focusing distances, whereas an ordinary lens produces its sharpest image at normal distances. A macro lens's mount can be extended more than that of an ordinary lens, which means that even without the use of extension tubes or bellows it can produce an image up to about half life size (1:2).

A macro-zoom lens has the zoom lens's variable focal lengths and will focus relatively close, although not as close as a macro lens of fixed focal length. It produces an image size of about one quarter life size (1:4).

Reversing a lens produces a sharper image when an ordinary lens is used very close to the subject. At a short focusing distance, the lens is being used under conditions for which it was not designed and, as a result, image sharpness decreases; reversing the lens improves sharpness. An adapter ring couples the lens to the camera in reversed position.

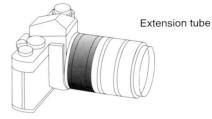

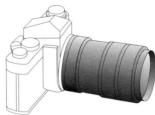

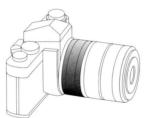

Extension tubes and bellows fit between the lens and the camera. They increase the distance from the lens to the film; the greater this distance, the closer you can bring the lens to the subject. Extension tubes

Bellows

come in graduated sizes that can be used in various combinations to make close-ups of different sizes. A bellows is more adaptable than fixed-length tubes because it can be expanded to any length. Using either extension tubes or bellows requires increasing the exposure, as explained opposite.

Calculating the Exposure Increase for Close-ups_

in inches in cm	11 28	51⁄8 13	3¼ 8.5	2¼ 5.75	2 5	1¾ 4.5	1¾ 3.5	1 2.5
Open lens aperture this number of f-stops	1⁄3	2/3	1	11⁄3	1½	12/3	2	2 ½
Or multiply exposure tlme by	1.3	1.6	2	2.5	2.8	3.2	4	5.7
Increase applies to a lens of any focal length used with a 35mm camera.								

If your camera does not increase the exposure automatically for close-ups, you can find the increase needed by using a ruler. Measure the long side of the area shown in the viewfinder. Find the exposure increase needed in the chart, right.

MORE ABOUT CLOSE-UPS

Depth of field is shallow in close-ups. At very close focusing distances, only an inch or less of the depth in the scene may be sharp. The closer the lens comes to the subject, the more the background and foreground go out of focus. Accurate focusing is essential or the subject may be out of focus altogether. Small apertures help by increasing the depth of field, but they also increase the exposure time. It may be necessary to use a tripod and, if you are photographing outdoors, to shield your subject from the wind to prevent its moving during the exposure.

Making the subject stand out from the background. Since a close-up is usually one small object or part of an object, rather than an entire scene, it is important to have some

way of making the object you are photographing stand out clearly from its background. If you move your camera around to view the subject from several different angles, you may find that from some positions the subject will blend into the background, whereas from others it becomes much more dominant. You can choose your shooting standpoint accordingly.

Shallow depth of field can be an asset in composing your picture. You can use it to make a sharp subject stand out distinctly from an out-of-focus background. Tonal contrast of light against dark, the contrast of one color against another, or the contrast of a coarse or dull surface against a smooth or shiny one can also make your close-up subject more distinct.

Depth of field is very shallow when a photograph is made close to a subject. Only the insect's head and upper body are in focus; the front and rear legs and even the tips of the antennae are not sharp. The shallow depth of field can be useful: since the sharply focused parts contrast with the out-offocus areas, the insect stands out clearly from the foreground and background.

Cross lighting brought out the texture and volume of this ear of corn. The main light angled across the subject from one side, while a weaker fill light close to the camera lightened the shadows.

At close working distances, you often have to arrange the lights carefully to prevent problems such as the camera casting a shadow on the subject. The best way to check the effect of a lighting setup is to look through the camera's viewfinder at the scene.

Lighting close-ups outdoors. Direct sunlight shining on a subject will be bright, so you can use smaller apertures for greater depth of field. But direct sunlight can be very contrasty, with bright highlights and dark shadows. If this is the case, fill light can help lighten the shadows (pages 132–133). Close-up subjects are small, so using even a letter-sized piece of white paper as a reflector can lighten shadows significantly.

Light that comes from the back or side of the subject often enhances it by showing texture or by shining through translucent objects so they glow. In the shade or on an overcast day the light is gentle and soft, good for revealing shapes and details.

Lighting close-ups indoors. You have more control over the lighting if you are arranging it yourself indoors, but stop for a moment and think about just what you want the lights to do. For a flat subject, such as a page from a book, lighting should be even. Two lights of equal intensity, one on each side of the sub-

ject, and at the same distance and angle, will illuminate it uniformly.

If you want to bring out texture, one light angling across the subject from the side will pick out every ridge, fold, and crease. With a deeply textured object, you may want to put a second light close to the lens to add fill light so that details are not lost in shadows.

Flash can be used to increase the overall light level if you want to use a smaller aperture or a short exposure time, or it can be used as a fill light. Using flash very close to the subject may make the light too bright; draping a handkerchief over the flash will soften the light and decrease its intensity. If the flash is on camera, arrange the handkerchief so it doesn't block the lens.

PROJECT **explore a subject up close**

YOU WILL NEED

A close-up lens, macro lens, extension tube, or bellows A camera that views through the lens (a single-lens reflex or view camera) is easiest to use for close-ups A tripod to keep the camera steady

PROCEDURE Select a subject that is three dimensional, rather than flat. It can be a person; a plant; an inanimate object such as a toy, vegetable, motorcycle—anything as long as it will stay still and parts of it look interesting up close.

Make a series of photographs up close, including several as close as your camera will focus sharply. Try varying the lighting, background, or point of view to bring out the subject's most striking aspect. Make some photographs concentrating on the subject's more abstract qualities, its curves, angles, planes, or textures.

You will need to increase the exposure if the lens is farther than normal from the film or if your exposure time is longer than 1 sec. (Pages **144–145** tell when and how to do so.)

HOW DID YOU DO? Compare several of your best resulting close-ups. What contributed to their success? Did you show some aspect of the subject in the close-up that isn't as evident at a normal viewing distance? Did you use shallow depth of field to focus attention on the sharpest part of the image? Would you prefer to have more depth of field, so that more of the scene is sharp? Is there any way to do that, such as by using a smaller aperture with a longer shutter speed?

USING FILTERS How to change film's response to light

Filters for black-and-white photography.

Most black-and-white films are panchromatic—sensitive to all colors to about the same extent that the human eye is. Blue colors, however, tend to record somewhat lighter than we expect them to in black-and-white photographs, and one of the most frequent uses of filters is to darken a blue sky so that clouds stand out more distinctly (shown opposite). A colored filter with black-and-white film will lighten objects of its own color and darken objects that are opposite in color. The chart opposite, top, lists some of the filters used in black-and-white pictures.

Filters for color photography. If you want a natural color rendition with color film, you need to match the color balance of the light source to the color balance of the film. You can't change the response of the film, but you can change the color of the light that reaches the film by using a filter. Using an FL (fluorescent) filter on the lens, for example, decreases the greenish cast of pictures taken under fluorescent light. Various filters for color photography are listed in the chart opposite, bottom.

Increasing exposures when filters are used. Filters work by removing some of the wavelengths of light that pass through them. To compensate for the resulting overall loss of light intensity, the exposure must be increased or the film will be underexposed. If you are using a hand-held meter, simply increase the exposure by the number of stops shown in the charts here or as recommended by the filter manufacturer. To review how to change exposure by stops, see page **20**.

Instead of giving the number of stops you need to increase the exposure, some sources do the same thing by giving you a filter factor. The factor tells how many times the exposure should be increased. A factor of 2 means the exposure should be doubled (a one-stop change). A factor of 4 means the exposure should be increased four times (a two-stop change). See chart this page.

Increasing exposures with a through-thelens meter. If you are using a camera with a through-the-lens meter, you may not get a good exposure if you meter the scene with a filter on the lens. The sensor in the camera that reads the amount of light may not respond to the color of light in the same way that film does. Generally, the sensor gives an accurate exposure reading with lighter filters but not always with darker ones that require several stops of exposure change. A deep red filter, for example, requires four stops extra exposure when used in daylight with blackand-white film, but some cameras give only 2¹/₂ more stops exposure if they meter through that filter. The result: 11/2 stops underexposure and a thin, difficult-to-print negative.

Here's how to check your camera's response if you plan to use one of the darker filters. Meter a scene without the filter and note the shutter speed and/or f-stop. Now put the filter on the lens and meter the same scene. Compare the number of stops the camera's settings change with the number of stops they should have changed. Adjust the settings manually, if needed, when using that filter.

Gelatin filters come in 2-in. and larger squares that can be cut to various sizes. They can be taped onto the front of the lens or fit into a filter holder. They are less expensive than glass filters and come in many colors, but they can be scratched or damaged relatively easily. Handle them by their edges only.

Glass filters attach to the front of the lens and are made in sizes to fit various lens diameters. To find the diameter of your lens, look on the ring engraved around the front of the lens. The diameter (in mm) usually follows the symbol \emptyset . They are convenient and sturdier than gelatin filters, but they are usually more expensive.

lf filter has a factor of	Increase exposure this many stops
1	0
1.2	1/3
1.5	2/3
2	1
2.5	1 1/3
3	1 ² /3
4	2
5	21/3
6	2 ² /3
8	3
10	3 ¹ / ₃
12	32/3
16	4
32	5

......................

Filter factors. You need to increase the exposure when using most filters. Sometimes this increase is given as a filter factor. If so, see chart for how many stops the exposure should be increased.

Filters for Black-and-White Film .

		E	Exposure Increase Needed		
		Type of Filter	In daylight	In tungsten light	
To darken blue objects, make clouds stand out against blue sky, reduce bluish haze in distant landscapes, or make blue water darker in marine scenes.	Darkens blue objects for a natural effect	8 (yellow)	1 stop	⅔ stop	
	Makes blue objects darker than normal	15 (deep yellow)	1⅓ stops	⅔ stop	
	Makes blue objects very dark	25 (red)	3 stops	21⁄3 stops	
To lighten blues to show detail, as in flowers. To increase haze for atmospheric effects in landscapes.		47 (blue)	2⅔ stops	3⅔ stops	
To lighten reds to show detail, as in flowers.		25 (red)	3 stops	21⁄3 stops	
To lighten greens to show detail, as in foliage.		11 (yellow-green)	2 stops	2 stops	
To make the range of tones on panchromatic black-and-white film appear more like the range of brightness seen by the eye.		In daylight, 8 (yellow)	1 stop		
		In tungsten, 11 (yellow-green)		2 stops	

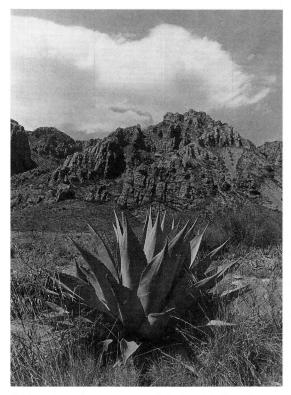

A blue sky may appear very light in a black-andwhite photograph because film is very sensitive to the blue and ultraviolet light present in the sky.

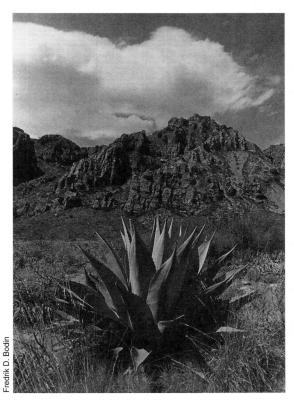

A deep yellow filter darkened the blue sky and made the clouds stand out. Notice that it also darkened shadow areas, which are bluish in tone.

Filters for Color Film _____

	Type of Filter	Exposure Increase Needed
To reduce the bluishness of light on overcast days or in the shade. To penetrate haze. Used by some photographers to protect lens.	1A (skylight) or UV (ultraviolet)	No increase
To decrease bluishness more than 1A or UV.	81A (yellow)	⅓ stop
To get a natural color balance with fluorescent light.	Use FL-B with tungsten- balanced film; FL-D with daylight-balanced film	1 stop
To get a natural color balance with daylight-balanced film exposed in tungsten light.	Use 80A (blue) with ordinary tungsten bulbs or 3200K photolamps; 80B (blue) with 3400K photofloods	12/3 stops (80B)
To get a natural color balance with indoor film exposed in daylight.	Use 85B (amber) with tungsten-balanced film; 85 (amber) with Type A film	⅔ stop
To balance film precisely as recommended by film manufacturer.	CC (color compensating): R (red), G (green), B (blue), Y (yellow), M (magenta), C (cyan)	Varies
To experiment with color changes.	Any color	Varies

LENS ATTACHMENTS Polarization and other effects

A polarizing filter can remove reflections.

If you have ever tried to photograph through a store window, but wound up with more of the reflections from the street than whatever you wanted to photograph inside the store, you know how distracting unwanted reflections can be. Using a polarizing filter is a way to eliminate some of these reflections (see photographs opposite). The filter eliminates or decreases reflections from glass, water, or any smooth nonmetallic surface.

Landscapes can be sharper and clearer with a polarizing filter. Light reflected from minute particles of water vapor or dust in the atmosphere can make a distant landscape look hazy and obscured. A polarizing filter will decrease these minute reflections and allow you to see more distant details. It may also help to make colors purer and more vivid by diminishing unwanted coloring such as reflections of blue light from the sky.

A polarizing filter works best at certain angles. The screen attaches to the front of the camera lens and can be rotated to increase or decrease the polarization. Changing the angle to the subject also affects the polarization (see diagrams, right). With a single-lens reflex or other camera that views through the lens, you can see in the viewfinder the effect of the filter and adjust your position or the filter until you get the results you want. An exposure increase of about 11/3 stops is required. A through-the-lens meter will adjust the exposure correctly if you meter with the filter on the lens.

Neutral-density (ND) filters remove a fixed quantity of light from all wavelengths, consequently reducing the overall amount of light that reaches the lens. These filters make it possible to use a slower shutter speed or larger aperture than you otherwise could. For example, if you want to blur action but can't use a slower shutter speed because you are already set to your smallest aperture, an ND filter over the lens has the effect of dimming the light, letting you then set a slower shutter speed. Similarly, if you want to decrease depth of field but are already set to your fastest shutter speed, an ND filter would let you open the aperture wider.

Special effects with lens attachments. In addition to the filters that change tone or color, other lens attachments manipulate or change the image itself. A soft-focus attachment blurs details slightly to make them appear hazy, as if seen through a filmy screen. A cross-screen attachment (star filter) causes streamers of light to radiate from bright light sources, such as light bulbs, reflections, or the sun (opposite, far left). Other lens attachments produce multiple images, vignette the image, or create other special effects. All of these special effects and more can also be achieved by using digital imaging (see next pages).

Best Positions for a Polarizing Filter

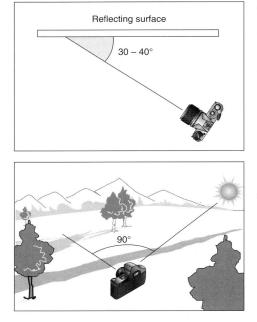

A polarizing filter removes reflections from surfaces such as glass (see photographs opposite). The filter works best at a 30°–40° angle to the reflecting surface.

When shooting landscapes, using a polarizing filter makes distant objects clearer. The effect is strongest when you are shooting at a 90° angle to the sun.

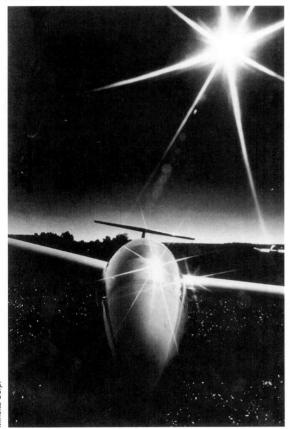

A cross-screen lens attachment, sometimes called a star filter, put the bright stars of light in the photograph above. An eight-ray attachment created the rays around the sun and its reflections from the aircraft. Other cross screens produce four, six, or other numbers of rays.

Reflections are a distracting element in the top photograph if the goal is to show the display inside the shop window. A polarizing filter on the camera lens removed most of the reflections in the bottom photograph so that the objects inside can be seen clearly. (The diagram on the opposite page, top, shows the best position to stand when using a polarizing filter to remove reflections.)

You may not always want to remove reflections, however; notice how the people reflected in the top photograph can be seen as an interesting addition to the picture.

DIGITAL IMAGING

Digital imaging makes it easy to composite (combine) elements from different photographs. The results can obviously depart from reality (such as the flying turtle on page 155), or can look completely realistic, as above.

Pedro Meyer explores photographic truths and fictions: what can be trusted or expected from an image. The scene above, shot at an outdoor market in Oaxaca,

Digital imaging has revolutionized photography. Digitizing a photograph (converting it to a numerical form that a computer can manipulate) lets you use computer software to lighten or darken all or part of a picture, change or add colors, seamlessly combine two or more images, remove unwanted elements, and make many other changes without ever stepping into a darkroom.

Photojournalists use digital imaging to send pictures by telephone from wherever they are directly to an editor's computer screen. Publishers and other commercial users employ it to prepare photographs for the printing press. Some artists use it either to facilitate the work they already do or to generate images that are radically different. Now Mexico, is believable as one that Meyer might have taken as a conventional photograph. But the man was in one part of the market, the awnings in another. Meyer's film did not have the latitude to record details both in the flowing awning and in the sky. All the elements were present at the time, but it was only possible to combine them digitally.

schools are increasingly teaching digital imaging.

The steps in digital imaging are not quite the same as those in conventional photography. You *capture* an image by recording a scene with an electronic camera or, more commonly, by using a scanner to digitize an image from a conventional negative, slide, or print. Once you have the image in the computer, you can *edit* it using software to change the image as you wish. You can *store* the electronic file that contains your image inside your computer or on a separate disk or tape. You can *transmit* it electronically to another location or *output* it to a printer that reproduces the image on paper or film. Pixels make up the picture. Pixels (short for picture elements) are the underlying structure of a digital image. The picture is divided into a grid, like a piece of graph paper, with each square of the grid described by a numerical listing of the brightness and color of that particular square.

Just as a conventional photograph consists of many grains of silver, a digital image consists of many tiny pixels, usually so small that you don't see them individually, but instead see the image as a smooth gradation of tones.

Above, the pixels that make up the area bracketed in the photograph at left.

Equipment and materials you'll need

You don't need to own all, or even any, of these items yourself. Many schools provide access to computers, scanners, printers, and other equipment. Computer services bureaus (often in shops that do copying and offset printing) rent time on computers, scan and print images, and generally offer help with how to use their services.

CAPTURE

The first step in digital imaging is to get your picture into digital (numerical) form so you can instruct your computer to display, edit, store, or transmit it.

Electronic camera does not use film. It electronically records an image, which then is sent to the computer directly as digital information.

Scanner reads and converts a conventional negative, slide, or print into digital form.

Kodak's Photo CD is

an easy means of acquiring scanned images. You take your negatives or slides to a photo store, lab, or computer service bureau to have them scanned onto a Photo CD disc, something like a music CD. Each picture is scanned onto the CD in several different file sizes for different uses. You need a suitable CD-ROM (Compact Disc Read-Only Memory) drive to transfer the pictures from the Photo CD to your computer.

EDITING

Computer is the heart of a digital-imaging system. It drives the monitor, printer, or other devices to which it is attached. You'll need a Macintosh computer in the Mac II family or better, or an IBM-type computer, 386 series or better, with Windows capability. The more powerful and faster models are preferable, especially if you will be working in color.

Computer monitor

displays the image you are working on and shows various software tools and other options.

Image-editing software such as Adobe Photoshop or Micrografx Picture Publisher lets you select editing commands that change the image.

STORAGE AND TRANSMISSION

Hard disk stores image files within the computer. Picture files occupy a great deal of memory, so generally only a limited number of pictures can be stored internally. See box, About File Sizes, below.

Removeable storage

media such as a floppy disk or a removable cartridge disk drive (which has a much larger storage capacity than a floppy) let you expand your storage or let you take a file to another location, for example, to be printed.

Modem sends files over phone lines and is often used by photojournalists and others who need to transmit pictures in a hurry from a distance. Digitally encoded images are also transmitted worldwide on the Internet.

OUTPUT

Printer transfers the image to paper. Print quality varies widely, ranging from high-quality and expensive dyesublimation prints to less expensive thermal-wax prints that are more like ordinary office photocopies.

Film recorder prints the image onto film as a positive transparency or a negative.

About File Sizes

File size affects the quality of an image. The greater the number of pixels per inch (ppi) and the greater the bit depth (the amount of information per pixel), the better the sharpness, color quality, and tonal range of the image—and the bigger the size of the computer file that the picture will occupy. Also, the bigger the print you want, the more the file size for that picture must increase.

But a very large file means that your computer could take a long time to execute each command you give it, and it increases the amount of computer memory or storage required for each picture. You may have to balance the quality and size of the picture you want against the practicality of file size for your particular computer.

At a school, your instructor can tell you how to specify the pixels per inch and other file characteristics when you are setting up an image-editing file on your computer. If you are using a service bureau to scan or print your pictures, ask them how they suggest you set up the file, based on the final output you want. See also your imageediting software manual.

File sizes are measured in bytes (units of digital information).

kilobyte (1K or KB)	1,000 bytes
megabyte (1M or MB)	1,000,000 bytes
gigabyte (1G or GB)	1,000,000,000 bytes

(The numbers are usually rounded off. A kilobyte actually contains 1,024 bytes.) A small file for a color photograph might be 900K, a medium-size file 18M, a large file 200M or more.

EDITING A DIGITAL IMAGE

When you print a photograph in a darkroom, you make decisions about exposure, contrast, and so on, by examining a test print. With digital imaging, you make changes as you look at the image on a computer's monitor screen. You don't have to make a print at all until you are reasonably sure the picture has been edited to your satisfaction.

Image-editing software gives you the tools to change the picture in various ways (see below). Most changes can be undone if you are not satisfied, and you always have the option of reopening the original file and starting again from the beginning. You can save several versions of the same image, but picture

Image-editing software (shown here, Adobe Photoshop) displays your photograph on screen. Several images can be displayed at once when you want to combine elements from multiple pictures. Measurements can be displayed around the picture, in inches, centimeters, or various other scales. files are quite large and storage space is often limited. You may want to keep your original file, however, even after you have edited it, in case you want it unedited some time in the future.

Know what you want to do, at least in general, before you begin editing. When you are learning digital imaging, it's useful—and enjoyable—to experiment with all its possibilities. But as you begin work on a particular picture, consider what exactly will enhance it. Just because image-editing software makes it possible to posterize, clone, dither, ripple, and pixelize an image, doesn't mean you need to or even should do so.

The commands used to manipulate an image appear on screen as small symbols called icons (some shown here on the right side of the screen). You can use the computer's mouse to click on the tool to activate it. the commands also appear as word commands, reached from the pull-down menus across the top of the screen.

Selection tools let you isolate parts of an image to be changed. The Elliptical Marquee, for example, helps you select rounded areas.

The Lasso (shown in use) lets you select irregular shapes.

Drawing and painting tools let you draw, paint, color, lighten, or darken parts of the image. The Paint Brush, for example, applies a color to any area it is moved over.

Dodge and Burn tools, like dodging and burning tools in a conventional darkroom, lighten or darken part of an image.

Tools can be customized to produce different effects. This window lets you select various brush sizes and types.

Dan Burkholder

To create an image of a flying turtle (above), Dan Burkholder used Adobe Photoshop software to combine three separate photographs that he made with a conventional 35mm camera and film on a shooting trip in south Texas. He photographed a sea turtle (shown on opposite page) at an aquarium. The doorway (right) was the exterior door of a mission building. A church altar (below) was part of an old church that was being torn down.

Beginning with the backgroud image of the church altar, Burkholder increased the contrast slightly to add depth to the shadows. There are several ways to do this in Photoshop. The Brightness/Contrast dialog box lets you lighten or darken the image or change the contrast by moving the triangles on the horizontal Brightness or Contrast lines. The Preview feature lets you see the results on screen as you make changes. Other dialog boxes, Levels and Curves, let you make similar changes with more precision.

Many other changes were made using various Photoshop features. For example, the lower portion of the door was darkened using the Burn tool (shown above). The pupil of the turtle's eye was also darkened. The images of the altar and the turtle were sharpened slightly. The shadow was created. Small imperfections, such as dust specks on the negative, were retouched. The edges of the door and turtle were feathered (softened) slightly so they would blend smoothly when they were pasted onto the background image of the altar.

WHAT'S IN THE PICTURE: The edges or frame 158 The background 160
DEPTH IN A PICTURE: Three dimensions become two 162
DEPTH OF FIELD: Which parts are sharp 164 Time and Motion in a Photograph 166 Portraits 168 More about Photographing People 170 Photographing the Landscape/ Cityscape 172 Responding to Photographs 174

SEEING LIKE

Pictures translate the world you see. If you have ever had a picture turn out to be different from what you expected, you know that the camera does not "see" the way a human sees. For example, in a blackand-white photograph, the colors you see in the world are translated into shades of gray. Color slides seldom record colors exactly the way the eye sees them, and a color print can create an even greater departure from reality.

The way you see contrast between light and dark is also different from the way film responds to it. When you look at a contrasty scene, your eye's pupil continuously adjusts to different levels of brightness by opening up or closing down. In a photograph, the contrast between very light and very dark areas is often too great for the film to record them both well in the same picture, so some areas may appear overexposed and too light or underexposed and too dark. Motion, sharpness, and other elements also can be similar to what you see in the original scene but never exactly the same.

The creative part of photography is that you can choose the way you want the camera and film to translate a scene. Before you shoot, ask yourself what you want in the photograph. What attracted you in the first place? If it is the expression on someone's face, then should you move in closer so that you can see it clearly? If it is the odd shape of a tree, then will it be distinctly visible or do you need to change your position so that the shape will not be lost against a busy background?

Once you have the photograph you think you want, stop for a moment to consider some other options. How would it look if you framed the scene vertically instead of horizontally? What if you moved to a very low point of view? What would a slow shutter speed do to the motion of the scene? Try some of the variations, even if you are not sure how they will look in a print—in fact, *especially* if you are not sure—because that is the way to learn how the camera and film will translate them. More about your choices—and how to make them—on the following pages.

Choices. To begin with, what do you choose to photograph? The whole person, head to toe? Their face? Or just their hand, holding something that reveals some part of their life? Opposite, the photographer moved in close to concentrate on the hand holding the photograph. Depth of field is shallow when the camera is close to the subject, so it is important to select and focus on the part of the scene you want to be sharp.

Above, during a 15-sec. exposure, lights on moving automobiles blurred into long streaks. A shorter exposure would have made the streaks shorter and the roadway darker.

WHAT'S IN THE PICTURE The edges or frame

One of the first choices to make with a photograph is what to include and what to leave out. The image frame, the rectangle you see when you look through the viewfinder, shows only a section of the much wider scene that is in front of you. The frame crops the scene or, rather, you crop it—when you decide where to point the camera, how close to get to your subject, and from what angle to shoot.

Decide before you shoot whether you want to show the whole scene (or as much of it as you can) or whether you want to move in close (or zoom in with a zoom lens) for a detail. You can focus attention on something by framing it tightly or you can step back and have it be just another element in a larger scene.

Where is your subject positioned in the frame? Usually it's better not to have a subject squarely in the middle of the frame, although there are exceptions to this and to any other rule.

When you look through the viewfinder, imagine you are viewing the final print or slide. This will help you frame the subject better. The tendency is to "see" only the main subject and ignore its surroundings. In the final print, however, the surroundings and the framing are immediately noticeable.

You can also change framing later by cropping the edges of a picture when it is printed. Many photographs can be improved by cropping out distracting elements at the edges of the frame. But it is best to crop when you take the picture, especially with slide film. Although you can duplicate a slide and change its cropping then, it's easier to frame the scene the way you want it when you shoot.

The edges of a picture, the frame, surround and shape the image. Look around the edges at how the frame cuts into some objects or includes them in their entirety. How do the different framings change these pictures?

You can frame the central subject of a picture with other parts of the scene. Showing the instruments surrounding the fiddler at center, while cropping out most of the musicians themselves, focuses attention on the fiddler.

PROJECT THE CUTTING EDGE

PROCEDURE Expose a roll of film using the edges of the picture, the frame, in various ways. As you look through the viewfinder, use the frame to surround and shape the image in different ways. Make a viewing aid by cutting a small rectangle in an 8×10 -inch piece of black cardboard. It will be easier to move it around and look through than a camera and can help you visualize your choices.

Put the main subject off to one side or one corner of the frame. Can you balance the image so that the scene doesn't feel lopsided?

Put the horizon line at the very top or very bottom of a photograph.

Have "nothing" at the center of the frame. Keep the viewer's interest directed toward the edges.

Make a portrait of someone without their head in the picture. Try to have the image express something of the subject's personality.

Have someone looking at or reaching for something outside the frame. Have them close to the side of the frame they are looking or reaching toward. Then have them far from that side, at the other side of the frame.

Photograph something in its entirety: a person, a shopfront, an animal, an overstuffed chair—whatever gets your attention. Move in a little closer. How will you use the frame to cut into the object? Do you crop the object evenly all around? More on one side than the other? Move in even closer. Closer.

HOW DID YOU DO? What worked best? What wouldn't you ordinarily have done?

WHAT'S IN THE PICTURE

Seeing the background. When you view a scene, you see most sharply whatever you are looking at directly, and you see less clearly objects in the background or at the periphery of your vision. If you are concentrating on something of interest, you may not even notice other things nearby. But the camera's lens does see them, and it shows unselectively everything within its angle of view. Unwanted or distracting details can be ig-

nored by the eye looking at a scene, but in a picture those details are much more conspicuous. To reduce the effect of a distracting background, you can shoot so that the background is out of focus or change your angle of view as shown in the photographs below. Interesting juxtapositions that usually go unnoticed—except in a photograph—are one of the pleasures of photography, as in the picture opposite.

Where's the subject? The lines of the building in the background attract the eye at least as much as the woman and child in the foreground. If the picture is about the location, then the building makes a useful contribution. But if the photograph is supposed to be about the woman and child, then the background seems an unnecessary element.

A less-intrusive background resulted when the photographer simply walked around to one side and changed the angle from which he shot the subject. The photographer also moved in closer so that the people would occupy a larger area of the picture.

Fredrik D. Bodir

If you look at the background of a scene as well as the main subject of interest, you may find some good combinations. Here, a baton twirler frames her high school band with her outstretched arm. The camera records everything within its angle of view and can make the relation between a foreground object and a background one more important than might otherwise be apparent.

Notice how large the person in the foreground appears relative to the band members in the

background. She seems very near, while the band appears much farther back. Actually, the two were not very far apart: the camera was simply much closer to one than to the other. Apparent size differences caused by the position of objects relative to the camera can create an exaggerated illusion of depth. Short-focallength lenses often create this effect because they can be focused very close to an object. More on the next page and on pages **42–43** about perspective and how to control it.

PROJECT **USING THE BACKGROUND**

PROCEDURE Make photographs in which the background either complements or contrasts with the subject. For example, someone drinking coffee in front of a large, ornate espresso maker; an arguing couple in front of a smiling-face poster; a child by a "Library Closed" sign; a shopkeeper standing in front of a store.

Look through the viewfinder (or a viewing aid, like the one described in

the Project box on page **159**) as you try different positions from which to photograph.

HOW DID YOU DO? Compare several of your most successful prints. Could the background be seen as clearly as the subject? What did the background contribute?

DEPTH IN A PICTURE Three dimensions become two

Photographs can seem to change the depth in a scene. When you translate the three dimensions of a scene that has depth into the two dimensions of a flat photograph, you can expand space so that objects seem very far apart or you can compress space so that objects appear to be flattened and crowded close together. For example, com-

pare the two photographs below of a pier. You can compress the buildings in a city (opposite) into flat planes to look almost as if they were pasted one on top of the other or you can give them exaggerated height. Pages **42–43** explain more about how to control such perspective effects that can change the way a photograph shows depth.

Alan Orai

Two lenses of different focal lengths gave two very different versions of the same scene from the same position: a shortfocal-length lens (top) expanded the space; a long-focal-length lens (bottom) compressed it.

Neither of the lenses actually changed anything in the scene. The shortfocal-length lens used for the top photo had a wide angle of view; it included nearby objects as well as those that were farther away. The long-focallength lens used for the bottom photo had a narrow angle of view; it showed only the farthest part of the scene. The part of the scene shown in the bottom photograph is exactly the same within the wider view of the scene shown in the top photograph.

Dan McCoy

Two perspectives of the same city. These sections of buildings seen from the side seem to lie on top of each other (top). Any clues to indicate the actual space that exists between the buildings are excluded from the scene.

Buildings appear to tower to great heights in photographs that look up at them or down on them (bottom). The closer any object is to your eye or to the camera, the bigger it appears to be, so, here, the building looks larger at the top than at the bottom because the camera was closer to its top stories than to its bottom ones.

DEPTH OF FIELD Which parts are sharp

When you look at a scene you actually focus your eyes on only one distance at a time, while objects at all other distances are not as sharp. Your eyes automatically adjust their focus as you look from one object to another. If you were at the scene shown opposite, bottom, you might look at the net and not notice that you were seeing the boats much less sharply. But in a photograph, differences in the sharpness of objects at different distances are immediately evident. Such differences can be distracting or they can add interest to the photograph, depending on how you use them. **Controlling the depth of field.** In some photographs you have no choice about depth of field (the area from near to far within which all objects will appear acceptably sharp). For example, in dim light or with slow film or under other conditions, the depth of field may have to be very shallow. But usually you can control the depth of field to some extent, as shown on pages **38–39**. It is not necessarily better to have everything sharp or the background out of focus or to follow any other rules, but it is important to remember that in the photograph you will notice what is sharp and what isn't.

The eye tends to look first at the sharpest objects in a photograph. The message of television preacher Reverend Ike is that God is generous and will give you exactly what you ask for, including, for example, a diamondstudded watch, ring, and cufflinks, which the photographer focused on.

Landscapes are often photographed so that everything is sharp from foreground to background. The entire landscape is more important than any single part of it. If you had been standing by the camera when this picture was taken, each part of the scene would have looked sharp to you. You wouldn't have noticed that your eves were actually focusing sharply first on the tree stump in the foreground, then refocusing on the tree in the middle distance, then refocusing again on the mountain in the background.

Here, the background is out of focus—but still an important element. The sharply focused swirl of rope stands out clearly. The out-of-focus boats provide a less prominent, but identifiable, background.

Ernest Braun

PROJECT USING DEPTH

PROCEDURE As you look at various subjects, try to anticipate how much depth of field you want, and how you can increase (or decrease) the depth of field to get more (or less) of the photograph to appear sharp. Page **39** shows how to use aperture size, focal length, and/or distance to do this.

Make several photographs of each scene. using depth of field in different ways. See for example, the field of flowers on page 74. You might have the entire scene sharp, as shown. Or for the same scene. the front row of flowers sharp and the backaround out of focus. How about just one flower sharp, with both foreground and backaround out of focus? Is there some object you can call attention to using shallow depth of field that might be overlooked with everything in focus?

Keep notes of your aperture size, focal length, distance, and why you chose them, to remind you later what you did.

HOW DID YOU DO?

Compare your results. Were you able to get everything sharp when you wanted it that way? When you wanted something out of focus, was it out of focus enough? Now that you look at the prints, do you see anything you might try next time?

TIME AND MOTION IN A PHOTOGRAPH

A photograph is a slice of time. Just as you select the section that you want to photograph out of a larger scene, you can also choose the section of time you want to record. You can think of a photograph as slicing through time, taking a wide slice at a slow shutter speed or a narrow slice at a fast shutter speed. In that slice of time, things are moving, and, depending on the shutter speed, direction of the motion, and other factors discussed earlier (pages 16–17), you can show objects frozen

in mid-movement, blurred until they are almost unrecognizable, or blurred to any extent in between. How would you have photographed the rodeo scene (opposite, top) sharp, as it is, or blurred to show the jolting of the bull? How about the boxers (below) blurred and streaked or sharp and crisp to show their exact stances? One choice is not necessarily better than another. The important thing is to choose and not let the camera always make the choice for you.

A fast shutter speed froze the motion of the bull, men, hat, and dust. In

buil, men, nat, and dust. In bright sunlight and using a high film speed, the photographer was also able to use a small aperture so that everything is sharply focused from foreground to background.

A slow shutter speed blurred the boxers' fists, which were moving, while their torsos, which were relatively still, are sharper.

Panning, moving the camera in the direction that the subject is moving, is another way to show motion. In this photograph, the moving subject is somewhat blurred, but sharper than the surrounding scene—with a sense of urgency overall.

PROJECT *showing*

YOU WILL NEED

A tripod, when you want to keep the camera steady during long exposures.

PROCEDURE Make a series of photographs that depict motion in different ways. Select a scene that will let you photograph the same action several times, such as people moving on a crowded street, children on swings, or moving water or leaves. Or have someone perform the same action for you several times, such as a skateboarder, a runner, or a dancer.

How can you make a photograph that makes a viewer feel the subject is moving? Try showing the subject sharp. Try showing it blurred. Try panning the camera with the subject, so that the subject appears sharp against a blurred background. Page **17** shows some of the ways you can control the representation of motion.

Try photographing from a different angle, such as very low to the ground. If you move closer to your subject's feet or skateboard, or whatever is moving, you'll get more of a blur than if you stay farther away.

Keep notes of the shutter speed, distance, and relative subject speed so later you can reconstruct what you did.

HOW DID YOU DO? What worked well? What didn't, but might have worked for another type of subject? Did some exposures produce too much blur? Did the subject disappear entirely in any frame?

ORTRAITS

A good portrait shows more than merely what someone looks like. It captures an expression, reveals a mood, or tells something about a person. Props or an environmental setting are not essential, but they can help show what a person does or what kind of a person he or she is (see photographs opposite).

Put your subject at ease. To do this, you have to be relaxed yourself, or at least look that way. You'll feel better if you are familiar with your equipment and how it works so you don't have to worry about how to set the exposure or make other adjustments.

Don't skimp on film with portraits. Taking three, four, or a dozen shots to warm up can get your subject past the nervousness that many people have at first when being photographed.

Try to use a fast enough shutter speed, 1/60 sec. or faster, if possible, so you can shoot when your subject looks good, rather than your having to say, "hold it," which is only An environmental likely to produce a wooden expression. Don't automatically ask your subject to smile, either. A quietly pleasant expression looks better than a pasted-on big smile.

Lighting. See what it is doing to the subject. Soft, relatively diffused light is the easiest to use; it is kind to most faces and won't change much even if you change your position.

Side lighting adds roundness and a threedimensional modeling. The more to the side the main light is, particularly if it is not diffused, the more it emphasizes facial texture, including wrinkles and lines. That's fine for many subjects, but bad, for instance, for your Uncle Pete if he wants to see himself as the young adult he used to be. Front lighting produces less modeling than does side lighting (see pages 130-131), but it minimizes minor imperfections. Three simple portrait lighting setups are shown on pages 134-135.

portrait. People shape the space around them and in turn are influenced by their surroundings. Photographing them where they play or work or wherever they have established a space that they inhabit can tell much more about them and their life than just a straight head-andshoulders portrait. Here, two city kids are comfortably at ease on the street that doubles as their playaround.

Light was diffused just inside an open doorway, much softer than if the portrait had been made in the direct sun outside, The photographer could have burned in the sunny hillside behind the woman to make it darker, but liked the contrast between its brightness and the shaded, sun-streaked wall.

Having someone look into the camera lens creates eye contact with the viewer of a portrait and often conveys a more intimate feeling than you get when the person is looking away. Here, an old radio and snow to the horizon are perfect props for Garrison Keillor, of Lake Woebegone fame. A bemused expression communicates the personality that Keillor portrays on his popular radio show.

Scott Goldsmith

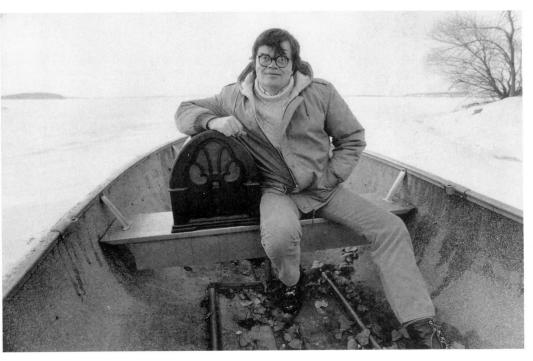

PROCEDURE There are at least as many different ways to make a portrait of someone as there are people in the world to photograph. Use at least one roll of film to photograph the same person in as many different ways as you can. Two or three rolls of the same person are even better. It may take a number of exposures before both you and your subject feel relaxed and comfortable. Here are some possibilities, but you can think up even more.

As a baseline, consider the conventional head-andshoulders, graduation-type portrait. Where can you go from there?

Try different sites and backgrounds, such as in a park, at home, at work. Does the background have to look pleasant? How about in front of a row of beat-up school lockers?

Try different angles: from above or below, as well as from eye level. Try moving in very close, so the camera exaggerates facial features. Does the person always have to be sitting or standing?

If the person feels relaxed enough or can role-play, have them express different emotions, such as anger, sadness, silly good humor.

Vary the lighting: front, side, top, bottom, back (see pages **130-131**). In direct sun, by a window, in the shade (see pages **126-127**).

Do you have to see their face? Can you make a revealing portrait from the back? As a silhouette?

You'll know you have shot enough when both you and your subject are worn out.

How DID YOU DO? Which are your favorite photographs? Why? Which are your subject's favorites? Why? How did the background, props, or other elements contribute to the picture? What would someone who didn't know this person think about them, based simply on seeing the photographs?

MORE ABOUT PHOTOGRAPHING PEOPLE

Some pictures of people appear to be unplanned, made either without the subjects knowing they are being photographed or without seeming posed or directed by the photographer. It isn't always easy to tell if a photograph was posed or not, and most viewers will care more about what the photograph conveys than about exactly how it got that way.

Set your camera's controls beforehand if you want to be relatively inconspicuous at a scene. Prefocus if you can, although that may not be possible with longer-focal-length lenses, which produce less depth of field and so require more critical focusing than do shorter lenses. With zone focusing (page 40), you focus in advance by using a lens's depth-of-field and distance scales. An automatic camera can help you work unobtrusively.

A fast shutter speed is even more important for unposed portraits than for planned ones, because your subject is likely to be moving and you are likely to be hand holding the camera rather than using a tripod. A fast film (ISO 400 works well in most situations) will be useful.

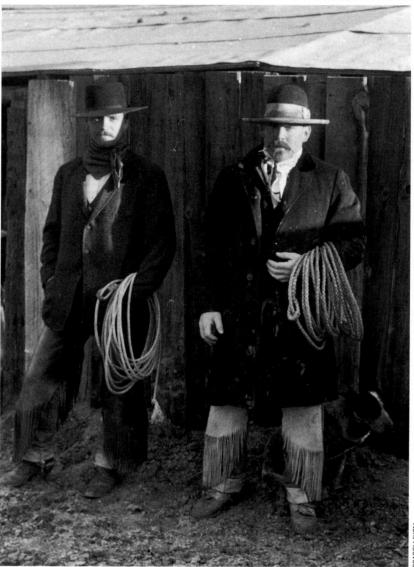

Eye contact may or may not be present in an informal portrait. These two cowboys have a relaxed and natural look, even though they face squarely into the camera. They might have paused to glance at the photographer and in a moment will turn and get on with their work.

A violin maker seems

absorbed in trying a violin, but viewers can't knowand most won't ask themselves-whether the photographer told the man to play. You can create a candid feeling by asking a subject who is aware of your presence to perform some typical action. People are likely to behave more naturally if they have something to do that involves them.

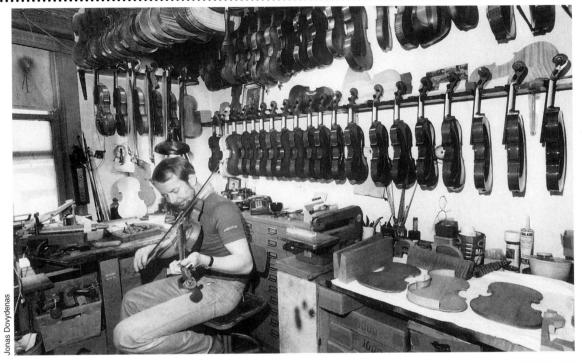

Take advantage of what is available. Two surgical nurses discussing the day's schedule are joined by their shadows as early morning sunlight streams through a window behind them onto a nearby wall.

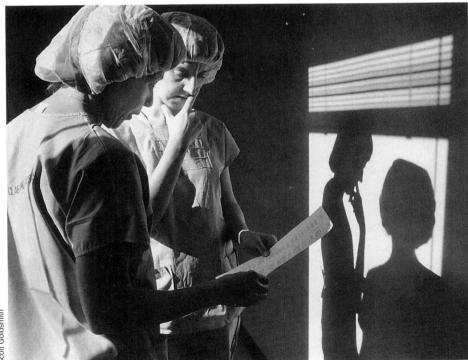

Scott Goldsmith

PHOTOGRAPHING THE LANDSCAPE/CITYSCAPE

How do you photograph a place? There are as many different ways to view a scene as there are photographers. Most important for you: What do you want to remember? What is the best part of the place for you? Do you want many buildings from a distance or just one structure up close? Is it the landscape as a whole that is interesting or some particular part of it? How does a place speak to you?

After photographing a standard view of New York City as seen from Brooklyn, across the East River (below), photographer Fred Bodin turned his attention to the nearby Brooklyn Bridge, cropping tight to its stone arches and cables to create a shape reminiscent of a Gothic cathedral (left).

Fredrik D. Bodir

Depth of field. We often expect a landscape to be sharp from foreground to background. Extremely deep depth of field, as in the photograph above, is easiest to obtain with a view camera, which has a front and back that are adjustable for just such an effect. How to maximize depth of field with any camera is shown on page **41**.

Look at a scene from different angles, walking around to view it from different positions. Above, in Ladakh, a remote part of India, Chris Rainier photographed a mound of stones with Buddhist inscriptions against a background of valley and sky. When you are close to an object, even a slight change of position will alter its relationship to the background.

The top of a picture usually identifies the top of a scene because we are used to seeing things—and photographing them—from an upright position. Change your point of view and a subject may reveal itself in a new way. Right, a photograph of dried mud taken from directly overhead is slightly disorienting. Not only is the subject matter ambiguous, but it isn't clear which way is up.

Responding to photographs

"It's good." "It's not so good." What else is there to say when you look at a photograph? What is there to see—and to say—when you respond to work in a photography class or workshop? Looking at other people's pictures helps you improve your own, especially if you take some time to examine an image, instead of merely glancing at it and moving on to the next one.

In addition to responding to other people's work, you need to be able to look at and evaluate your own. What did you see when you brought the camera to your eye? How well did what you had in mind translate into a picture? Would you do anything differently next time?

Following are some items to consider when you look at a photograph. You don't have to deal with each one every time, but they can give you a place to start. **Type of photograph.** Portrait? Landscape? Advertising photograph? News photo? A caption or title can provide information, but look at the picture first so the caption does not limit your response.

Suppose the picture is a portrait. Is it one that might have been made at the request of the subject? One made for the personal expression of the photographer? Is the sitter simply a body or does he or she contribute some individuality? Does the environment surrounding the sitter add anything?

Emphasis. Is your eye drawn to some part of the picture? What leads your eye there? For example, is depth of field shallow, so that only the main subject is sharp and everything else out of focus?

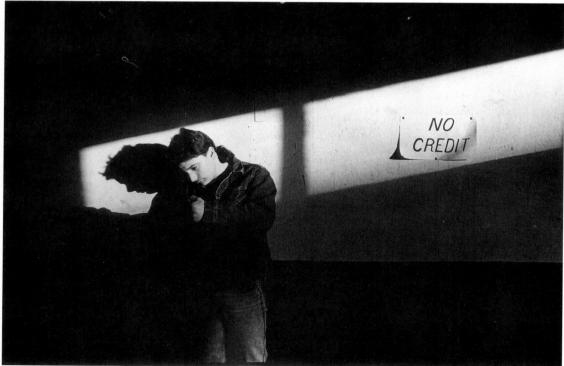

What a viewer sees in a photograph is usually more important than the real situation in which the photograph was made. Harsh, angular light, dark shadows, a bowed head, and "no credit" create a more intense image than the actual scene, which was only a mechanic in an auto shop examining a motor part. Sometimes a caption carries an explanation, but more often it is the evidence in the photograph itself that matters.

Scott Goldsmith

Technical considerations. Do they help or hinder? For example, is contrast harsh and gritty, suitable to the subject or not? **What else does the picture tell you** besides what is immediately evident? Photographs often have more to say than may appear at first.

Emotional or physical impact. Does the picture make you feel sad, amused, peaceful? Does it make your eyes widen, your muscles tense? What elements might cause these reactions?

what is immediately evident? Photographs often have more to say than may appear at first. For example, is a fashion photograph about the design of the clothes, or is it really about the roles of men and women in our culture?

Trust your own responses to a photograph. See how you actually respond to an image and what you actually notice about it.

Visual Elements

Following are some of the terms that can be used to describe the visual or graphic elements of a photograph. See the page cited for an illustration of a particular element.

Focus and Depth of Field

Sharp overall (page 165 top), soft focus overall (page 128) Selective focus: One part sharp, others not (page 38). See also Shallow depth of field.

Shallow depth of field: Little distance between nearest and farthest sharp areas (pages **39** left, **146**)

Extensive depth of field: Considerable distance between nearest and farthest sharp areas (pages **39** right, **74**)

Motion

Frozen sharp even though subject was moving (pages 17 top right, 167 top)

Blurred: Moving camera or subject blurred part or all of the image (pages **17** top left, **166**)

Light

Front light: Light comes from camera position, few shadows (pages **130** top, **139** top left)

Back light: Light comes toward camera, front of subject is shaded (page **131** bottom left)

Side light: Light comes from side, shadows cast to side (pages **48, 131** top left)

Direct light: Hard-edged, often dark shadows (page **126**) *Directional diffused light:* Distinct, but soft-edged shadows (page **127** bottom)

Diffused light: No, or almost no, shadows (page **127** top) *Silhouette:* Subject very dark against light background (pages **9** bottom right, **71**)

Glowing light: Subject glows with its own or reflected light (page 157)

Contrast and Tone

Full scale: Black, white, and many tones of gray (page 109 top)

High contrast: Very dark and very light tones, few gray tones (pages 52, 118, 125)
Low contrast: Mostly gray tones
High key: Mostly light tones (page 70)
Low key: Mostly dark tones (page 110)

Texture

Emphasized: Usually results from light striking subject from an angle (page 147) *Minimized:* Usually results from light coming from camera position (page 130 top)

Viewpoint and Framing

Eye-level viewpoint (pages 168, 169)

High (page **70**), *low* (page **159**), or *unusual viewpoint* (page **161**)

Framing: The way the edges of the photograph meet the shapes in it (pages **30**, **158**)

Perspective

Compressed perspective (telephoto effect): Objects seem crowded together, closer than they really are (pages **42** bottom, **162** bottom)

Expanded perspective (wide-angle "distortion"): Parts of the scene seem stretched or positioned unusually far from each other (pages **42** top, **162** top)

Line

Curved (page 143), straight (page 163)

Horizontal (page 167 bottom), *vertical* (page 163 top), *diagonal* (page 174)

Position of horizon line (pages 41, 56)

Balance

An internal, physical response. Does the image feel balanced or does it tilt or feel heavier in one part than another?

OSSARY Glossary originally prepared by Lista Duren

- Aberration Optical defect in a lens (sometimes unavoidable) causing distortion or loss of sharpness in the final image.
 - Adapter ring A ring used to attach one camera item to another: for example, to attach a lens to a camera in reverse position in order to increase image sharpness when focusing very close to the subject.
 - Agitate To move a solution over the surface of film or paper during the development process so that fresh liquid comes into contact with the surface.
 - Angle of view The amount of a scene that can be recorded by a particular lens from a given position; determined by the focal length of the lens.
 - Aperture The lens opening formed by the iris diaphragm inside the lens. The size is variable and is adjusted by the aperture control.
 - Aperture control The ring on the camera lens (a pushbutton on some models) that, when turned, adjusts the size of the opening in the iris diaphragm and changes the amount of light that reaches the film.
- Aperture-priority mode An automatic exposure system in which the photographer sets the aperture (f-stop) and the camera selects a shutter speed for normal exposure
- ASA A film speed rating similar to an ISO rating.
- Auto winder See Motor drive unit.
- Automatic exposure A mode of camera operation in which the camera automatically adjusts either the aperture, the shutter speed, or both for normal exposure.
- Automatic flash An electronic flash unit with a light-sensitive cell that determines the duration of the flash for normal exposure by measuring the light reflected back from the subject.
- Available light A general term implying relatively dim light that already exists where a photograph is to be made.
- Averaging meter An exposure meter with a wide angle of view. The indicated exposure is based on an average of all the light values in the scene.
- B See Bulb.
- Base The supporting material that holds a photographic emulsion. For film, it is plastic or acetate. For prints, it is paper.
- Bellows An accordion-like section inserted between the lens and the camera body. In close-up photography the bellows allows closer-than-normal focusing resulting in a larger image.
- Bleed mount To mount a print so that there is no border between the edges of the print and the edges of the mounting surface.
- Blotters Sheets of absorbent paper made expressly for photographic use. Wet prints dry when placed between blotters.
- Body The light-tight box that contains the camera mechanisms and protects the film from light until you are ready to make an exposure.

Bounce light Indirect light produced by

- pointing the light source at a ceiling or other surface to reflect the light back toward the subject. Softer and less harsh than direct light
- Bracketing Taking several photographs of the same scene at different exposure settings, some greater than and some less than the setting indicated by the meter, to ensure a well-exposed photograph.
- Built-in meter An exposure meter in the camera that takes a light reading (usually through the camera lens) and relays exposure information to the electronic controls in an automatic camera or to the photographer if the camera is being operated manually.
- Bulb A shutter-speed setting (marked B) at which the shutter stays open as long as the shutter release is held down.
- Burn in To darken a specific area of a print by giving it additional printing exposure.
- Byte A unit of digital data used, for example, to measure the size of a computer file. See also Kilobyte, Megabyte.
- Cable release An encased wire that attaches at one end to the shutter release on the camera and has a plunger on the other end that the photographer depresses to activate the shutter. Used to avoid camera movement or to activate the shutter from a distance.
- Carrier A frame that holds a negative flat in an enlarger.
- Cassette A light-tight metal or plastic container in which 35mm film is packaged.
- Center-weighted meter A through-the-lens exposure meter that measures light values from the entire scene but gives greater emphasis to those in the center of the image area.
- Changing bag A light-tight bag into which a photographer can insert his or her hands to handle film safely when a darkroom is not available.
- Close-up A larger-than-normal image obtained by using a lens closer than normal to the subject.
- Close-up lens A lens attached to the front of an ordinary lens to allow focusing at a shorter distance in order to increase image size.
- Color balance 1. A film's response to the colors in a scene. Color films are balanced for use with specific light sources. 2. The reproduction of colors in a photograph.
- Color temperature Description of the color of a light source. Measured on a scale of degrees Kelvin.
- Compound lens A lens made up of several lens elements.
- Condenser enlarger An enlarger that illuminates the negative with light that has been concentrated and directed by condenser lenses placed between the light source and the negative.

- Contact printing The process of placing a negative in contact with sensitized material, usually paper, and then passing light through the negative onto the material. The resulting image is the same size as the image on the negative.
- Contamination Traces of chemicals that are present where they don't belong, causing loss of chemical activity, staining, or other problems.
- Contrast The difference between the light and dark parts of a scene or photograph.
- Contrast grade The contrast that a printing paper produces. Systems of grading contrast are not uniform, but in general grades 0 and 1 have low or soft contrast; grades 2 and 3 have normal or medium contrast; grades 4 and 5 have high or hard contrast.
- Contrasty Having greater-than-normal differences between light and dark areas. The opposite of flat.
- Crop To trim the edges of an image, often to improve the composition. Cropping can be done by moving the camera position while viewing a scene, by adjusting the enlarger or easel during printing, or by trimming the finished print.
- Darkroom A room where photographs are developed and printed, sufficiently dark to handle light-sensitive materials without causing unwanted exposure.
- Daylight film Color film that has been balanced to produce natural-looking color when exposed in daylight.
- Dense Describes a negative or an area of a negative in which a large amount of silver has been deposited. A dense negative transmits relatively little light. The opposite of thin.
- Density The relative amount of silver present in various areas of film or paper after exposure and development. Therefore, the darkness of a photographic print or the lightstopping ability of a negative or transparency.
- Depth of field The distance between the nearest and farthest points that appear in acceptably sharp focus in a photograph. Depth of field varies with lens aperture, focal length, and camera-to-subject distance.
- Developer A chemical solution that changes the invisible, latent image produced during exposure into a visible one.
- Development 1. The entire process by which exposed film or paper is treated with various chemicals to make an image that is visible and permanent. 2. Specifically, the step in which film or paper is immersed in developer.
- Diaphragm (iris diaphragm) The mechanism controlling the size of the lens opening and therefore the amount of light that reaches the film. It consists of overlapping metal leaves inside the lens that form a circular opening of variable sizes. (You can see it as you look into the front of the lens.) The size of the opening is referred to as the f-stop or aperture.

- **Dichroic head** An enlarger head that contains yellow, magenta, and cyan filters that can be moved in calibrated stages into or out of the light beam to change the color balance of the enlarging light.
- Diffused light Light that has been scattered by reflection or by passing through a translucent material. An even, often shadowless, light.
- **Diffusion enlarger** An enlarger that illuminates the negative with light that has been diffused by passing it through a piece of translucent material above the negative.
- Digital camera A camera that records an image directly in digital form, instead of on conventional silver film.
- **Digital imaging** A means by which a photograph is recorded as a digital image that can be read and manipulated by a computer, and subsequently reformed as a visible image.
- **DIN** A numerical rating used in Europe that indicates the speed of a film. The rating increases by three each time the sensitivity of the film doubles.
- **Diopter** Unit of measurement that indicates the magnifying power of a close-up lens.
- **Direct light** Light shining directly on the subject and producing strong highlights and deep shadows.
- **Directional/diffused light** Light that is partly direct and partly scattered. Softer and less harsh than direct light.
- **Dodge** To lighten an area of a print by shading it during part of the printing exposure.
- **Dry down** To become very slightly darker and less contrasty, as most photographic printing papers do when they dry after processing.
- **Dry mount** To attach a print to another surface, usually a heavier mat board, by placing a sheet of adhesive dry-mount tissue between the print and the mounting surface. Generally, this sandwich is placed in a heated mounting press to melt the adhesive in the tissue. Some tissues are pressuresensitive and do not need to be heated.
- **Easel** A holder to keep sensitized material, normally paper, flat and in position on the baseboard of an enlarger during projection printing. It may have adjustable borders to frame the image to various sizes.
- EI See Exposure index.
- Electronic camera A camera that records an image by using electronic circuitry instead of film. See also Digital camera, Still-video camera.
- Electronic flash (strobe) A camera accessory that provides a brief but powerful flash of light. A battery-powered unit requires occasional recharging or battery replacement, but, unlike a flashbulb, can be used repeatedly.
- **Emulsion** A thin coating of gelatin, containing a light-sensitive material such as silverhalide crystals plus other chemicals, coated on film or paper to record an image.
- **Enlargement** An image, usually a print, that is larger than the negative. Made by projecting an enlarged image of the negative onto sensitized paper.
- **Enlarger** An optical instrument ordinarily used to project an image of a negative onto sensitized paper. More accurately called a

projection printer because it can project an image that is either larger or smaller than the negative.

- **Environmental portrait** A photograph in which the subject's surroundings are important to the portrait.
- **Etch** To remove a small, dark imperfection in a print or negative by scraping away part of the emulsion.
- Exposure 1. The act of allowing light to strike a light-sensitive surface. 2. The amount of light reaching the film, controlled by the combination of aperture and shutter speed.
 Exposure index A film speed rating similar
- to an ISO rating. Abbreviated EI. **Exposure meter (light meter)** An instrument that measures the amount of light and provides aperture and shutter speed combinations for correct exposure. Exposure meters may be built into the camera or they may be separate instruments.
- Exposure mode The type of camera operation (such as manual, shutter-priority, aperture-priority) that determines which controls you set and which ones the camera sets automatically. Some cameras operate in only one mode. Others may be used in a variety of modes.
- **Extension tubes** Metal rings attached between the camera lens and the body to allow closer-than-normal focusing in order to increase the image size.
- Fast 1. Describes a film or paper that is very sensitive to light. 2. Describes a lens that opens to a very wide aperture. 3. Describes a short shutter speed. The opposite of slow.
- Fiber-base paper Formerly the standard type of paper available; now being replaced to a certain extent by resin-coated papers.
- Fill light A light source or reflector used to lighten shadow areas so that contrast is decreased.
- Film A roll or sheet of a flexible material coated on one side with a light-sensitive emulsion and used in the camera to record an image.
- Film advance lever A device, usually on the top of the camera, that winds the film forward a measured distance so that an unexposed segment moves into place behind the shutter.
- Film plane See Focal plane.
- Film speed The relative sensitivity to light of photographic film. Measured by ISO (or ASA or DIN) rating. Faster film (higher number) is more sensitive to light and requires less exposure than slower film. See also Speed.
- Filter 1. A piece of colored glass or plastic placed in a camera's or enlarger's light path to alter the quality of the light reaching the film. 2. To use such a filter.
- Filter factor A number, provided by the filter manufacturer, that tells you how much to increase exposure to compensate for the light absorbed by the filter.
- Fisheye lens An extreme wide-angle lens covering a 180° angle of view. Straight lines appear curved at the edge of the photograph, and the image itself may be circular.
- **Fixer** A chemical solution (sodium thiosulfate or ammonium thiosulfate) that makes a photographic image insensitive to light. It dissolves unexposed silver halide crystals

while leaving the developed silver image. Also called hypo.

- Flare Non-image-forming light that reaches the film, resulting in a loss of contrast or an overall grayness in the final image. Caused by stray light reflecting between the surfaces of the lens.
- Flash 1. A short burst of light emitted by a flashbulb or electronic flash unit to illuminate the scene being photographed. 2. The equipment used to produce this light.
- Flashbulb A battery-powered bulb that emits one bright flash of light and then must be replaced.
- Flat Having less-than-normal differences between light and dark areas. The opposite of contrasty.
- **Focal length** The distance from an internal part of a lens (the rear nodal plane) to the film plane when the lens is focused on infinity. The focal length is usually expressed in millimeters (mm) and determines the angle of view (how much of the scene can be included in the picture) and the size of objects in the image. A 100mm lens, for example, has a narrower angle of view and magnifies objects more than a lens of shorter focal length.
- Focal plane The surface inside the camera on which a focused lens forms a sharp image.
- Focal-plane shutter A camera mechanism that admits light to expose film by opening a slit just in front of the film (focal) plane.
- Focus 1. The point at which the rays of light coming through the lens converge to form a sharp image. The picture is "in focus" or sharpest when this point coincides with the film plane. 2. To change the lens-to-film distance (or the camera-to-subject distance) until the image is sharp.
- **Focusing ring** The band on the camera lens that, when turned, moves the lens in relation to the film plane, focusing the camera for specific distances.
- Focusing screen See Viewing screen.
- Fog An overall density in the photographic image caused by unintentional exposure to light, unwanted chemical activity, or excess heat or age.
- Frame 1. A single image in a roll of film. 2. The edges of an image.
- Fresnel An optical surface with concentric circular ridges. Used in a viewing screen to equalize the brightness of the image.
- **F-stop (f-number)** A numerical designation (f/2, f/2.8, etc.) indicating the size of the aperture (lens opening).
- Full-scale Describes a print having a wide range of tonal values from deep, rich black through many shades of gray to brilliant white.
- **Ghosting** 1. A kind of flare caused by reflections between lens surfaces. It appears as bright spots the same shape as the aperture (lens opening). 2. A combined blurred and sharp image that occurs when flash is used with bright existing light. The flash creates a sharp image; the existing light adds a blurred image if the subject is moving.
- **Glossy** Describes a printing paper with a great deal of surface sheen. The opposite of matte.

- **Graded-contrast paper** A printing paper that produces a single level of contrast. To produce less or more contrast, a change has to be made to another grade of paper. See Variable-contrast paper.
- **Grain** The particles of silver that make up a photographic image.
- **Grainy** Describes an image that has a speckled look due to particles of silver clumping together.
- **Gray card** A card that reflects a known percentage of light falling on it. Often has a gray side reflecting 18 percent and a white side reflecting 90 percent of the light. Used to take accurate exposure meter readings (meters base their exposures on a gray tone of 18 percent reflectance).
- **Ground glass** 1. A piece of glass roughened on one side so that an image focused on it can be seen on the other side. 2. The viewing screen in a reflex or view camera.
- **Guide number** A number rating for a flash unit that can be used to calculate the correct aperture for a particular film speed and flash-to-subject distance.
- Hand-held meter An exposure meter that is separate from the camera.
- Hand hold To support the camera with your hands rather than with a tripod or other fixed support.
- Hard 1. Describes a scene, negative, or print of high contrast. 2. Describes a printing paper emulsion of high contrast such as grades 4 and 5.
- **High-contrast film** Film that records light tones lighter and dark tones darker than normal, thereby increasing the difference between tones.
- **Highlight** A very light area in a scene, print, or transparency; a very dense, dark area in a negative. Also called a high value.
- **Hot shoe** A clip on the top of the camera that attaches a flash unit and provides an electrical link to synchronize the flash with the camera shutter, eliminating the need for a sync cord.
- Hyperfocal distance The distance to the nearest object in focus when the lens is focused on infinity. Setting the lens to focus on this distance instead of on infinity will keep the farthest objects in focus as well as extend the depth of field to include objects closer to the camera.
- **Hypo** A common name for any fixer; taken from the abbreviation for sodium hyposulfite, the previous name for sodium thiosulfate (the active ingredient in most fixers).
- **Hypo clearing bath** A chemical solution used between fixing and washing film or paper. It shortens the washing time by converting residues from the fixer into forms more easily dissolved by water. Also called fixer remover or washing aid.
- **Incident-light meter** A hand-held exposure meter that measures the amount of light falling on the subject. See also Reflectedlight meter.

Indoor film See Tungsten film.

Infinity Designated ∞. The farthest distance marked on the focusing ring of the lens, generally about 50 feet. When the camera is focused on infinity, all objects at that distance or farther away will be sharp.

- **Infrared film** Film that is sensitive to wavelengths slightly longer than those in the visible spectrum as well as to some wavelengths within the visible spectrum.
- Interchangeable lens A lens that can be removed from the camera and replaced by another lens.
- Iris diaphragm See Diaphragm.ISO A numerical rating that indicates the speed of a film. The rating doubles each time the sensitivity of the film doubles.
- **Kilobyte** Approximately 1,000 bytes. A measure of computer file size. Abbreviated K or KB.
- Latent image An image formed by the changes to the silver halide grains in photographic emulsion upon exposure to light. The image is not visible until chemical development takes place.
- Latitude The amount of over- or underexposure possible without a significant change in the quality of the image.
- Leaf shutter A camera mechanism that admits light to expose film by opening and shutting a circle of overlapping metal leaves.
- LED See Light-emitting diode.
- Lens One or more pieces of optical glass used to gather and focus light rays to form an image.
- Lens cleaning fluid A liquid made for cleaning lenses.
- Lens coating A thin transparent coating on the surface of the lens that reduces light reflections.
- Lens element A single piece of optical glass that acts as a lens or as part of a lens.
- Lens hood (lens shade) A shield that fits around the lens to prevent unwanted light from entering the lens and causing flare.
- Lens tissue A soft lint-free tissue made specifically for cleaning camera lenses. Not the same as eyeglass cleaning tissue.
- Light-emitting diode (LED) A display in the viewfinder of some cameras that gives you information about aperture and shutter speed settings or other exposure data. Light meter See Exposure meter.
- Long-focal-length lens A lens that provides a narrow angle of view of a scene, including less of a scene than a lens of normal focal length and therefore magnifying objects in the image. Often called telephoto lens.
- **Macro lens** A lens specifically designed for close-up photography and capable of good optical performance when used very close to a subject.
- **Macrophotography** Production of images on film that are life-size or larger.
- Macro-zoom lens A lens that has closefocusing capability plus variable focal length.
- Magnification The size of an object as it appears in an image. Magnification of an image on film is determined by the lens focal length. A long-focal-length lens makes an object appear larger (provides greater magnification) than a short-focal-length lens.
- **Main light** The primary source of illumination, casting the dominant shadows.
- Manual exposure A nonautomatic mode of camera operation in which the photogra-

pher sets both the aperture and the shutter speed.

- Manual flash A nonautomatic mode of flash operation in which the photographer controls the exposure by adjusting the size of the camera's lens aperture.
- Mat A cardboard rectangle with an opening cut in it that is placed over a print to frame it. Also called an overmat.
- Mat cutter A short knife blade (usually replaceable) set in a large, easy-to-hold handle. Used for cutting cardboard mounts for prints.
- Matte Describes a printing paper with a relatively dull, nonreflective surface. The opposite of glossy.
- Megabyte Approximately one million bytes. A measure of computer file size. Abbreviated M or MB.
- Meter 1. See Exposure meter. 2. To take a light reading with a meter.
- Middle gray A standard average gray tone of 18 percent reflectance. See Gray card.
- Midtone An area of medium brightness, neither a very dark shadow nor a very bright highlight. A medium gray tone in a print.
- Mirror A polished metallic reflector set inside the camera body at a 45° angle to the lens to reflect the image up onto the focusing screen. When a picture is taken, the mirror moves out of the way so that light can reach the film.
- Motor drive unit (auto winder) A camera device that automatically advances the film once it has been exposed.
- **Mottle** A mealy gray area of uneven development in a print or negative. Usually caused by too little agitation or too short a time in the developer.
- **Negative** 1. An image with colors or dark and light tones that are the opposite of those in the original scene. 2. Film that was exposed in the camera and processed to form a negative image.
- **Negative film** Photographic film that produces a negative image upon exposure and development.
- **Neutral-density filter** A piece of dark glass or plastic placed in front of the camera lens to decrease the intensity of light entering the lens. It affects exposure, but not color.
- **Normal-focal-length lens (standard lens)** A lens that provides about the same angle of view of a scene as the human eye.
- **One-shot developer** A developer used once and then discarded.
- **Open up** To increase the size of the lens aperture. The opposite of stop down.
- **Orthochromatic film** Film that is sensitive to blue and green light but not red light.
- **Overdevelop** To give more than the normal amount of development.
- **Overexpose** To expose film or paper to too much light. Overexposing film produces a negative that is too dark (dense) or a transparency that is too light. Overexposing paper produces a print that is too dark.
- **Oxidation** Loss of chemical activity due to contact with oxygen in the air.
- Pan To move the camera during the exposure in the same direction as a moving subject. The effect is that the subject stays

relatively sharp and the background becomes blurred.

- Panchromatic film Film that is sensitive to all the wavelengths of the visible spectrum.
- Parallax The difference in point of view that occurs when the lens (or other device) through which the eye views a scene is separate from the lens that exposes the film.
- **Pentaprism** A five-sided optical device used in an eye-level viewfinder to correct the image from the focusing screen so that it appears right side up and correct left to right.
- **Perspective** The optical illusion in a twodimensional image of a three-dimensional space suggested primarily by converging lines and the decrease in size of objects farther from the camera.
- **Photo CD** A disc (looks like a music CD) onto which photographs can be scanned and stored, then read into the computer.
- Photoflood A tungsten lamp designed especially for use in photographic studios. It emits light at 3400 K color temperature.
- Photomicrography Photographing through a microscope.
- Pinhole A small clear spot on a negative usually caused by dust on the film during exposure or development.
- **Pixel** Short for picture element. The smallest unit of a digital image that can be displayed or changed.
- **Plane of critical focus** The part of a scene that is most sharply focused.
- **Polarizing screen (polarizing filter)** A filter placed in front of the camera lens to reduce reflections from nonmetallic surfaces like glass or water.
- **Positive** An image with colors or light and dark tones that are similar to those in the original scene.
- Print 1. An image (usually a positive one) on photographic paper, made from a negative or a transparency. 2. To produce such an image.
- **Printing frame** A holder designed to keep sensitized material, usually paper, in full contact with a negative during contact printing.
- **Programmed automatic** A mode of automatic exposure in which the camera sets both the shutter speed and the aperture for a normal exposure.
- **Proof** A test print made for the purpose of evaluating density, contrast, color balance, subject composition, and the like.
- **Push** To expose film at a higher film speed rating than normal, then to compensate in part for the resulting underexposure by giving greater development than normal. This permits shooting at a dimmer light level, a faster shutter speed, or a smaller aperture than would otherwise be possible.
- **Quartz lamp** An incandescent lamp that has high intensity, small size, long life, and constant color temperature.
- RC paper See Resin-coated paper.
- Reciprocity effect (reciprocity failure) A shift in the color balance or the darkness of an image caused by very long or very short exposures.
- Reducing agent The active ingredient in a developer. It changes exposed silver halide

crystals into dark metallic silver. Also called the developing agent.

- Reel A metal or plastic reel with spiral grooves into which roll film is loaded for development.
- Reflected-light meter An exposure meter (hand held or built into the camera) that reads the amount of light reflected from the subject. See also Incident-light meter.
- **Reflector** Any surface—a ceiling, a card, an umbrella, etc.—used to bounce light onto a subject.
- **Reflex camera** A camera with a built-in mirror that reflects the scene being photographed onto a ground-glass viewing screen. See Single-lens reflex, Twin-lens reflex.
- **Replenisher** A substance added to some types of developers after use to replace exhausted chemicals so that the developer can be used again.
- **Resin-coated paper** Printing paper with a water-resistant coating that absorbs less moisture than a fiber-base paper, consequently reducing some processing times. Abbreviated RC paper.
- **Reticulation** A crinkling of the gelatin emulsion on film that can be caused by extreme temperature changes during processing.
- **Reversal film** Photographic film that produces a positive image (a transparency) upon exposure and development.
- **Reversal processing** A procedure for producing a positive image on film (a transparency) from the film exposed in the camera or a positive print from a transparency with no negative involved.
- **Rewind crank** A device, usually on the top of the camera, for winding film back into a cassette once it has been exposed.
- **Roll film** Film (2¹/₄ in. wide) that comes in a roll, protected from light by a length of paper wound around it. Loosely applies to any film packaged in a roll rather than in flat sheets.
- Safelight A light used in the darkroom during printing to provide general illumination without giving unwanted exposure.
- Scanner A device that optically reads a conventional negative, slide, or print, converting it to digital form for use in digital imaging.
- **Sharp** Describes an image or part of an image that shows crisp, precise texture and detail. The opposite of blurred or soft.
- **Shoe** A clip on a camera for attaching a flash unit. See also Hot shoe.
- Short-focal-length lens (wide-angle lens) A lens that provides a wide angle of view of a scene, including more of the subject area than a lens of normal focal length.
- Shutter A device in the camera that opens and closes to expose the film to light for a measured length of time.
- Shutter-priority mode An automatic exposure system in which the photographer sets the shutter speed and the camera selects the aperture (f-stop) for normal exposure.
- Shutter release The mechanism, usually a button on the top of the camera, that activates the shutter to expose the film.
- Shutter-speed control The camera control that selects the length of time the film is exposed to light.
- Silhouette A dark shape with little or no de-

- tail appearing against a light background. **Silver halide** The light-sensitive part of a photographic emulsion, including the compounds silver chloride, silver bromide, and silver iodide.
- Single-lens reflex (SLR) A type of camera with one lens which is used both for viewing and for taking the picture. A mirror inside the camera reflects the image up into the viewfinder. When the picture is taken, this mirror moves out of the way, allowing the light entering the lens to travel directly to the film.
- Slide See Transparency.
- Slow See Fast.
- SLR See Single-lens reflex.
- Sodium thiosulfate The active ingredient in most fixers.
- Soft 1. Describes an image that is blurred or out of focus. The opposite of sharp. 2. Describes a scene, negative, or print of low contrast. The opposite of hard or high contrast. 3. Describes a printing paper emulsion of low contrast, such as grade 0 or 1.
- **Spectrum** The range of radiant energy from extremely short wavelengths to extremely long ones. The visible spectrum includes only the wavelengths to which the human eye is sensitive.
- Speed 1. The relative ability of a lens to transmit light. Measured by the largest aperture at which the lens can be used. A fast lens has a larger maximum aperture and can transmit more light than a slow one. 2. The relative sensitivity to light of photographic film. See Film speed.
- Spot To remove small imperfections in a print caused by dust specks, small scratches, or the like. Specifically, to paint a dye over small white blemishes.
- **Spot meter** An exposure meter with a narrow angle of view, used to measure the amount of light from a small portion of the scene being photographed.
- Still-video camera A camera that records an image onto a small floppy disk, instead of on film.
- **Stock solution** A concentrated chemical solution that must be diluted before use.
- Stop 1. An aperture setting that indicates the size of the lens opening. 2. A change in exposure by a factor of two. Changing the aperture from one setting to the next doubles or halves the amount of light reaching the film. Changing the shutter speed from one setting to the next does the same thing. Either changes the exposure one stop.
- Stop bath An acid solution used between the developer and the fixer to stop the action of the developer and to preserve the effective-ness of the fixer. Generally a dilute solution of acetic acid; plain water is sometimes used instead of a stop bath for film.
- Stop down To decrease the size of the lens aperture. The opposite of open up. Strobe See Electronic flash.
- Substitution reading An exposure meter reading taken from something other than the subject, such as a gray card or the photographer's hand.
- Sync (or synchronization) cord A wire that links a flash unit to a camera's shutterrelease mechanism.
- **Synchronize** To cause a flash unit to fire while the camera shutter is open.

- **Tacking iron** A small, electrically heated tool used to melt the adhesive in dry-mount tissue, attaching it partially to the back of the print and to the mounting surface. This keeps the print in place during the mounting procedure.
- Telephoto effect A change in perspective caused by using a long-focal-length lens very far from all parts of a scene. Objects appear closer together than they really are. Telephoto lens See Long-focal-length lens.
- Thin Describes a negative or an area of a negative where relatively little silver has been deposited. A thin negative transmits a large amount of light. The opposite of dense
- Through-the-lens meter (TTL meter) An exposure meter built into the camera that takes light readings through the lens.
- **Transparency (slide)** A positive image on a clear film base viewed by passing light through from behind with a projector or light box. Usually in color.
- **Tripod** A three-legged support for the camera.
- **TTL** Abbreviation for through the lens, as in through-the-lens viewing or metering.
- **Tungsten film** Color film that has been balanced to produce colors that look natural when exposed in light from an incandescent bulb, specifically light of 3200 K color temperature. *Type A tungsten film* has a slightly different balance for use with photoflood bulbs of 3400 K color temperature.

- Twin-lens reflex A camera in which two lenses are mounted above one another. The bottom (taking) lens forms an image to expose the film. The top (viewing) lens forms an image that reflects upward onto a ground-glass viewing screen. Abbreviated TLR.
- **Umbrella reflector** An apparatus constructed like a parasol with a reflective surface on the inside. Used to bounce diffused light onto a subject.
- **Underdevelop** To give less development than normal.
- **Underexpose** To expose film or paper to too little light. Underexposing film produces a negative that is too light (thin) or a transparency that is too dark. Underexposing paper produces a print that is too light.
- Variable-contrast paper A printing paper in which varying grades of print contrast can be obtained by changing the color of the enlarging light source, as by the use of filters. See Graded-contrast paper.
- View camera A camera in which the taking lens forms an image directly on a groundglass viewing screen. A film holder is inserted in front of the viewing screen before exposure. The front and back of the camera can be set at various angles to change the plane of focus and the perspective.
- Viewfinder eyepiece An opening in the camera through which the photographer can

- see the scene to be photographed. Viewing screen The surface on which the image in the camera appears for viewing. This image appears upside down and reversed left to right unless the camera contains a pentaprism to correct it.
- Vignette To shade the edges of an image so they are underexposed. A lens hood that is too long for the lens will cut into the angle of view and cause vignetting.
- Visible spectrum See Spectrum.
- Washing aid See Hypo clearing bath.
 Wetting agent A chemical solution, such as Kodak Photo-Flo, used after washing film. By reducing the surface tension of the water remaining on the film, it speeds drying and prevents water spots.
- Wide-angle distortion A change in perspective caused by using a wide-angle (shortfocal-length) lens very close to a subject. Objects appear stretched out or farther apart than they really are.
- Wide-angle lens See Short-focal-length lens. Working solution A chemical solution diluted to the correct strength for use.
- Zone focusing Presetting the focus to photograph action so that the entire area in which the action may take place will be sharp.
- **Zoom lens** A lens with several moving elements which can be used to produce a continuous range of focal lengths.

BIBLIOGRAPHY

A vast number of books on photography are available, whether your interest is in its technique or its history, its use for art or for commerce. Look for them in your local library, bookstore, or camera store.

If you want a broader selection than you can find locally, two bookstores sell only books on photography, including occasional out-of-print volumes. They both produce catalogs and sell by mail: A Photographer's Place, 133 Mercer Street, New York, NY 10012 (212-431-9358), and Photo-Eye, 376 Garcia Street, Santa Fe, NM 87501 (505-988-5152), or e-mail 73311.776@compuserve.com. Light Impressions, P. O. Box 940, Rochester, NY 14603, is an excellent source of photographic storage, preservation, and display materials, as well as publications. Catalogs are free.

Eastman Kodak Company publishes hundreds of books and pamphlets ranging from basic picture-making to highly technical subjects. Get a free copy of their *Index to Photographic Information* (publication L-1), listing mostly pamphlets, from Eastman Kodak Company, Rochester, NY 14650. Kodak's books are available from Silver Pixel Press, 21 Jet View Drive, Rochester, NY 14624. Write for a catalog. Two useful basic reference books are *Kodak Black-and-White Darkroom Dataguide* (R-20), and *Kodak Professional Black-and-White Films* (F-5).

Technical references

Adobe Systems, Inc. *Classroom in a Book: Adobe Photoshop* and *Advanced Adobe Photoshop*. Indianapolis: Adobe Press/Macmillan, 1994. Includes a CD-ROM containing tutorial images. The easiest way to learn the basics of the most popular imageediting software.

Grotta, Sally Wiener and Daniel Grotta. *Digital Imaging for Visual Artists*. New York: Windcrest/ McGraw-Hill, 1994. Extensive information, clearly written.

Hirsch, Robert. *Exploring Color Photography*, 3rd ed. Madison, WI: Brown & Benchmark, 1996. Profusely illustrated, detailed compendium of color processes and techniques.

Horenstein, Henry. *Beyond Basic Photography*. Boston: Little, Brown & Co., Inc., 1977. An excellent next step, in black and white, after learning the basics.

Kobré, Kenneth. *Photojournalism: The Professionals' Approach*, 3rd ed. Newton, MA: Focal Press, 1995. Complete coverage of equipment, techniques, and approaches used by photojournalists.

London, Barbara, and John Upton. *Photography*, 5th ed. New York: HarperCollins, 1994. Comprehensive and widely used as a text. Schaefer, John P. *Basic Techniques of Photography: The Ansel Adams Guide.* Boston: Bulfinch Press, 1992. The master's techniques, updated.

Stone, Jim, ed. *Darkroom Dynamics: A Guide to Creative Darkroom Techniques.* Newton, MA: Focal Press, 1979. Illustrated instructions on how to expand your imagery with multiple printing, toning, hand coloring, high contrast, and other techniques.

History of Photography, Collections

Goldberg, Vicki. *The Power of Photography: How Photographs Changed Our Lives*. New York: Abbeville Press, Inc., 1991. Very readable essays on the influence of photography on society.

Greenough, Sarah, and Colin Westerbeck. *On the Art of Fixing a Shadow.* Boston: Bulfinch Press, 1991. Beautifully reproduced catalog of a survey exhibition from the National Gallery and the Art Institute of Chicago.

Rosenblum, Naomi. *A World History of Photography*. New York: Abbeville Press, Inc., 1984. Comprehensive and profusely illustrated.

Szarkowski, John. *Photography Until Now*. Boston: Bulfinch Press, 1990. Eloquently written history from the influential curator.

Periodicals

American Photo, 1633 Broadway, New York, NY 10019. Photography in all its forms, including the fashionable and the famous.

Aperture, 20 East 23rd Street, New York, NY 10011. A superbly printed magazine dealing with photography as an art form. Published at irregular intervals.

Photo District News, 1515 Broadway, New York, NY 10036. Directed toward professionals, particularly in stock and advertising photography.

Photo Electronic Imaging, 57 Forsyth Street NW, Atlanta, GA 30303. Commercial and industrial photography, emphasizing electronic imaging.

The Photo Review, 301 Hill Avenue, Langhorne, PA 19047. Fine-art photography, exhibition and book reviews with portfolios.

Popular Photography, 1633 Broadway, New York, NY 10019. Mainly a magazine for hobbyists that mixes information about equipment with portfolios and how-to articles.

Shutterbug, 5211 South Washington Avenue, Titusville, FL 32780. A classified ad magazine for new, used, and vintage camera equipment.

Photographic Organizations

Most of these non-profit membership organizations publish magazines and newsletters. If you live near one, you may also wish to join for their sponsored workshops, lectures, or exhibitions.

Center for Photography at Woodstock, 59 Tinker Street, Woodstock, NY 12498. Publishes *Photography Quarterly*.

CEPA (Center for Exploratory and Perceptual Art), 700 Main Street, Buffalo, NY 14202. Their occasional magazine is *CEPA Journal*.

Friends of Photography, 250 Fourth Street, San Francisco, CA 94103. Has several galleries, including one devoted to founding sponsor Ansel Adams. Publishes *re:view*, a newsletter, and the beautifully produced *see: A Journal of Visual Culture.*

George Eastman House, 900 East Avenue, Rochester, NY 14607. A museum of photography and cameras, including the restored mansion and gardens of Kodak's founder. Publishes *Image.*

Houston Center for Photography, 1441 West Alabama, Houston, TX 77006. Publishes Spot.

The Light Factory, P. O. Box 32815, Charlotte, NC 28232.

Light Work, 316 Waverly Avenue, Syracuse, NY 13244. Sponsors artists' residencies and publishes the quarterly *Contact Sheet* plus several exhibition catalogs each year.

Los Angeles Center for Photographic Studies, 6518 Hollywood Boulevard, Los Angeles, CA 90028.

National Press Photographers Association, 3200 Croasdaile Drive, Suite 306, Durham, NC 27705. An organization of working and student photojournalists, publishes the monthly *News Photographer.* (Home page http://sunsite.unc.edu/nppa/).

Photographic Resource Center, 602 Commonwealth Avenue, Boston, MA 02215. Publishes *Views: The New England Journal of Photography.*

San Francisco Camerawork, 70 Twelfth Street, San Francisco, CA 94103. Publishes *Camerawork: A Journal of Photographic Arts.*

Space constrains this list of organizations and periodicals to those in the United States. Many other countries have organizations and publications devoted to photography, which can be found through a good public library, or by contacting the non-profits listed here.

NDEX

Angle of view, 26-27, 28, 30, 32, 34 Aperture. See also F-stop amount of light and, 18, 20 control, 13 depth of field and, 19, 20-21, 36, 38, 39 flash and, 137 maximum, 25 shutter speed and, 20-21 Aperture-priority exposure, 14, 67 Aperture ring, 12, 15, 25, 40 ASA rating, 51 Automatic operation. See Exposure, automatic; Flash, automatic; Focusing, automatic Background choice of, 160-161 in close-ups, 146 lightness of, and exposure, 68, 73 out-of-focus, 165 Backlight, 68, 131, 132, 147 Backlight button, 64 Batteries, 22 Beach scene, adjusting exposure for, 70, 73 Bellows, 10, 145 Black-and-white film color temperature and, 55 fill lights for, 132 filters and, 148-149 processing, 74-93 special purpose, 52-53 Bleed mounting, 122-123 Blurring camera motion and, 44 shutter speed and, 17, 20-21 Body, 15 Bottom lighting, 131 Bounce flash, 137, 139 Bracketing exposures, 63, 71, 129, 144 Burning in, 112-114 Cable release, 44 Camera(s), 2-23 automatic, 3. See also Exposure, automatic; Flash, automatic; Focusing, automatic care of, 22-23 cases, 22 controls, 12-15

getting started with, 4-9

motion, blurring and, 44

problems, 45

Chemicals

Chrome, 49

types of, 10-11

for printing, 97

Cityscapes, 163, 172

Close-up lens, 145

Close-ups, 144-147

Clearing bath, 77, 86, 103

holding and supporting, 44

for developing, 77-78, 86-87

depth of field and, 143, 146

lighting for, 147 macro lens for, 34, 145 Color balance, 54-55 Color film, 54-55 filters and, 148-149 types of, 49, 54 Color temperature, 54-55 Contact prints, 98-99 Contamination, chemical, 78, 95 Contrast fill light and, 132 film speed and, 50 high, and exposure, 68-69 light quality and, 126-127 in negatives, 88 in prints, 107, 108-109, 110-111 Cover sheet, for print, 119 Critiquing photographs, 174-175 Cropping, 3, 115, 158 Cross-screen lens attachment, 150, 151 Cut film, 49 Density of negatives, 73, 88-89 in prints, 108-109, 110 Depth. See Perspective Depth of field, 36, 173 aperture and, 19, 20-21, 36, 38, 39 in close-ups, 143, 146 controlling, 20-21, 38-39, 164-165 focusing for, 36, 38, 40-41 previewing, 40-41 scale, 25, 40 short lens and, 32-33 Developer for film, 77 one-shot, 78, 84 for prints, 97 replenishable, 78 role of, 86-87 time and temperature of, 79, 86-87 Developing film, 74-93 chemicals for, 77-78, 86-87 equipment for, 76-77

equipment for, 144, 145

exposure for, 144, 145

time and temperature of, 79, 86-87 Developing film, 74-93 chemicals for, 77-78, 86-87 equipment for, 76-77 problems, 92-93 steps in, 79-85 Diaphragm, 15, 18 Digital cameras, 11 Digital imaging, 111, 114, 116, 152-155 editing, 154-155 equipment for, 153 steps in, 152 DIN rating, 51 Diopters, 145 Distance scale, 25, 40 Distortion, 32, 34, 42 Dodging, 112, 114 Dry mounting, 118, 120-121

Easel for printing, 96 Electronic cameras, 11, 153 Emulsion, 47, 111 Enlarger, 96 filters for, 111 vibration of, 117 Environmental portrait, 168-169 Exposure, 20-21, 56-73 aperture priority, 14, 67 automatic, 10, 14, 60 of average scene, 66-67 bracketing, 63, 71, 129 for close-ups, 144-145 of darker than normal scenes, 70 equivalent, 20 filters and, 148-149 with flash, 136-137, 140 for hard-to-meter scene, 71-72 of high contrast scene, 68-69 with infrared film, 53 of lighter than normal scenes, 70 manual, 14, 60, 62, 64-65, 67 negative density and, 88 normal, 58-59, 89 over-, 58-59, 89 overriding automatic, 3, 63, 64 problems, 68, 72-73, 140 programmed, 14, 67 shutter-priority, 14, 67 under-, 58-59, 68, 89, 144 Exposure compensation dial, 64 Exposure lock, 64 Exposure meters, 60-61 averaging, 61 built-in, 60, 66-67 center-weighted, 61 hand-held, 60, 62, 66-67, 148 hard-to-meter situations and, 71-72 high-contrast scenes and, 68-69 incident-light, 61, 67 multi-segment, 61 reflected-light, 61, 66-67, 69 spot, 61 through-the-lens (TTL), 60, 143, 148 using, 66-69 Extension tubes, 145 Fiber-base paper, 96-97, 100 mounting, 120 processing, 100-103 spotting, 116 File sizes, 153 Fill light, 132-133, 147 Film, 15, 46-55 advance, 15 care of, 22, 48, 53 cassette, 15 color, 54-55 fast, 51, 120 filters for, 148-149 fogging of, 45, 48 getting started with, 4 high-contrast, 49, 52 infrared, 47, 49, 52-53

light sensitivity of, 47

negative-type, 49, 54 orthochromatic, 47 panchromatic, 47 reversal-type, 49, 54 selecting, 4, 48-49 special-purpose, 49, 52-53 speed of, 48 storing, 48, 53 types of, 47, 49, 52-53 X-ray devices and, 48 Film processing (developing), 74-93 chemicals for, 77-78, 86-87 equipment for, 76-77 problems, 92-93 procedure, 79-85 push processing, 90-91 Film speed, 49 grain and, 50 push processing and, 90 ratings, 50, 51 Film speed setting, 64 Filters for enlarger, 111 exposure and, 148-149 factors for, 148 for film, 148-149 fluorescent, 54, 148 gelatin, 148 glass, 148 for infrared film, 53 as lens protector, 23 neutral-density, 150 polarizing, 150-151 star, 150, 151 vignetting and, 45 Filter size, 25, 148 Fisheye lens, 32, 34-35 Fixer, 77, 83, 86, 97 printing problems and, 117 Flare, 45 Flash, electronic, 136-141 automatic, 136 bounce, 137, 139 for close-ups, 147 direct, 139 exposures, 136-137, 140 for fill light, 133, 134 hot shoe, 15 positioning, 138-139 problems, 140-141 synchronizing with shutter, 136, 140 Flashbulbs, 136 Fluorescent light, 54 filter for, 148 Focal length, of lens, 13, 25, 26-27 depth of field and, 36, 38-39 long (telephoto), 30-31, 42, 162 normal, 28-29 perspective and, 42-43, 162 short (wide angle), 32-33, 42, 161, 162 shutter speed and, 44 Focal-plane shutter, 16, 136 Focusing, 13, 36 automatic, 37

depth of field and, 36, 38, 40-41

with infrared film, 53 zone, 40 Focusing magnifier, 96 Focusing ring, 12, 13, 15, 25 Frame, of image, 158-159 Front light, 130, 132, 168 F-stop, 18, 19, 20. See also Aperture

Ghosting, 45 Graded-contrast paper, 97, 110, 111 Graininess film speed and, 50 push processing and, 90 Gray card, 69, 187

Hand-holding cameras, 44 Hard-to-meter situations, 71 High-contrast film, 49, 52 High-contrast scenes, 68-69 Hinge mounting, 123 Hot shoe, 15 Hyperfocal distance, 41 Hypo. *See* Fixer Hypo check, 77 Hypo clearing bath. *See* Clearing bath

Image frame, 158-159 Incident-light meter, 61, 67 Infrared film, 47, 49, 52-53 Instant cameras, 11 Inverse square law, 137 ISO rating, 51

Landscapes, 172-173 Latitude, 58 Leaf shutter, 17 Lens, 24-45. See also Focal length attachments, 150-151 barrel, 25 care of, 22-23 close-up, 145 elements, 15 enlarger, 96 fisheye, 32, 34-35 focal length. See Focal length interchangeable, 10, 12, 26-27 macro, 34-35, 145 macro-zoom, 34, 145 problems, 45 reversing, for close-up, 145 speed, 25 zoom, 26, 27, 34, 145 Lens shade (hood), 45 Lens-to-subject distance depth of field and, 38-39 perspective and, 42-43 Light color temperature of, 54-55 controlling amount of, 16, 18, 20-21 diffused, 66, 126-127, 168 dim, 90-91, 128-129 direct, 66, 126, 130 directional/diffused, 127 existing (available), 128-129 outdoors, 134 qualities of, 126-127 streaks, 45 from window, 134, 135 Lighting, 124-141 artificial, 136

back, 131, 132, 147 bottom, 131 for close-ups, 147 cross, 147 fill, 132-133, 147 front, 130, 132, 168 high 45°, 130 main, 130-131, 134, 135 for portraits, 130-131, 134-135, 136, 138-139, 168 positions, 130-131, 138-139, 147 side, 131, 147, 168 top, 131 Light meters. See Exposure meters Long lens. See also Focal length perspective and, 42, 162 Macro lens, 34-35, 145 Macrophotography, 144 Magnification, focal length and, 26-27 Manual exposure, 14, 60, 62, 64-65, 67 Mat cutter, 119 Memory lock, for exposure, 64 Metering and meters. See Exposure: Exposure meters Metering cell, 15 Mirror, 15 Motion panning and, 17, 166-167 shutter speed and, 16-17, 20-21 Mount board, 118, 119 Mounting, 118-123 bleed, 122-123 dry, 118, 120-121 materials for, 118-119 Negative carrier, 96 Negative envelopes, 77 Negative film, 49, 54, 55

Negatives color, 54 contrast in, 55, 88-89, 110 density of, 73, 88-89 evaluating, 88-89 vs. positives, 58, 95 problems with, 92-93 processing (developing), 74-93 Normal lens. See Focal length

Orthochromatic (ortho) film, 47 Overexposure, 58-59, 89 Overmatting, 118, 122-123 Oxidation, 78

Panchromatic (pan) film, 47 Panning, 17, 166-167 Panoramic cameras, 11 Paper. See Printing paper Parallax, 10, 11 Pentaprism, 15 Perspective, 42-43, 162-163 Photoflood, for fill light, 133, 134 Photomicrography, 144 Pixels, 152, 153 Plane of critical focus, 36 Point of view, 157, 173 Polarizing screen, 150-151 Portraits, 168-171 environmental, 168-169 lighting for, 130-131, 134-135, 136, 138-139, 168 medium-long lens for, 31

Positives vs. negatives, 58, 95 Prints burning in, 112-114 from color negatives or slides, 55 cropping, 3, 115, 158 dodging, 112, 114 evaluating, 99, 107, 108-109 mounting, 118-123 spotting, 116 Printing, 94-123 chemicals for, 97 contact, 98-99 enlarging, 104-107 equipment for, 96-97 problems in, 72-73, 117 processing procedure, 100-103 Printing frame, 96 Printing paper. See also Fiberbase paper; Resin-coated paper contrast grades, 97, 110, 111 types of, 96-97 Processing of film, 74-93 of prints, 100-103 Programmed exposure, 14, 67 Projects color balance during day, 55 cutting edge, 159 exploring subject up close, 147 exposing roll of film, 3 lens focal length, 26 portrait, 169 same subject in different light, 126 showing motion, 167 using background, 161 using depth of field, 165 Push processing, 90-91 Quartz lamps, 136 Rangefinder cameras, 10, 40 Reciprocity effect, 144 Red eye, 140 Reducing agent, 86 Reflected-light meter, 61, 66-67, 69 Reflections, 140, 150-151 Reflector, 133, 134, 139

Reciprocity effect, 144 Red eye, 140 Reducing agent, 86 Reflected-light meter, 61, 66-67, 69 Reflections, 140, 150-151 Reflector, 133, 134, 139 Resin-coated (RC) paper, 96, 100 mounting, 120 processing, 100-103 spotting, 116 Responding to photographs, 174-175 Reversal film, 49, 54, 55 Rewind mechanism, 15 Roll film, 49

Safelights, 97 Shadows fill light and, 132-133 lighting and, 126-127, 130-131 Sheet film, 49 Short lens. *See also* Focal length perspective and, 42, 161, 162 Shutter, 15, 16-17, 136 Shutter-priority exposure, 14, 67 Shutter release, 15 Shutter release, 15 Shutter speed amount of light and, 16, 20 aperture and, 20-21 blurring and, 17, 20-21 control, 13

dial, 15 flash and, 136, 140 to hand hold camera. 44 motion and, 13, 16-17, 20-21, 166-167 selector, 12 settings, 16 Side (cross) light, 131, 147, 168 Silhouette, 63, 68, 70 Single-lens reflex (SLR) cameras, 10, 12, 15 for close-ups, 143 depth of field and, 40 Slides. See Transparencies Snow scene, adjusting exposure for, 70, 73 Sodium thiosulfate, 86 Soft-focus lens attachment, 150 Spot meter, 61 Spotting, 116 Stereo cameras, 11 Still-video cameras, 11 Stop bath, 77, 83, 86, 97 Stops, of exposure. 20 Strobe. See Flash, electronic Substitution reading, 69 Synchronization cord, 139 Tacking iron, 119 Telephoto lens. See Focal length, long Transparencies black-and-white, 49 color, 49, 54-55, 132 exposure and, 58 fill light and, 132 Tripods, 44, 144 Twin-lens reflex (TLR) cameras, 11 Umbrella reflector, 139 Underexposure, 58-59, 68, 89 in close-ups, 144 Underwater cameras, 11 Variable-contrast paper, 97, 110, 111 View cameras, 10-11, 40, 143 Viewfinder cameras, 10 Viewfinder eyepiece, 15 Viewing screen, 9 Vignetting, 45 Visual elements, 175

Wetting agent, 77 Wide-angle lens. *See* Focal length, short

X-ray devices, film and, 48

Zone focusing, 40 Zoom lens, 26, 27, 34, 145 Cut out and assemble the light meter dials on page 185 to see how film exposure is related to light intensity, film speed, shutter speed, and aperture.

Assembling the dials

Cut out the 3 dials and the 2 windows in the dials.

 $2^{\rm Connect}$ the 3 dials by putting a pin first through the center point of the smallest dial, then the mediumsize dial, and finally the largest dial. (A pushpin, with a piece of cardboard underneath the largest dial, works best.)

C Line up the 2 windows so you can read the film O speeds through them.

Using the dials

To calibrate your meter to your film, set the arrow ▲ marked ISO to the speed of your film. For a trial, set it to ISO 100.

 $2^{\rm With}$ a real light meter, you point its light-sensitive cell at a subject to get a reading of the brightness of the light. In one type of meter, a needle on a gauge (not shown here) indicates the brightness of the light.

Suppose this light measurement reading was 17. Keep the film-speed arrow pointing to 100 while you set the other arrow \blacktriangle , which points to the light measurement, to 17.

 $3\,{\rm Now}$ you can see, lined up opposite each other, combinations of shutter speed and aperture that will produce a correct exposure for this film speed and this amount of light: 1/250 sec. shutter speed at f/8 aperture. 1/125 sec. at f/11, and so on. All these combinations of shutter speed and aperture let in the same amount of light.

 $4\,{\rm Try}$ increasing (or decreasing) the film speed to see how this affects the shutter speed and aperture combinations. For example, keep the light-measurement arrow at 17 while you move the film-speed arrow to 200. Now the combinations show a 1-stop change: 1/250 sec. at f/11, 1/125 sec. at f/16, and so on.

 $5\,$ lf the light gets brighter (or dimmer), how would this affect the shutter speed and aperture combinations? Suppose the light is dimmer, and you only get a light reading of 16. Set the light-measurement arrow to 16. while you keep the film-speed arrow at 200. What are the combinations?

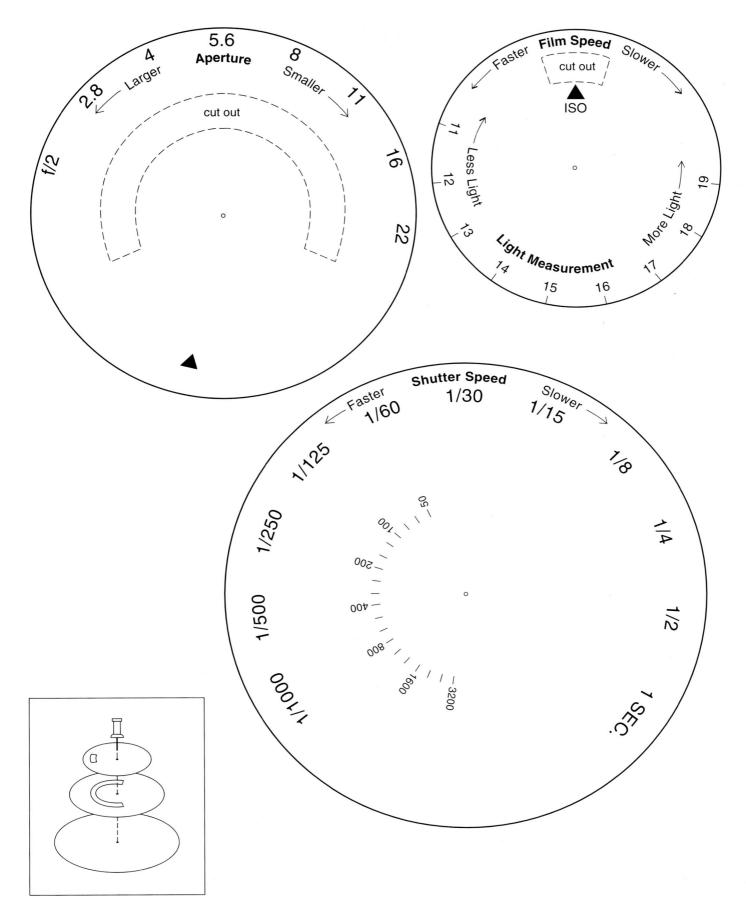

Opposite: A "gray card," a tone of approximately 18 percent reflectance that can be used for substitution meter readings. See page **69**.